Dedicated to the memory of Clifton C. Edom

PICTURES OF THE YEAR
PHOTOJOURNALISM 16

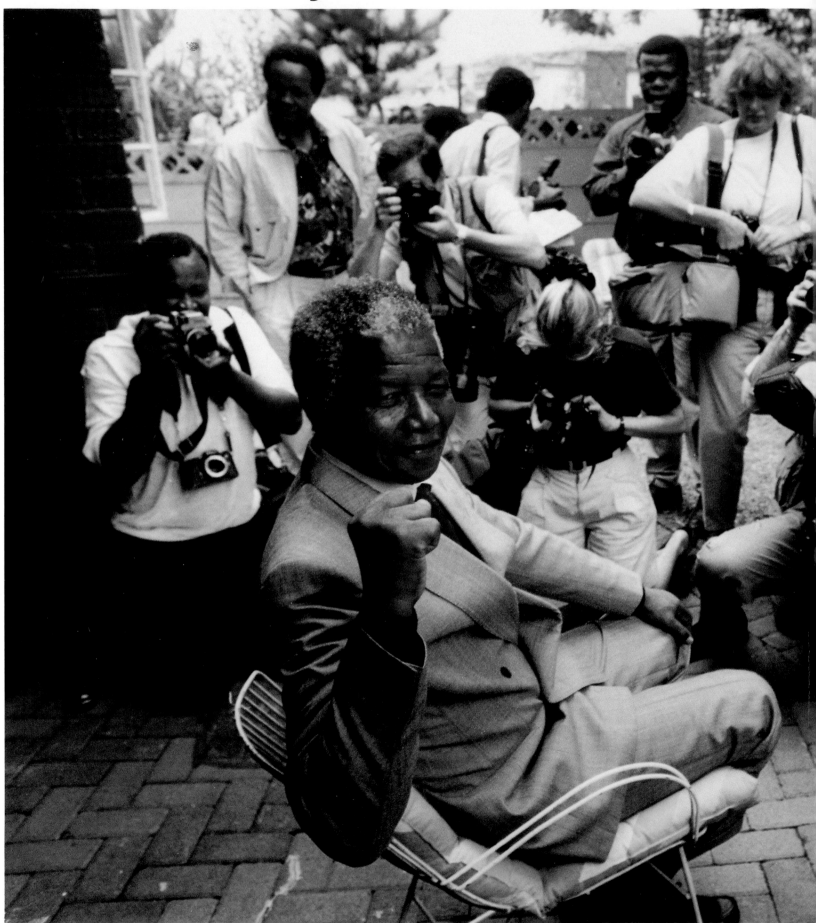

David C. Turnley, Detroit Free Press
Nelson Mandela meets the press shortly after his release from prison in South Africa.

An annual based
on the 48th
Pictures of the Year
competition sponsored
by the National
Press Photographers
Association
and the University
of Missouri
School of Journalism,
supported by grants to the
university from Canon
U.S.A., Inc., and
Eastman Kodak Co.

FROM NPPA'S PRESIDENT

The photographs that grace the pages of this book have been judged to be the finest made in 1990.

They are the winners in the 48th annual Pictures of the Year competition sponsored by the National Press Photographers Association and the University of Missouri. More than a series of fine images, however, these photographs do what we do best — document our times. They recorded the events and trends of this past year. These images are timeless.

We as photojournalists have a responsibility to document society and to preserve its images as a matter of historical record. We must not lose sight of the value of our work.

It is vital that we perpetuate documentary photography, even in the changing visual world of glitz and flash. We must remember our roots as documentary photojournalists.

Beyond the images, NPPA and the University of Missouri honor newspapers and magazines for how they use photographs. For the first time, a traveling award, named to honor Angus McDougall, professor emeritus of the University of Missouri, was given for overall excellence in picture usage. The first winner is *The Sacramento Bee*.

We all like to be rewarded for a job well done, but a more important lesson to be learned while preparing for the competition is the evaluation of the past year's work, to see what one has accomplished and set sights on new horizons for the coming year. The people whose work you see on these pages stretched beyond the norm. Their work is memorable and will stand the test of time.

The photographs in the book are not to be emulated; they are to inspire one to reach for new heights.

Michael T. Martinez
President

© 1991 National Press Photographers Association
3200 Croasdaile Drive
Suite 306
Durham, NC 27705

ISBN (paperback): 0-56138-067-9

Front cover photo by Jeff Tuttle
Back cover photo by Paul Kuroda

Printed and bound in the United States of America by Jostens Printing and Publishing Division, Topeka, KS. 66609. The editor wishes to thank Dave Klene for his cooperation during this project. As usual, he offered guidance and helped NPPA create a quality book.

Canadian representatives: General Publishing Co., Ltd., Don Mills, Ontario M3B 2T6.

International representatives: Worldwide Media Services, Inc., 115 East 23rd Street, New York, NY 10010.

9 8 7 6 5 4 3 2 1
Digit on the right indicates the number of this printing

This book may be ordered by mail. Please include $2.50 for postage and handling. *But try your bookstore first!*

Running Press Book Publishers, 125 South 22nd Street, Philadelphia, PA 19103.

TABLE OF CONTENTS

NEWSPAPER PHOTOGRAPHER
OF THE YEAR

PAGE
27

MAGAZINE PHOTOGRAPHER
OF THE YEAR

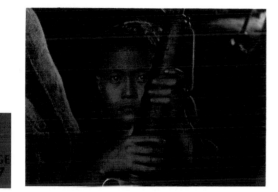

PAGE
37

KODAK CRYSTAL EAGLE

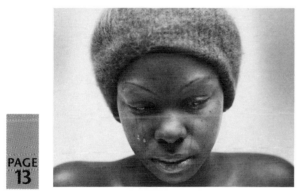

PAGE
13

CANON PHOTO ESSAY

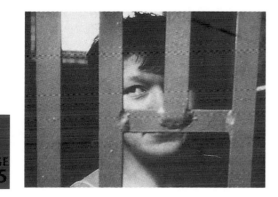

PAGE
215

THE STAFF

Editor, designer
Howard I. Finberg
Associate editor, photo editor
Joe Coleman
Associate editor, photo coordinator
Judy Tell
Associate editor, designer
Phil Hennessy
Associate editor, designer
Carolyn Rickerd
Associate editor, designer
Diana Shantic
Associate editor, designer
Pete Watters
Text editor
Patricia Biggs Henley
Computer assistance
Don Foley
Image scanning
Susan Cleere
Keith Rosborough

INTRODUCTION

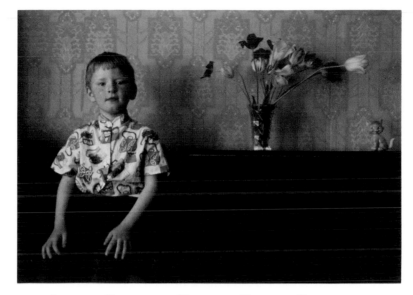

AWARD OF EXCELLENCE, NEWSPAPER PORTRAIT/PERSONALITY
Joe Patronite, Dallas Times Herald
A youngster in Kungur, in the Soviet republic of Russia.

O ur business is of the moment: Quick, freeze the image and then move on to the next assignment. There is little time to reflect, to gather one's thoughts about the impact photography has on the reader. Two events last year offered an opportunity to explore photography's role and impact.

One was the death of Cliff Edom, professor emeritus at the University of Missouri. But that title doesn't touch upon his great influence on the role of photography in newspapers and magazines. Through his teachings and his work with the National Press Photographers Association, Professor Edom probably influenced more journalists than can be counted.

He understood the changing role of visuals in the print media and the important function photography plays in communicating news and information. In 1976, he wrote in the last chapter in his book, *Photojournalism, Principles and Practices*:

> One important influence on the photojournalism of tomorrow are the people who depend upon words and pictures for their news, information and entertainment. Born in a visual age and nurtured on television and on picture newspapers and magazines, they are demanding. Not satisfied with just

Continued on next page

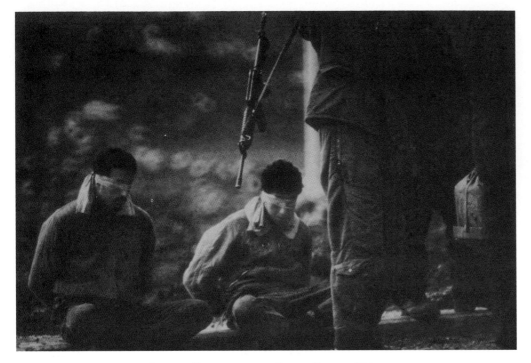

SPECIAL RECOGNITION, CANON PHOTO ESSAY
James Lukoski, free-lance
Palestinian prisoners, tied and blindfolded, await their fates
in the Gaza Strip.

AWARD OF EXCELLENCE
**Andrew Itkoff, Fort Lauderdale News/
Sun-Sentinel**
A homeless teen in Fort Lauderdale, Fla.

any "click of the shutter," they demand much of today's photojournalist and in the future will demand even more. Photojournalism of the future must be perceptive and must have integrity and believability.

Key to mastering photojournalism of the future is still mutual respect between newspapers and readers. That respect is earned, a process that newspapers still have difficulty with. Cliff Edom knew the rewards of this type of journalism because he saw the change from "shutter clickers" to photojournalism. He helped create the principle that a photographer was a journalist with a camera, a visual reporter. While he will be missed by family and friends, his influence will endure.

The second important event last year — on the surface unrelated to Professor Edom — was the publication of a study by the Poynter Institute for Media Studies.

This study, by Dr. Mario R. Garcia and Dr. Pegie Stark, was done to find out the influence of color upon newspapers and newspaper readers. Tucked into the back of this study was the concrete data that many have believed in their hearts about the importance of pictures on a printed page:

"Photos attract attention. They are the dominant point of entry on nearly every page, only occasionally sharing that role with headlines. Overall, 75 percent of the photos (in the study) are processed.

"This high level of processing holds true whether the photo is in black and white or color.

"If it's true that photos attract attention, it's also true that big photos attract more attention. We (Drs. Garcia and Stark) find, to no one's surprise, a link between size and reader processing of photographs."

The study cautions that this is a new area of research and that the findings are based on a small sample. However, this is the first time there has been "proof" of the importance of photography in the process of reading a daily newspaper. No surprise to the hard-working photographer or picture editor. And probably not a surprise to people like Cliff Edom.

The images in this book met the goals of integrity and believability, often at great risk of danger to the photographer trying to communicate information to the reader. And despite attempts by governments and "official agencies" to reduce the photographer's role to that of a "shutter clicker" at "media opportunities," there are still the brave souls who risk all to share images and life with the reader, the most important person in the whole process.

Howard I. Finberg, editor

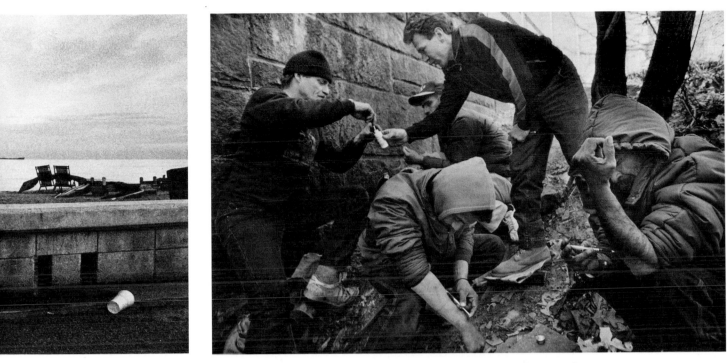

AWARD OF EXCELLENCE, MAGAZINE PICTURE STORY
David Binder, free-lance
Jon Parker, founder of the National AIDS Brigade, distributes needles and alcohol to
addicts, trying to prevent the spread of acquired immune deficiency syndrome.

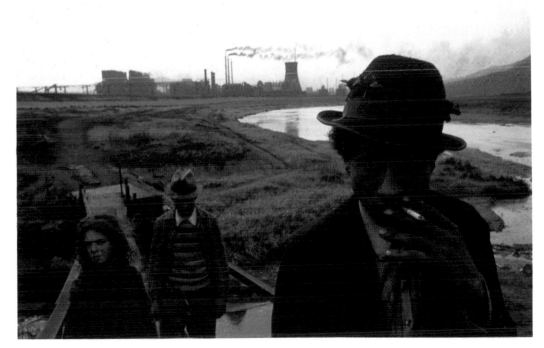

AWARD OF EXCELLENCE
Anthony Suau, Black Star for Time
Gypsies return home after working in the carbon factory in Copsa Mica, Romania.

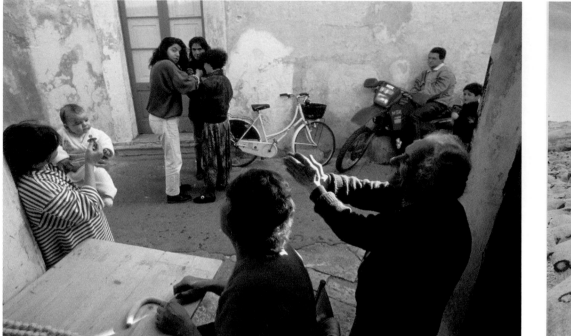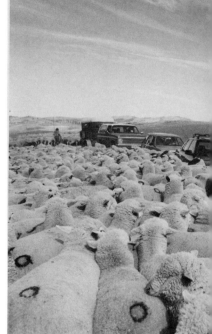

Jim Richardson, A Day in the Life of Italy, Collins Publishing
Four generations share an ordinary moment in the back alleys of a town in Italy.

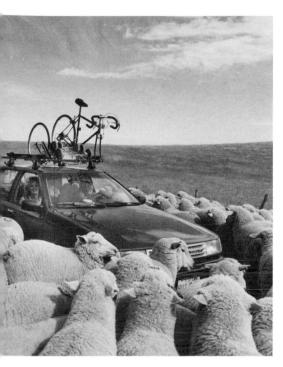

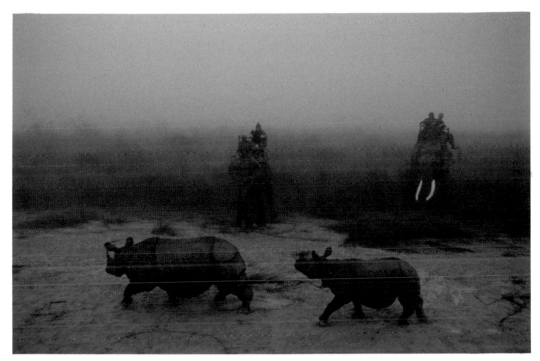

AWARD OF EXCELLENCE, SPORTS FEATURE
Jim Evans, Jackson Hole Guide
Support crews for bicycle racers are
snarled in a flock of sheep in Idaho.

AWARD OF EXCELLENCE, MAGAZINE NEWS/DOCUMENTARY
Galen Rowell, One Earth, Collins Publishing
Low-impact tourism leaves only footprints in Nepal's Chitwan National Park, a former
hunting reserve that now is a rhinoceros sanctuary.

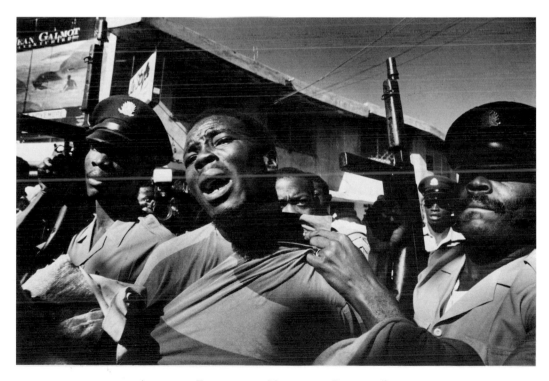

AWARD OF EXCELLENCE, NEWSPAPER PICTURE STORY
Carol Guzy, The Washington Post
During a funeral for victims of the Tonton Macoutes in Haiti, a suspected member of the
Macoutes is led away from a mob intent on killing him.

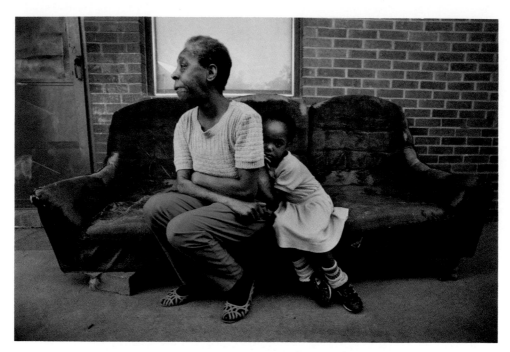

AWARD OF EXCELLENCE, NEWSPAPER PORTRAIT/PERSONALITY
Joey Ivansco, Atlanta Journal and Constitution
Five-year-old Shoin "Pinkie" Bass nestles next to her grandmother, Vester Bass,
outside their Atlanta apartment.

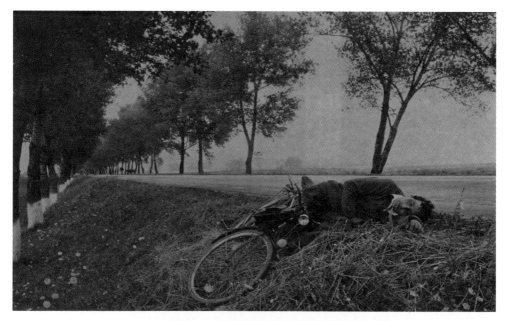

AWARD OF EXCELLENCE, MAGAZINE PICTURE STORY
Anthony Suau, Black Star for Time
A cyclist traveling in Romania sleeps along the road.

Darkness at Home

The epitome of success: Garth and Lisa, in 1981, seemed to have it all, rearing five children in an upper-class home in Westchester, N.Y., surrounded by a circle of friends, enjoying the American dream.

Photographer Donna Ferrato, who was living with them at the time, began chronicling their life together in what she thought would be an upbeat character study.

"I had never met a family that was more loving," Ferrato says.

Ferrato left for four months in 1982. When she returned, she says, she was shocked at the change in the couple.

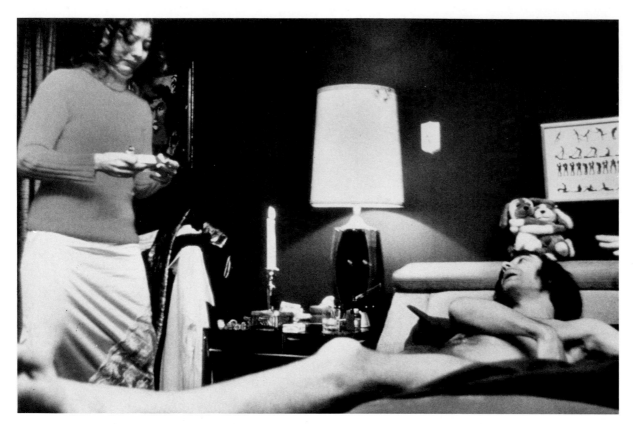

Tensions between the pair begin to surface. Garth turns to cocaine; Lisa turns to alcohol. (1981)

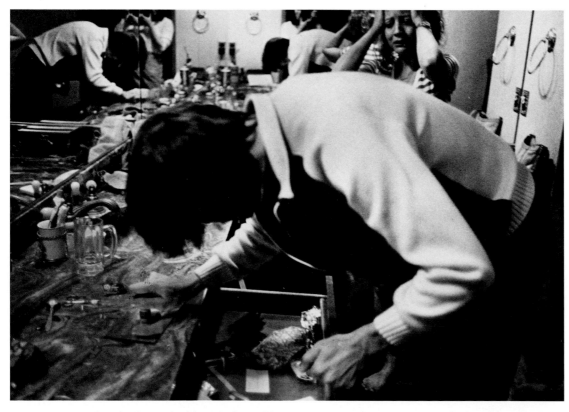

Late one night, the household is awakened by noise as Garth searches frantically through the bathroom for a cocaine pipe. (1982)

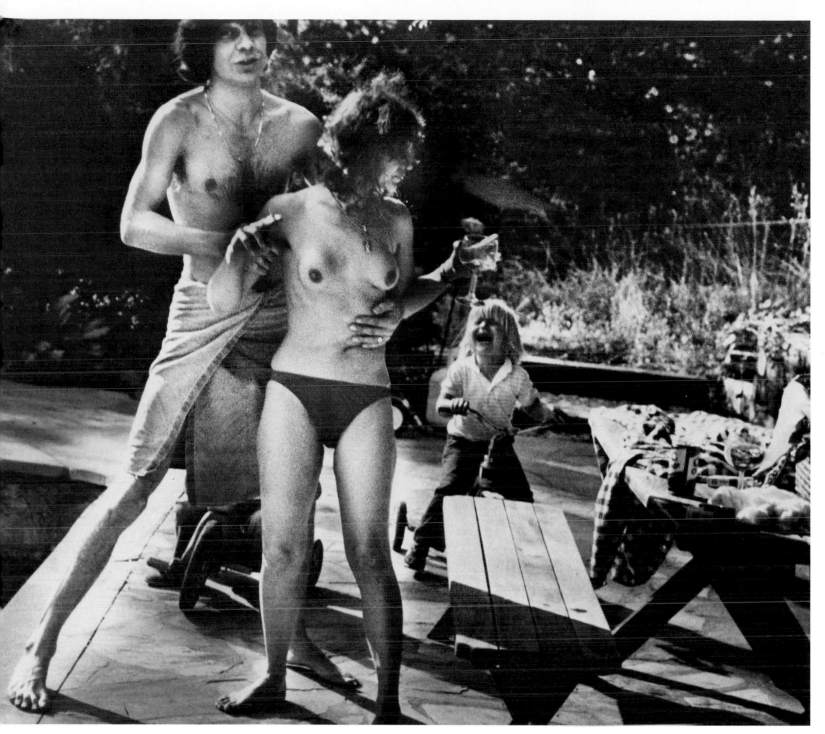

Garth forcibly pulls Lisa away from the pool. (1982)

"Lisa seemed to be completely overwhelmed. They were obviously doing more and more drugs. I first saw the husband be abusive when he dragged her in from the pool."

One night, Ferrato was awakened by loud noises. "I took my camera. . . . I went down to investigate."

Garth was in the bathroom, rooting through drawers. Ferrato says that because of the time she'd spent documenting the couple, she reacted automatically. "The camera was up to my eye," she says.

"Garth didn't seem to notice me. I was in the midst of this storm." She photographed Garth hitting his wife, but when he tried to strike Lisa again, Ferrato stopped him.

"He never hit her again in front of me," she says. The couple later divorced.

The incident prompted Ferrato to examine domestic violence, to portray families dealing with what she calls "that darkness in their lives."

She lived in shelters for abused women in Pennsylvania. She attended counseling sessions for abusive men in Colorado. Last year, she spent time in Renz Prison in Missouri with women prisoners who had killed their abusers.

For her photographic study of domestic violence, Ferrato is the winner of the 1990 Kodak Crystal Eagle Award for Impact in Photojournalism.

Donna Ferrato

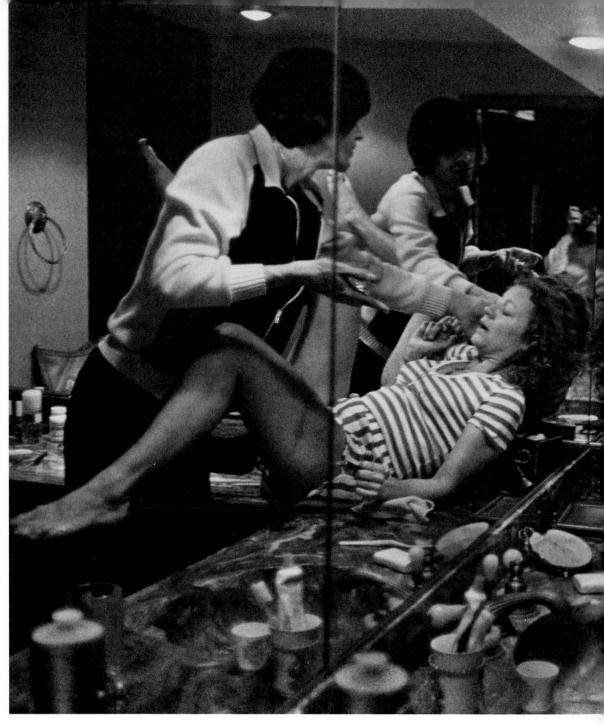

Garth corners Lisa against the bathroom mirrors, demanding that she tell him where she hid the cocaine pipe. Lisa refuses, saying, "I'm trying to save our marriage." (1982)

Donna Ferrato

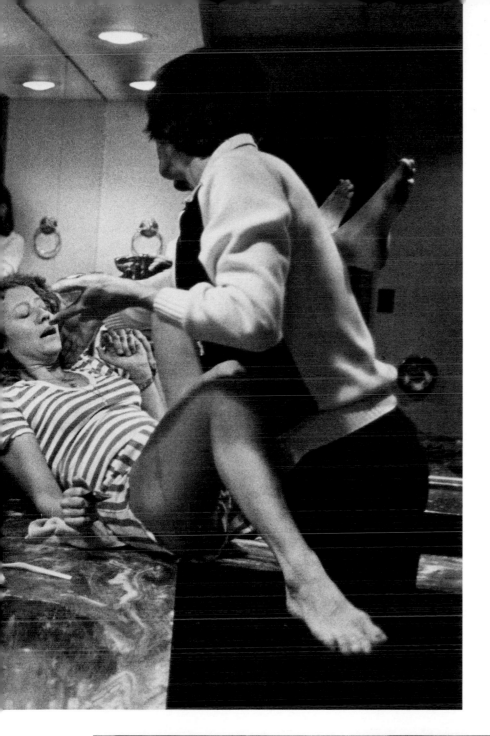

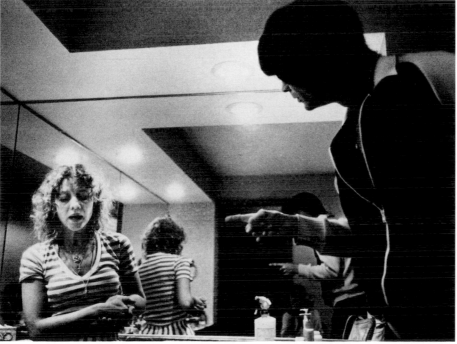

Following Page:
Garth strikes Lisa

Donna Ferrato

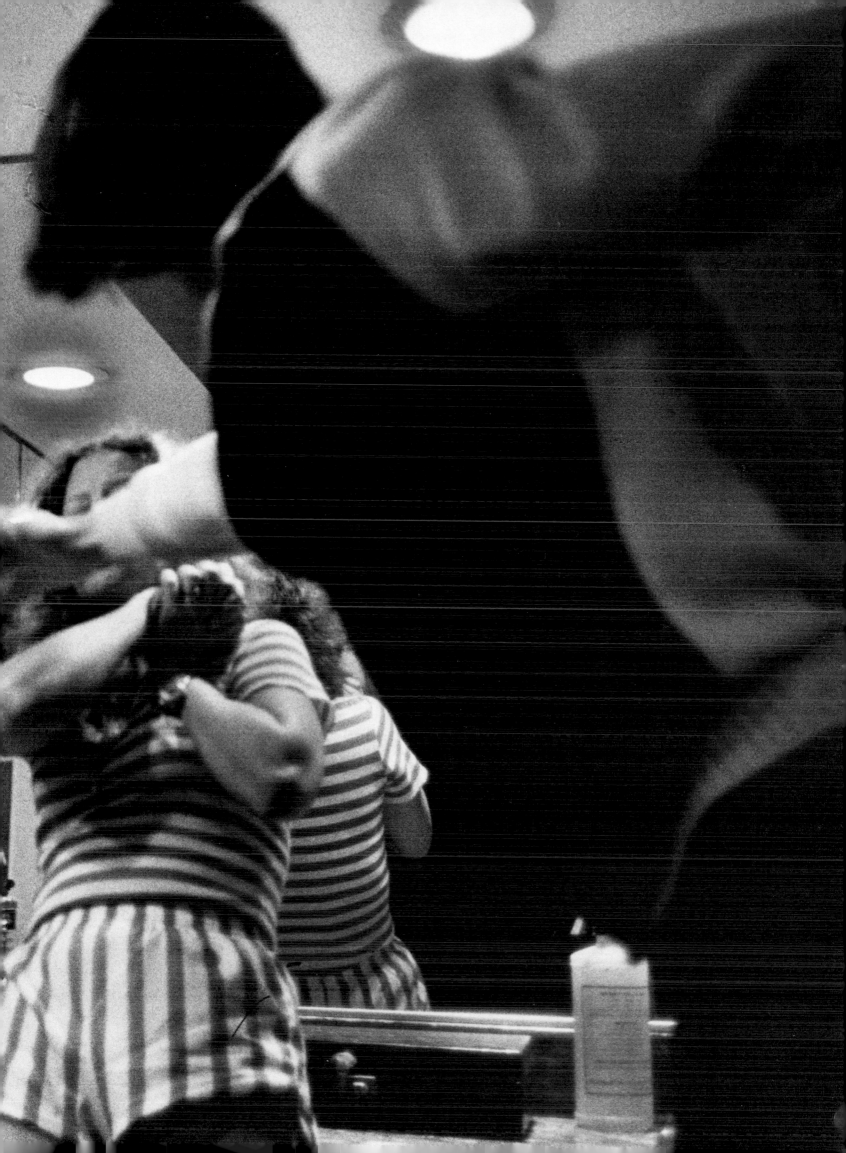

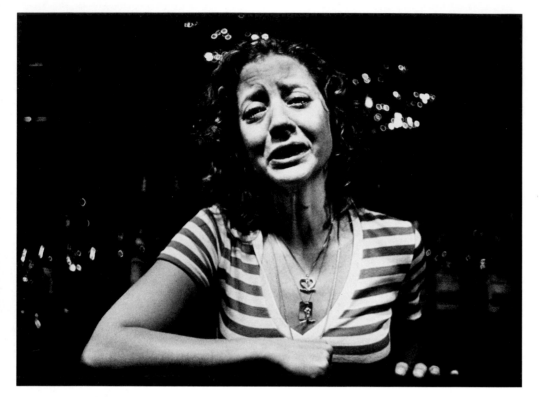

"How can he say he loves me, and beat me worse than he would our dog?" (1982)

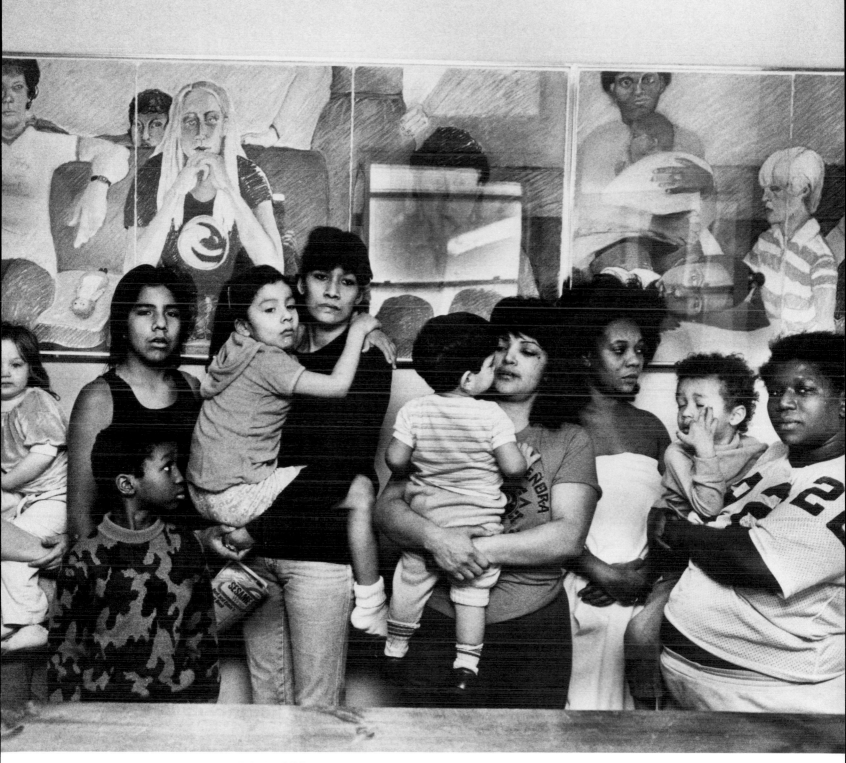

Battered women and their children seek refuge at the Women's Advocates Shelter in St. Paul, Minn. (1988)

Donna Ferrato

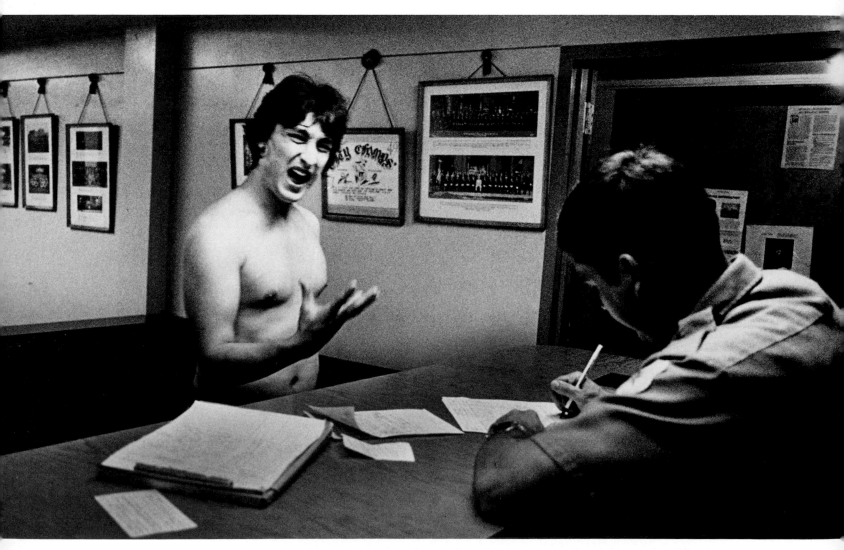

After his arrest in a domestic-violence case, a man shouts about having to spend a night in jail. (1982)

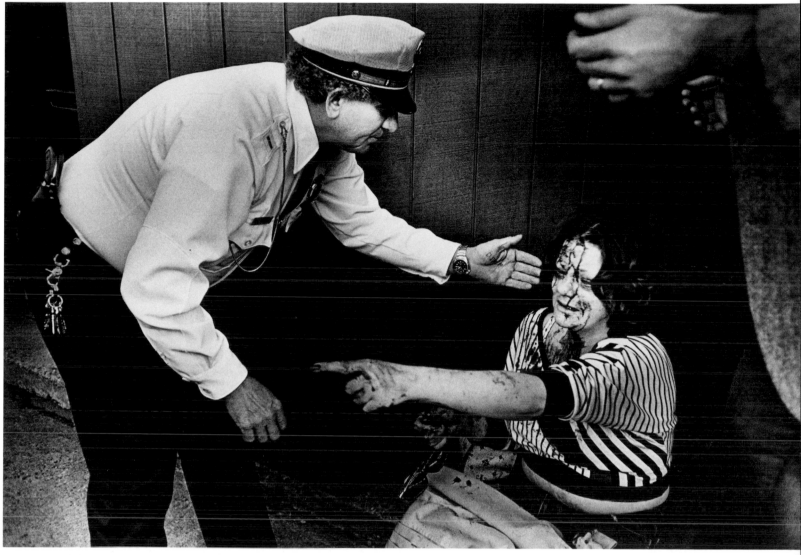

This woman was attacked by a friend while they walked home from a bar. He fled before police arrived. (1982)

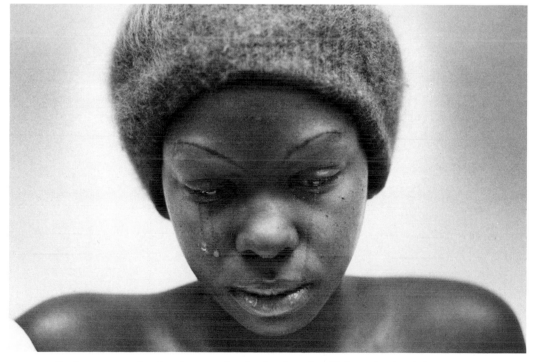

Janice, years after leaving an abusive husband, still fears for her life. (1984)

Donna Ferrato

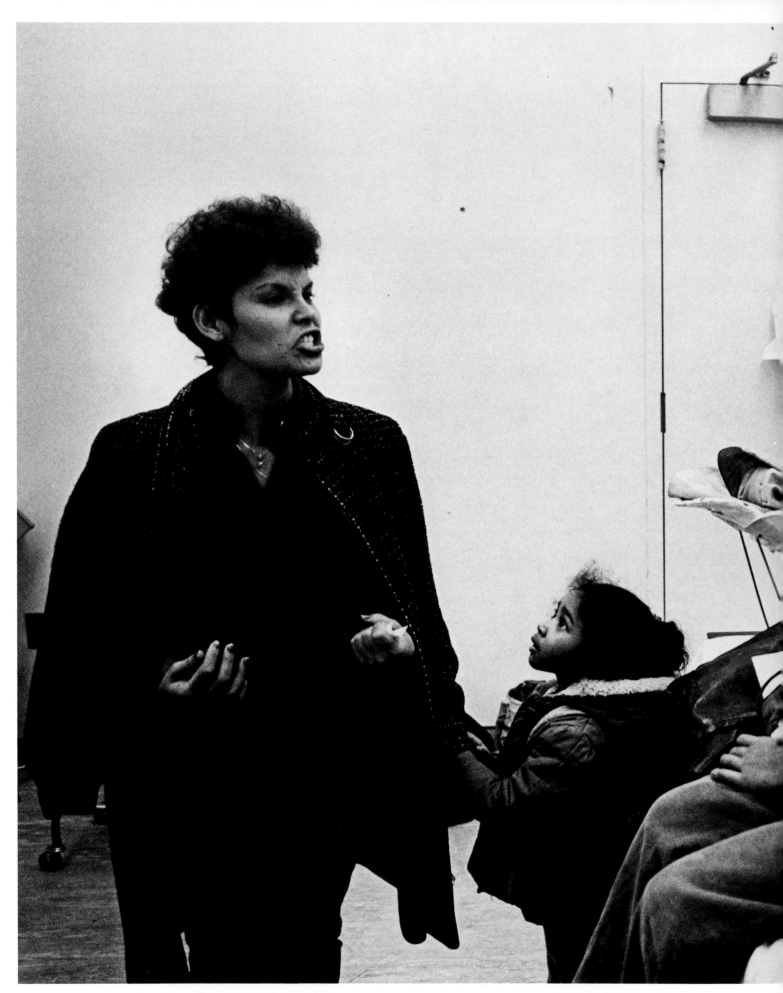

Lilly (left) helped her neighbor, Sandra, (right) escape an abusive husband. In the ruckus, Sandra's husband cut Lilly's hand. "Don't go back to that man," Lilly says at the hospital. (1985)

Donna Ferrato

KODAK CRYSTAL EAGLE

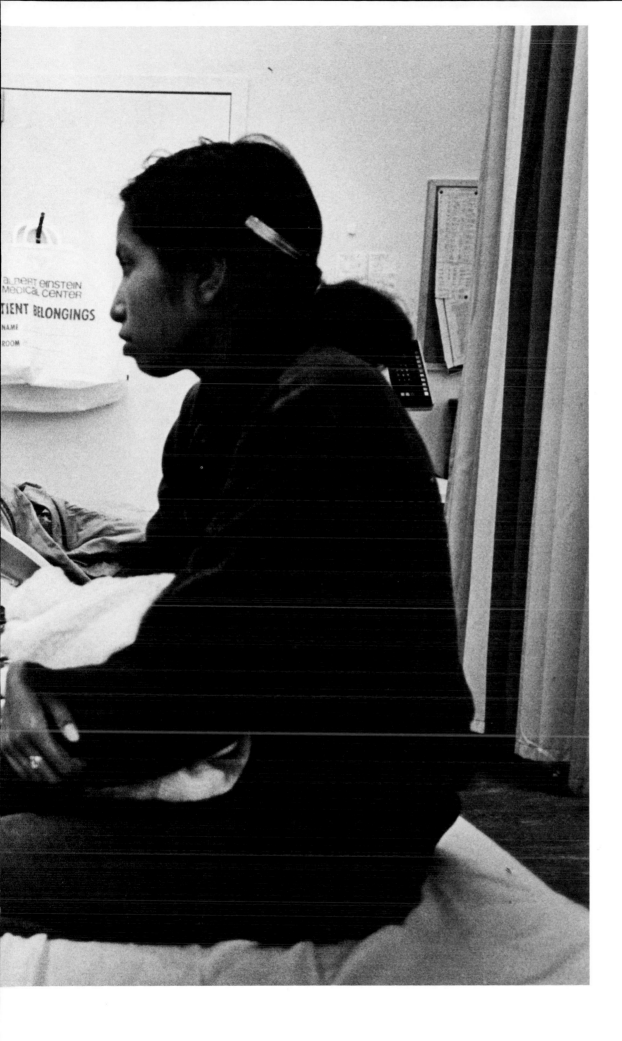

Donna Ferrato

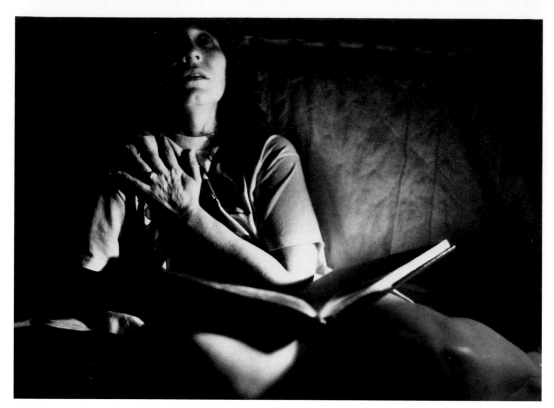

Helen, sentenced to 50 years without parole for killing a violent husband, looks at photographs of her only daughter. (1990)

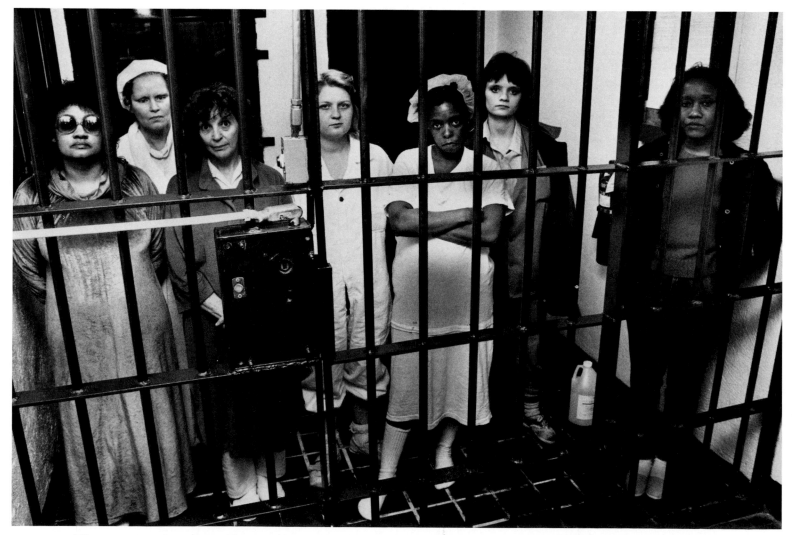

These women were abused by men. Most of them will remain imprisoned for life for killing their abusers. (1990)

Donna Ferrato

Paul Kuroda / The Orange County Register

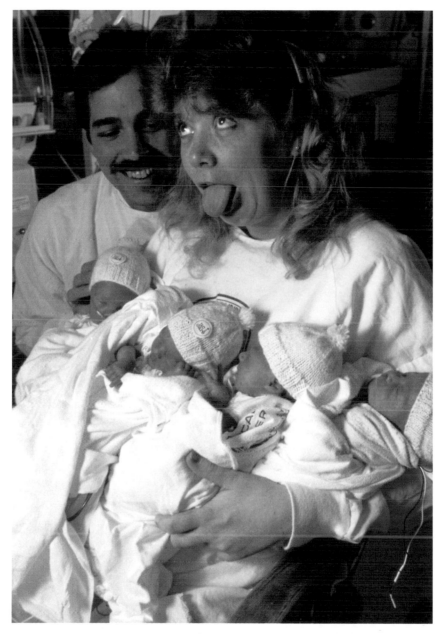

Karen Miner of Orange, Calif., expresses the joy of quadruplets.

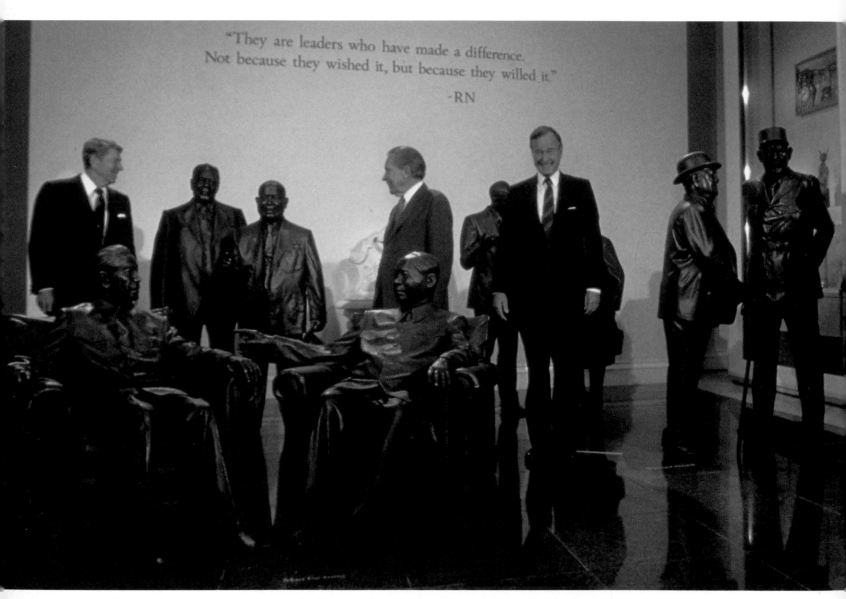

The president and three former presidents gather for the opening of the Nixon Library in Yorba Linda, Calif.

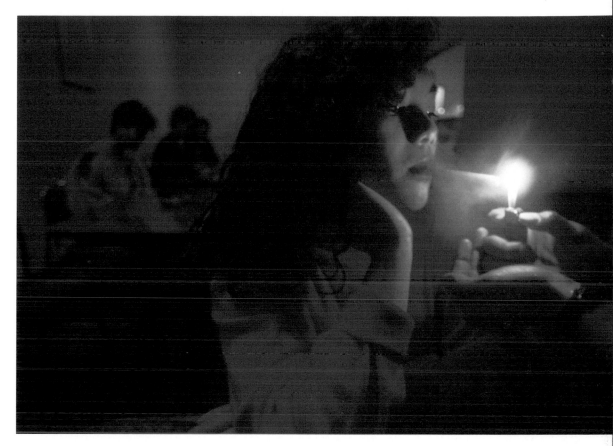

Vietnamese gang leader Michele Nguyen receives a light in a cafe in Westminster, Calif.

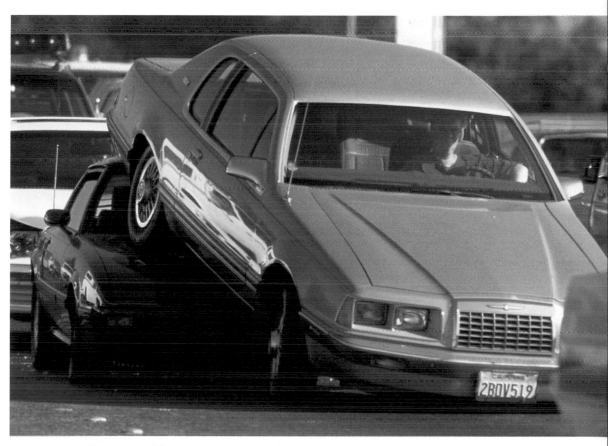

Sharon Smaldino waits in her car for emergency units in Anaheim, Calif.

Paul Kuroda

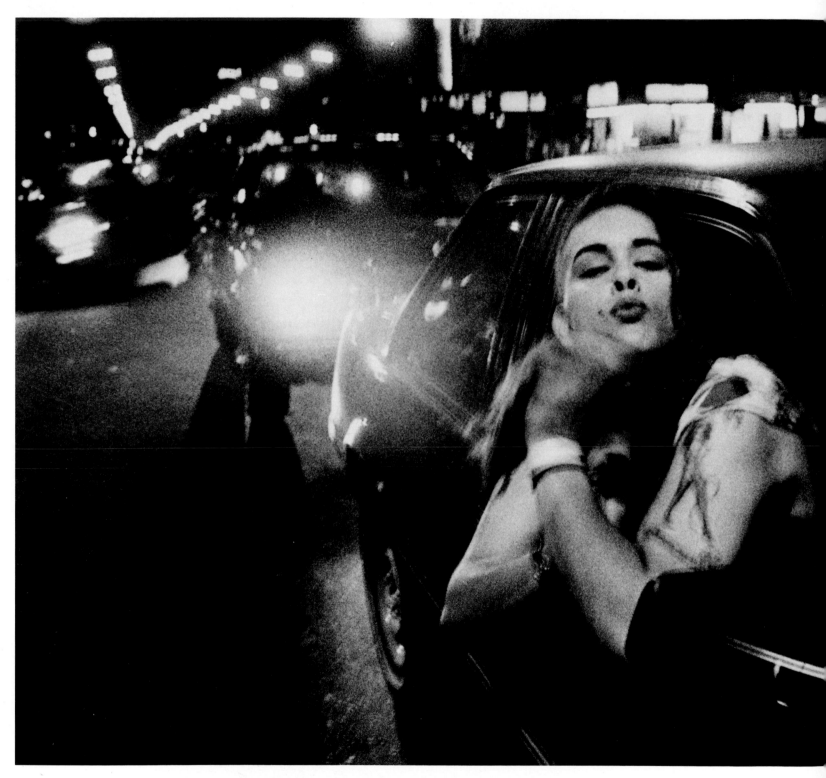

A young man cruises Hollywood Boulevard in California.

Paul Kuroda

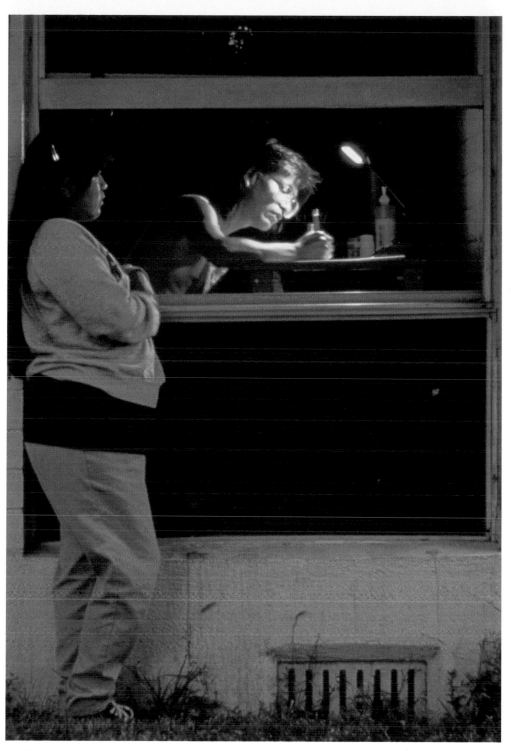

Cheryl Migriel chats with Derek Ramon while he studies in his dormitory room at Sherman Indian High School in Riverside, Calif.

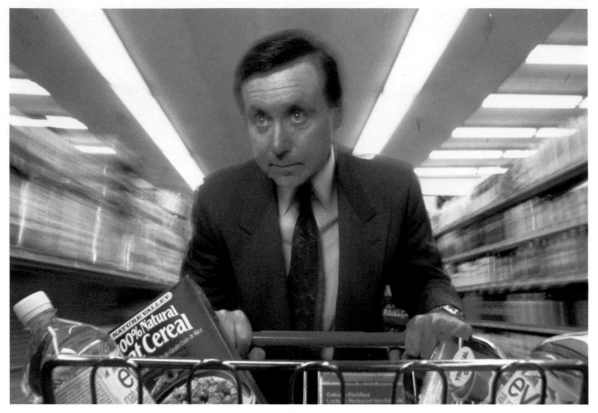

Consumer advocate David Horowitz demonstrates his grocery-shopping tips.

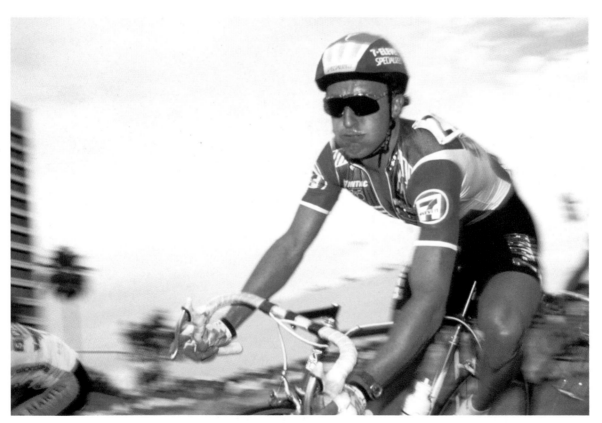

A bicyclist on the 7-Eleven team races at Cyclefest in Newport Beach, Calif.

Hispanics await nightfall before crossing illegally into the United States. The border fence is at left.

Border Chase

The dream of a better life lures thousands of Hispanics into California every day. But for many of those who enter the country illegally, reality quickly tarnishes their hopes.

If the immigrants manage not to fall prey to bandits, they face an even graver danger: Nearly 300 have been killed in the past three years while trying to cross Interstate 5 to avoid a border checkpoint.

Although the Border Patrol is detaining 3,000 illegal immigrants daily, the Census Bureau estimates that nearly one-fourth of the increase in this country's Hispanic population during the 1980s consisted of those who entered the country unlawfully.

Paul Kuroda
NEWSPAPER PHOTOGRAPHER OF THE YEAR

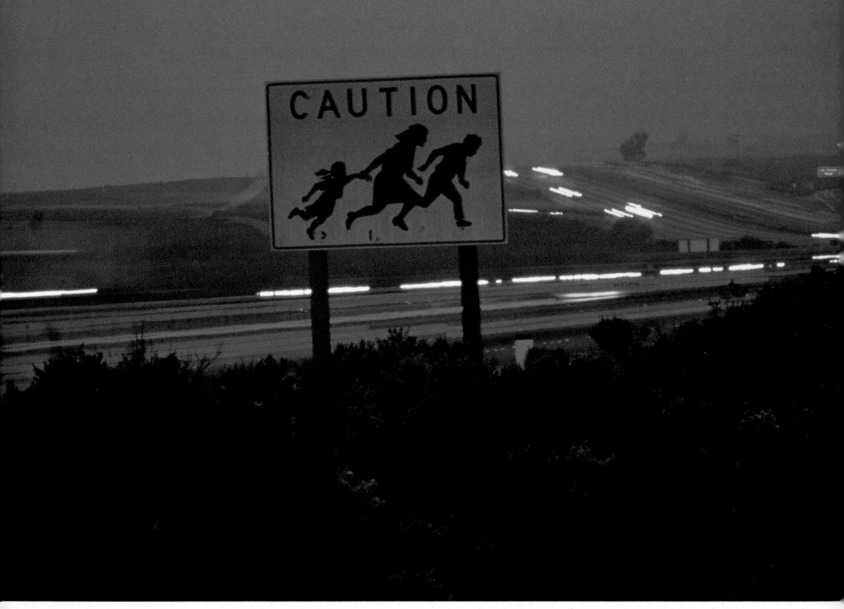

Many illegal immigrants are killed trying to outrun cars on Interstate 5 in San Clemente, Calif.

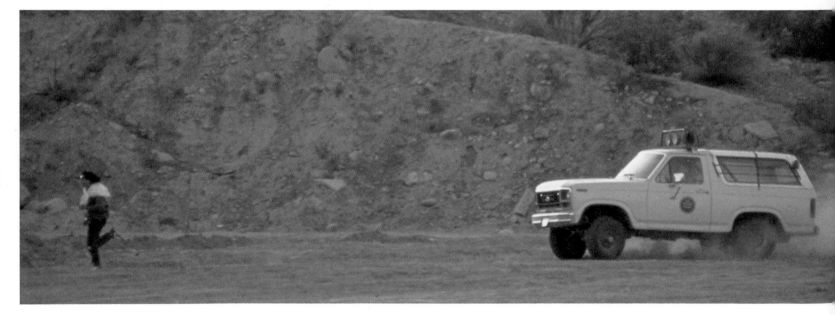

A U.S. Border Patrol officer pursues a Mexican national in San Diego at the border. The man escaped up a steep hill.

Paul Kuroda

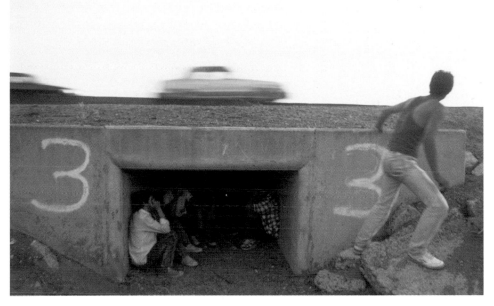

A smuggler watches for his ride while illegal immigrants hide in a drainage tunnel under a southern California freeway.

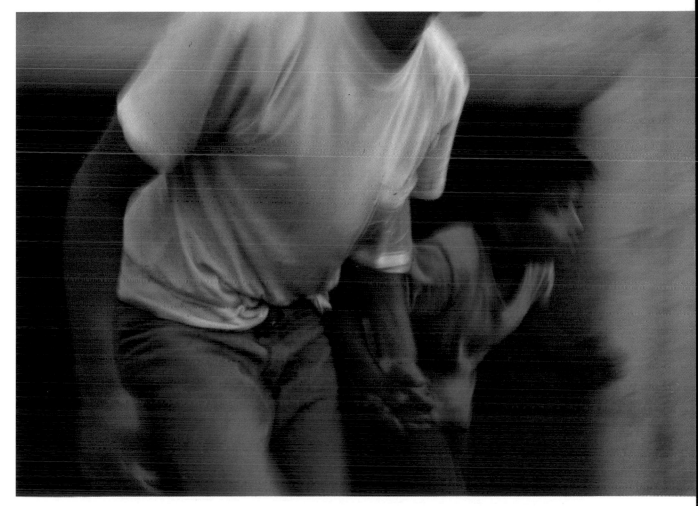

A man and his son emerge from a tunnel after hiding from Border Patrol officers.

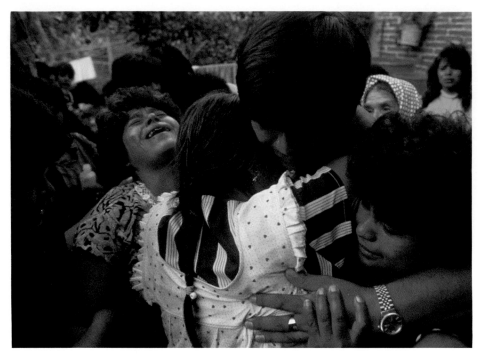

A man comforts relatives after the death of his parents. The couple were struck
by cars while trying to cross a California freeway.

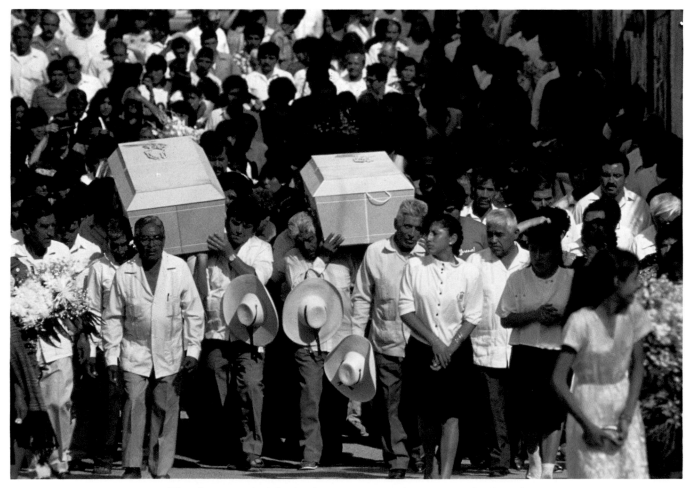

The dream ends: The bodies are returned to Mexico for burial.

Paul Kuroda

NEWSPAPER PHOTOGRAPHER OF THE YEAR

James Nachtwey, Magnum

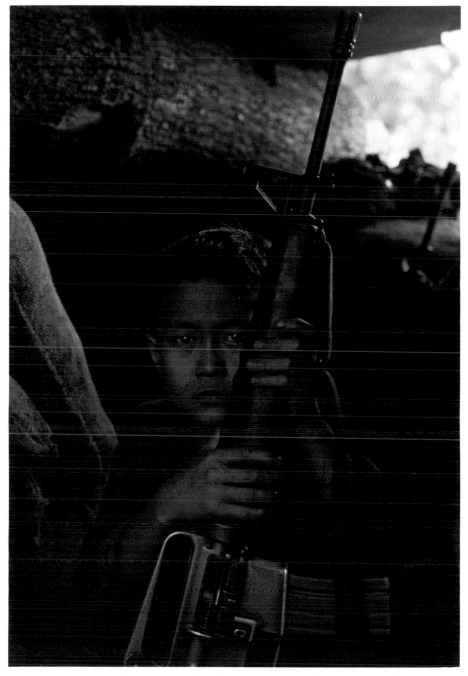

A 13-year-old member of the rebel Karen National Liberation Army, an ethnic minority group that is fighting the Burmese government.

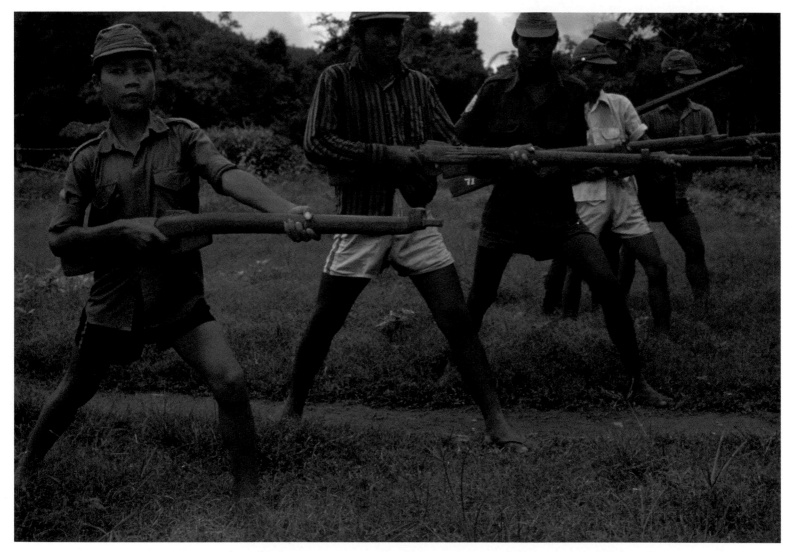

Karen boys train to become rebel fighters in Burma.

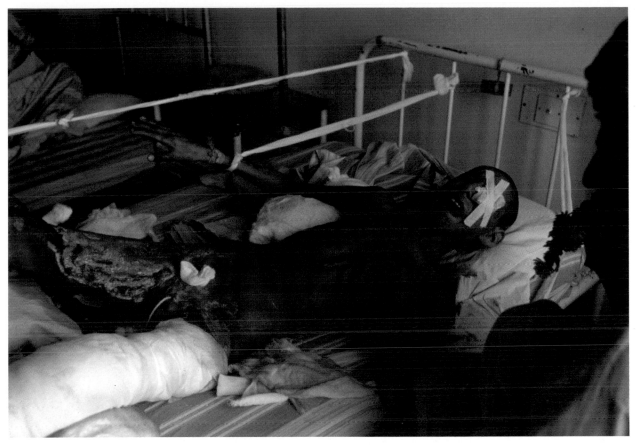

An Afghan youth, injured by a land mine while traveling with mujahideen warriors,
lies dying from his wounds.

A 15-year-old was killed by police during a demonstration in Belfast, Northern Ireland.

James Nachtwey

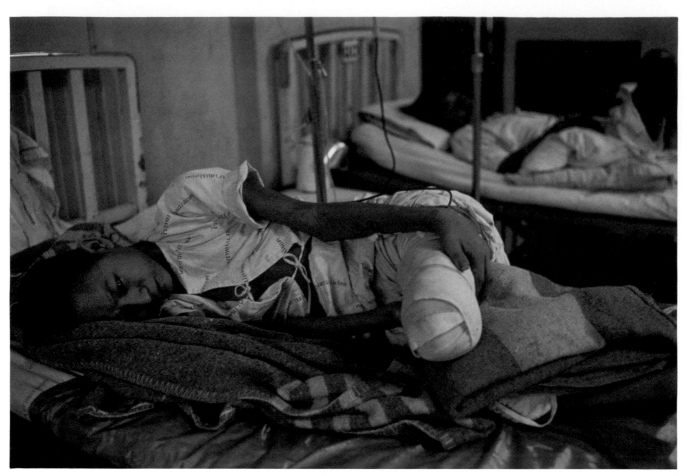

A Burmese boy, shot while carrying supplies to Karen rebels, loses his leg.

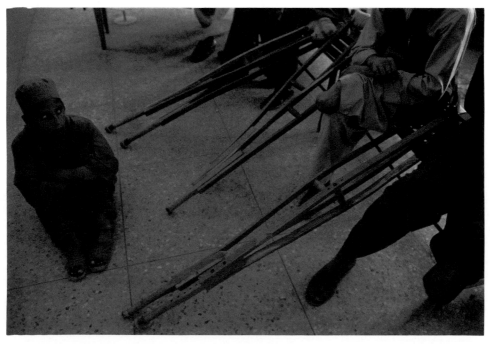

An Afghan boy, potentially a future Islamic holy warrior, waits in the amputee ward
of a Pakistan hospital where mujahideen are fitted for artificial limbs.

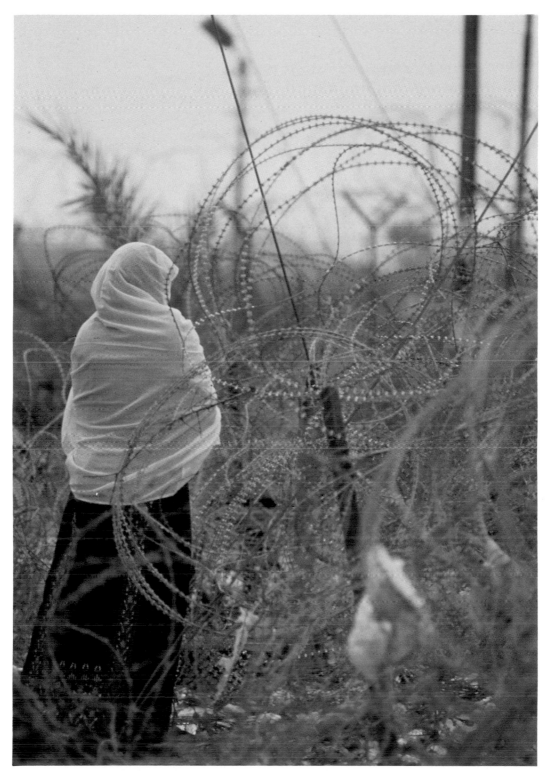

When the Sinai peninsula was returned to Egypt by Israel in 1982, the new boundary sliced through Rafah. Since then, people have communicated with friends on the other side by shouting over a barbed-wire fence.

A Palestinian day worker in Tel Aviv, Israel, sweeps the beach front.

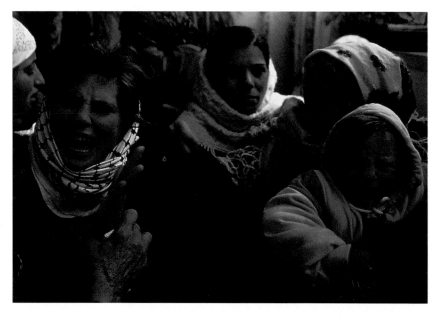

Palestinian women grieve a man who was killed by Israeli guards during a "disturbance" in a prison for political detainees.

A Palestinian youth wanted by the Israeli army hides in a cave.

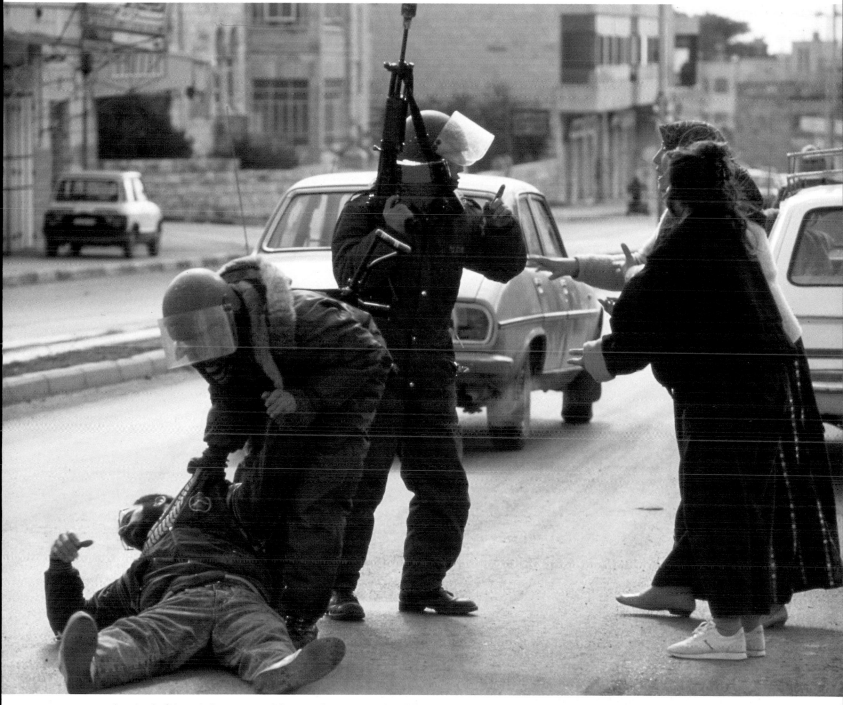

An Arab feigns injury to avoid arrest by an Israeli soldier during a demonstration in Ramallah on the West Bank.

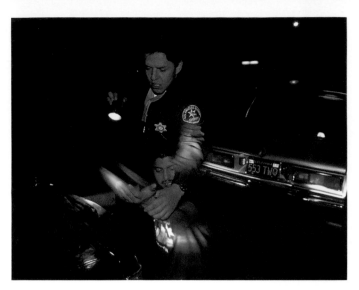

A Los Angeles deputy searches for signs of drug use.

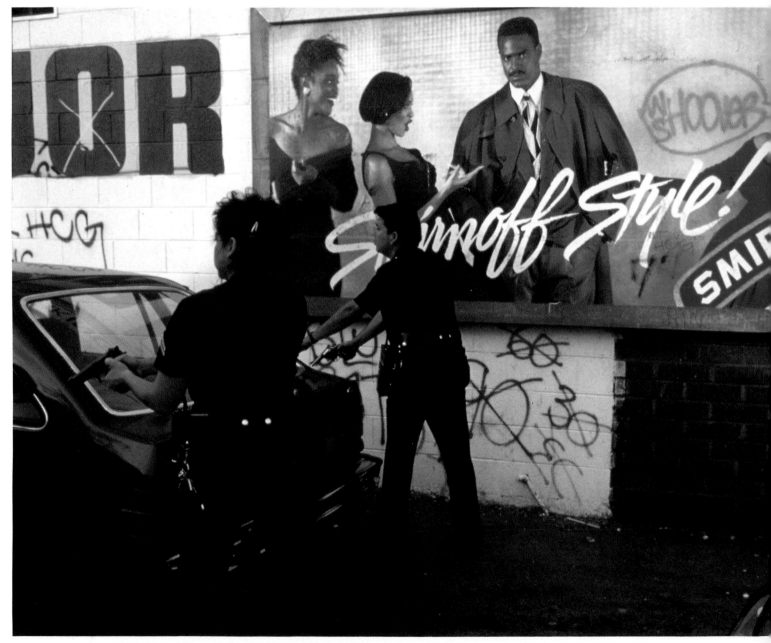

Los Angeles police officers prepare for a shoot-out.

James Nachtwey

A deputy interrogates a suspect in Los Angeles.

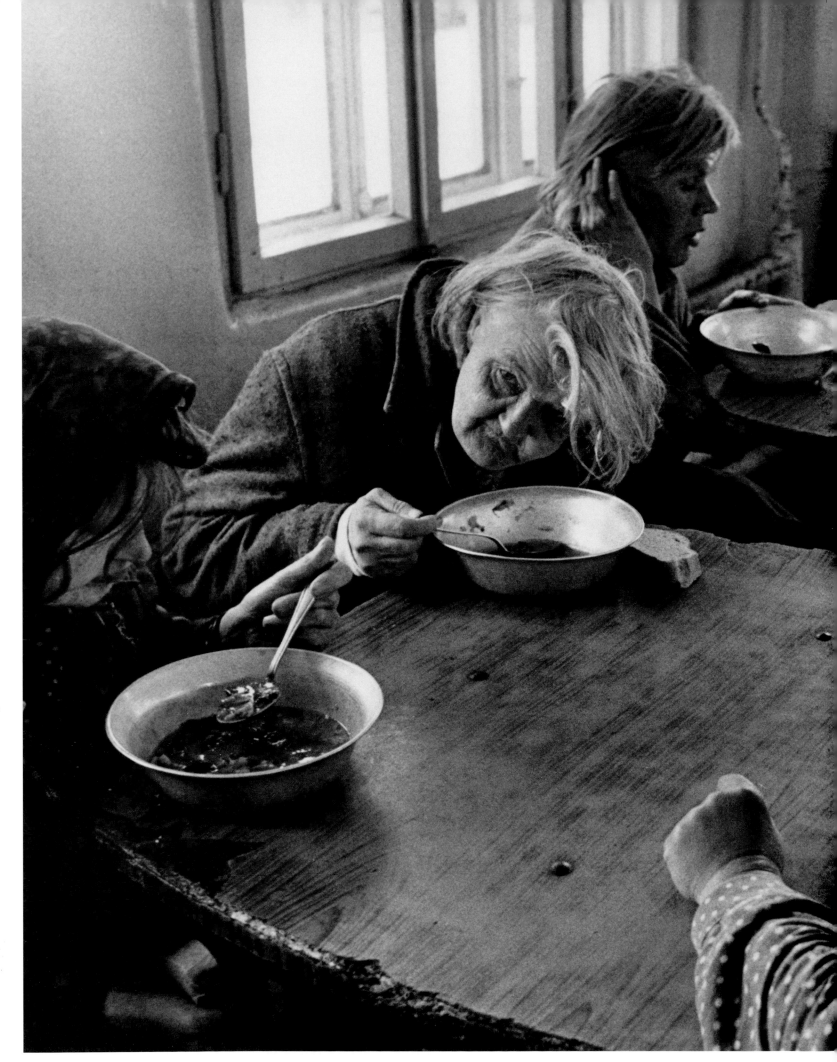

Institutionalized mental patients in Romania seem lonely even while together at mealtime.

James Nachtwey

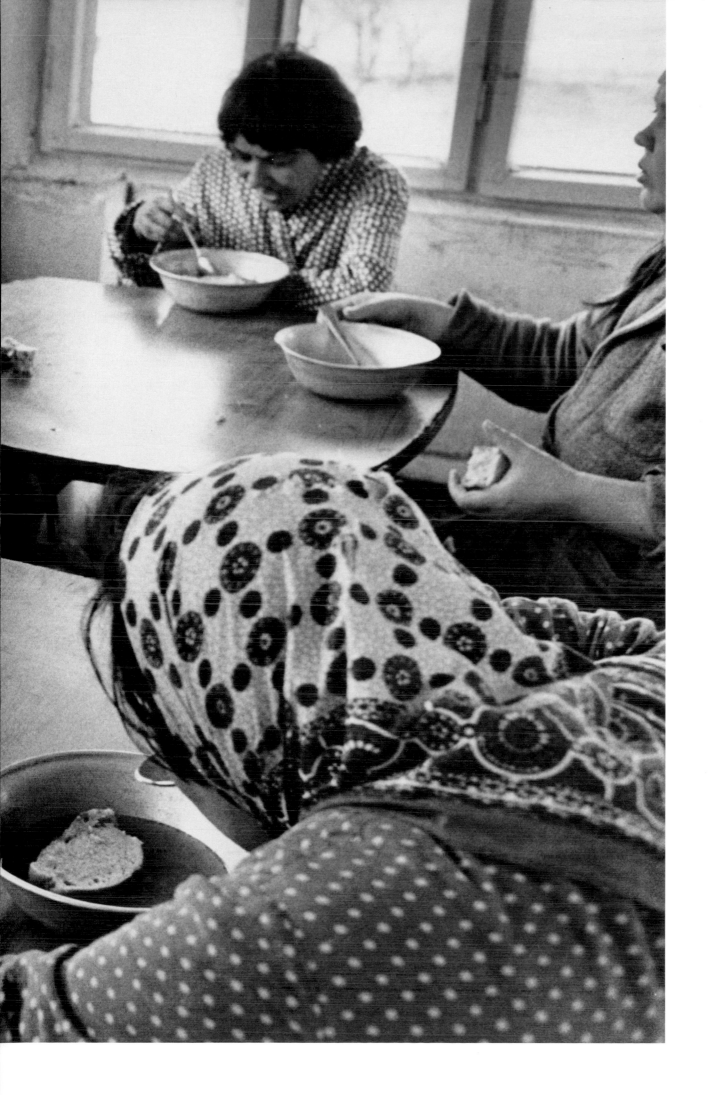

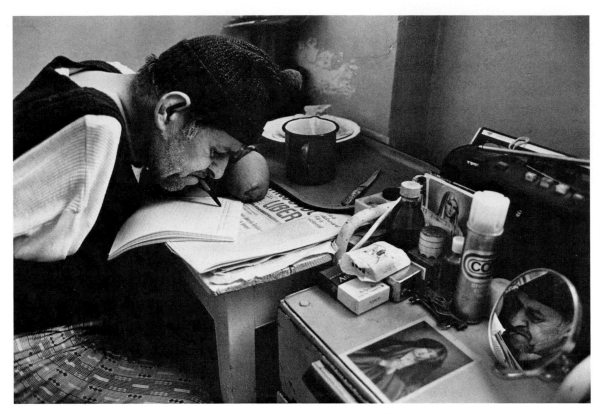

An armless man in a Romanian institution has learned to write.

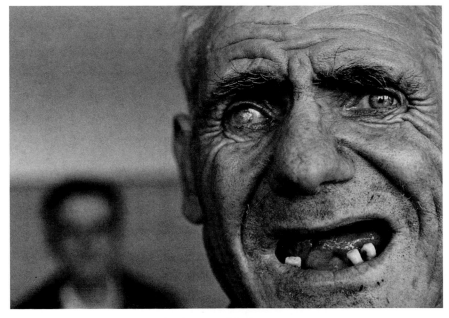

An insane elderly man.

2ND PLACE

Genaro Molina, The Sacramento Bee

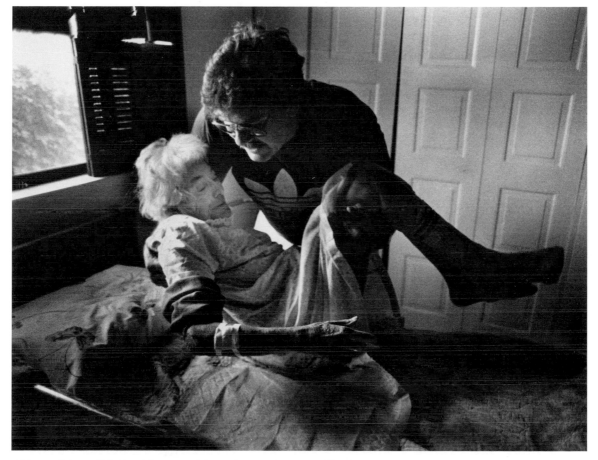

Wayne Pierce lifts his 81-year-old mother, Lula, out of bed in the morning. Lula, who suffers from Alzheimer's disease, is unable to walk.

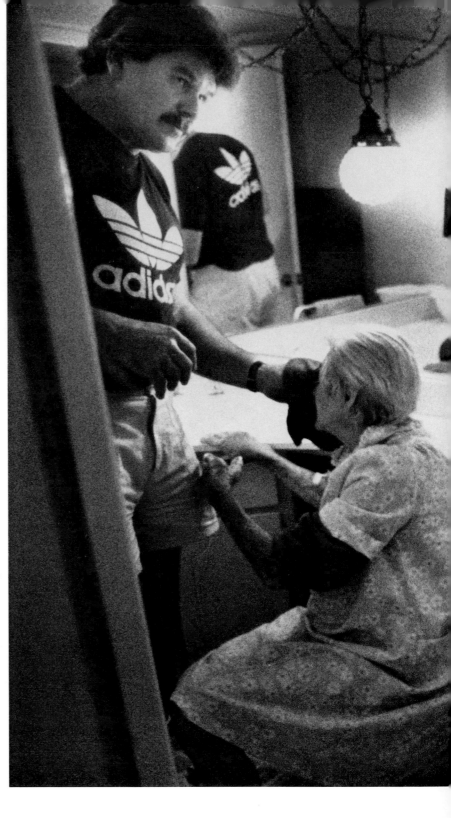

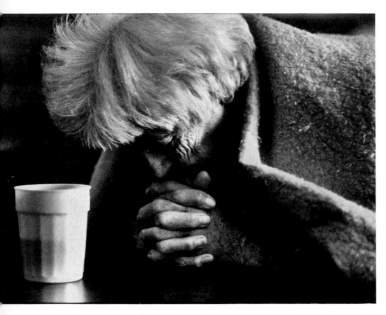

Lula rests her head while waiting to be fed breakfast.

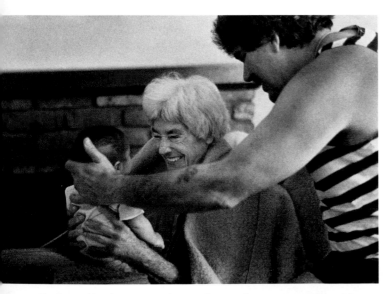

Lula rarely shows much reaction to her surroundings, but she seems to enjoy the infant son of a visiting family friend.

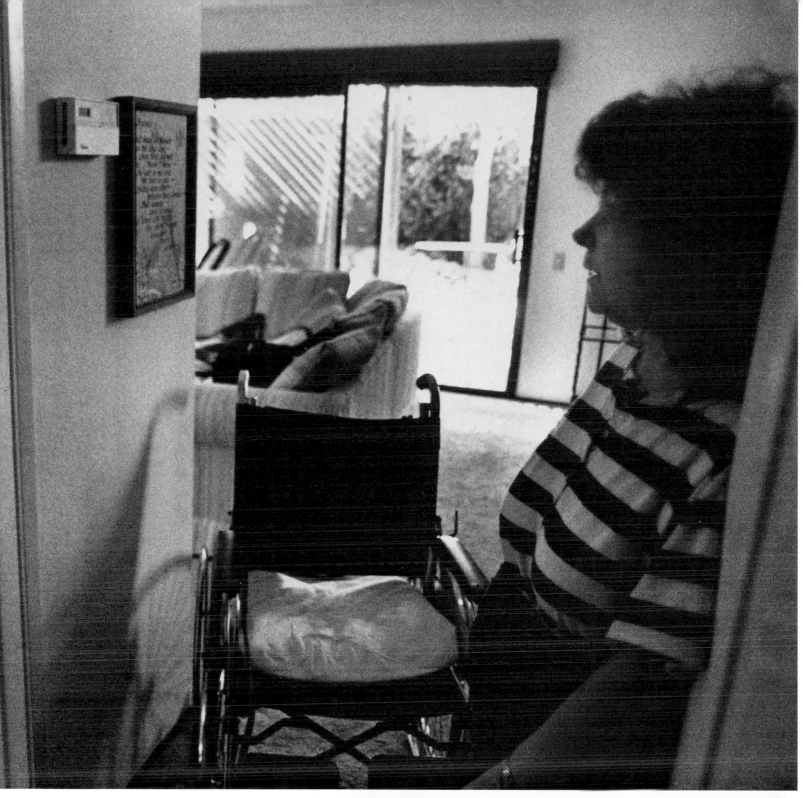

Wayne bathes his mother as his wife, Darlene, looks on. After putting Lula to bed (right), Wayne takes a moment to himself. "This is just a shell of my mom," he says.

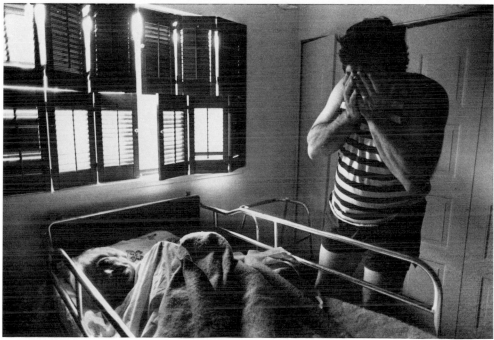

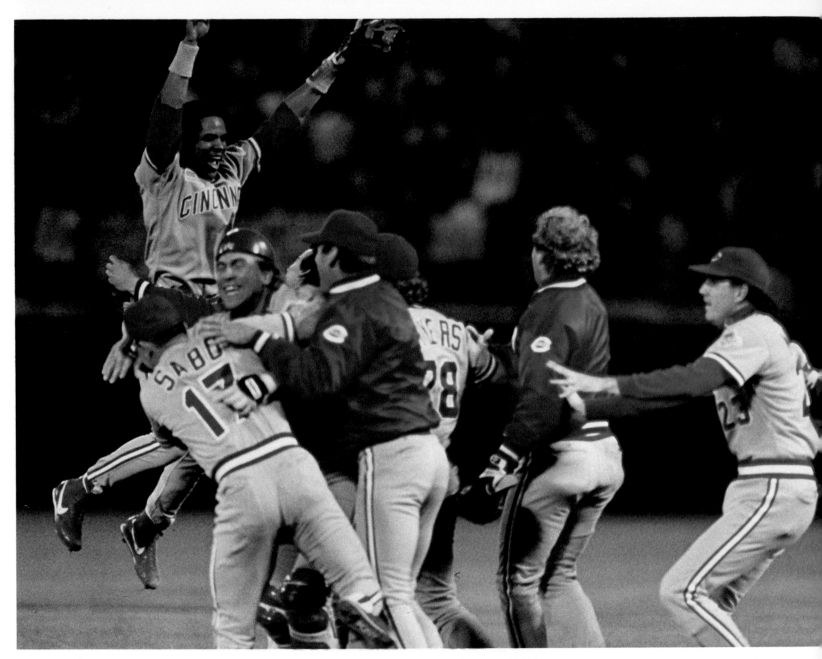

The Cincinnati Reds celebrate after winning the World Series in four straight games against the Oakland A's.

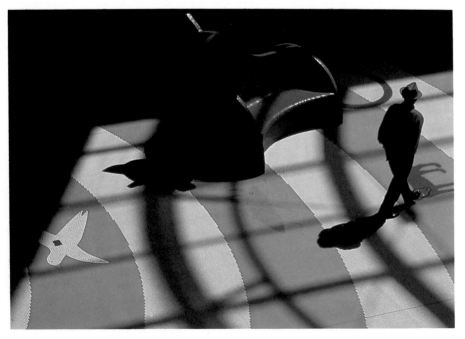

A lone shopper makes his way through the early morning shadows at a mall.

Genaro Molina, The Sacramento Bee

2ND PLACE, NEWSPAPER PHOTOGRAPHER OF THE YEAR

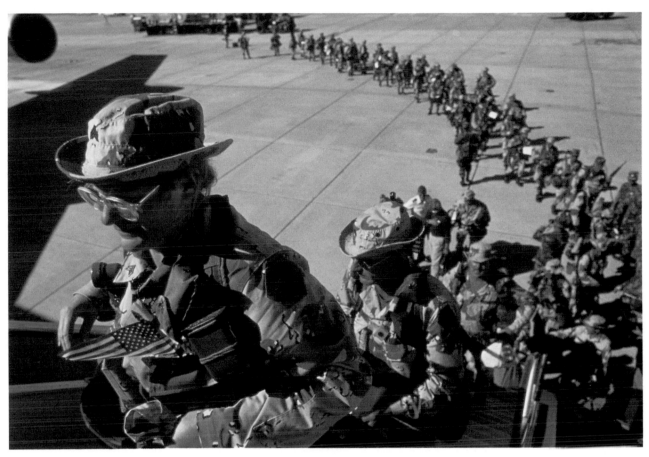

California Army National Guard troops board a 747 destined for the Persian Gulf.

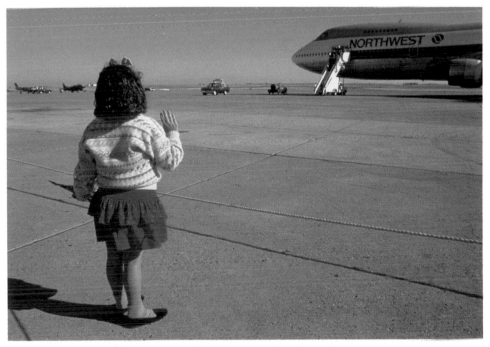

Monique Abeyta, 10, waves goodbye to her father, Staff Sgt. Henry Abeyta Jr. He was part of Operation Desert Shield.

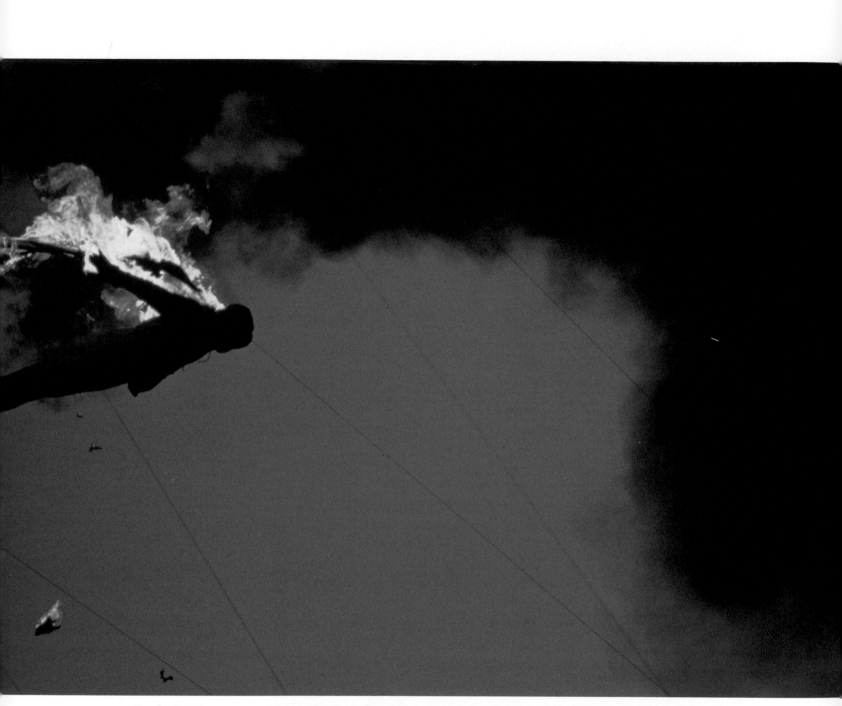

Professional stunt man "Diver Dan" performs the "human torch" dive at the California State Fair.

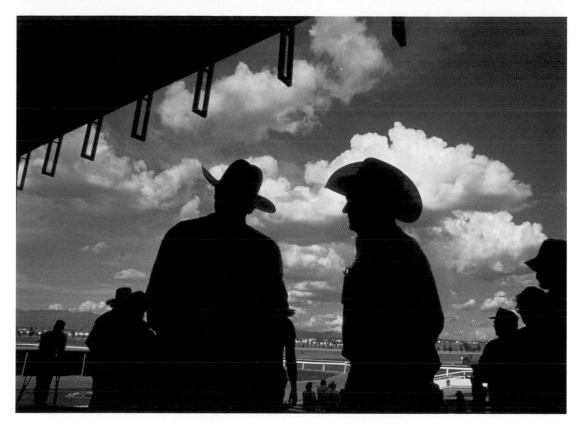

After placing their bets, horse-racing enthusiasts wait for the next race to begin.

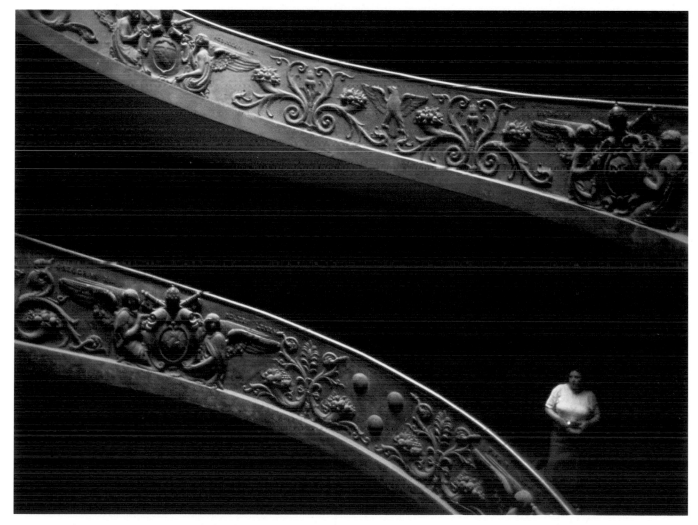

A tourist pauses to catch her breath on her way up a spiral staircase to the museum in Vatican City.

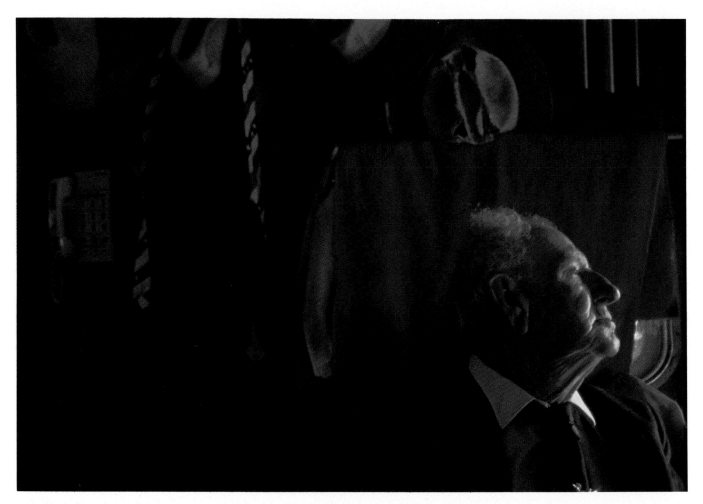

Ancil Wyatt, 80, who claims to be a distant relative of Wyatt Earp, shot a man while trying to make a citizen's arrest during a robbery.

2ND PLACE, NEWSPAPER PHOTOGRAPHER OF THE YEAR

3RD PLACE

*Al Podgorski, Retirement Research Foundation
and Chicago Sun Times*

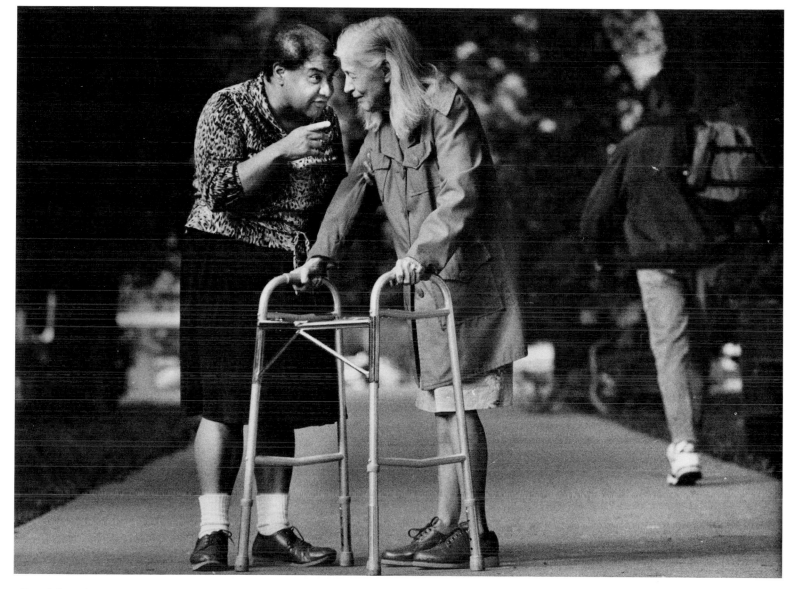

Good friends Yvonne (left) and Sally had to take a senior-housing project to court to be allowed to room together, because Yvonne is only 42, and the minimum age at the development is 62. Sally is 85.

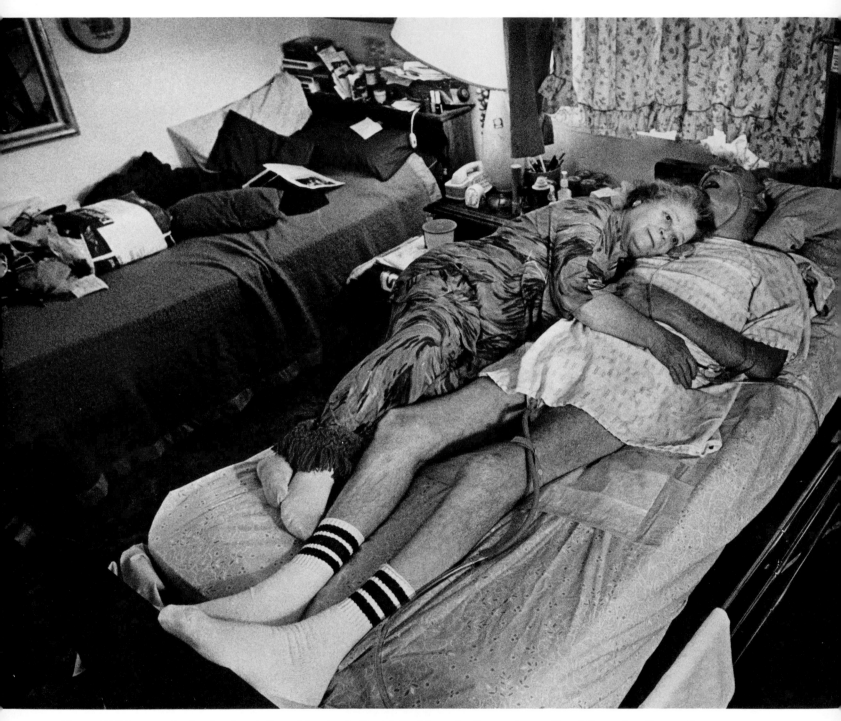

Betty Childs cares for her husband, Donald, who is ill with Parkinson's disease. He suffered from the ailment for seven years.

Al Podgorski, Chicago Sun Times

3RD PLACE, NEWSPAPER PHOTOGRAPHER OF THE YEAR

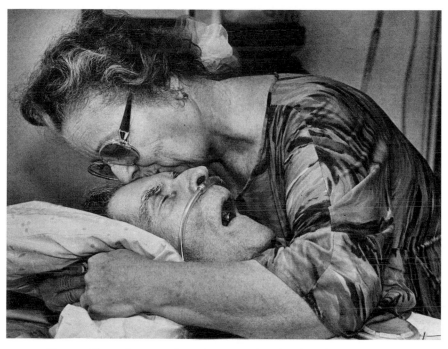

Betty offers what comfort she can as her husband nears death.

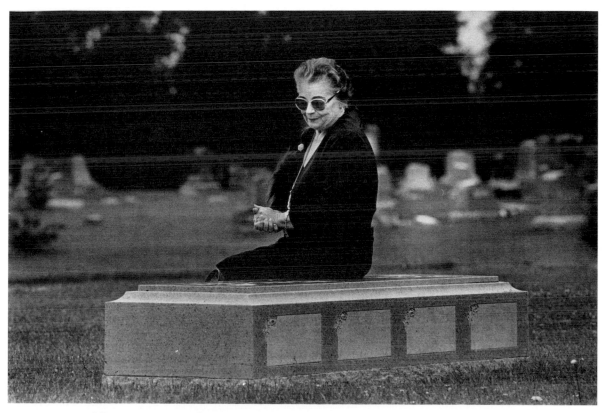

After seven years of constant care-giving, Betty says farewell to her spouse.

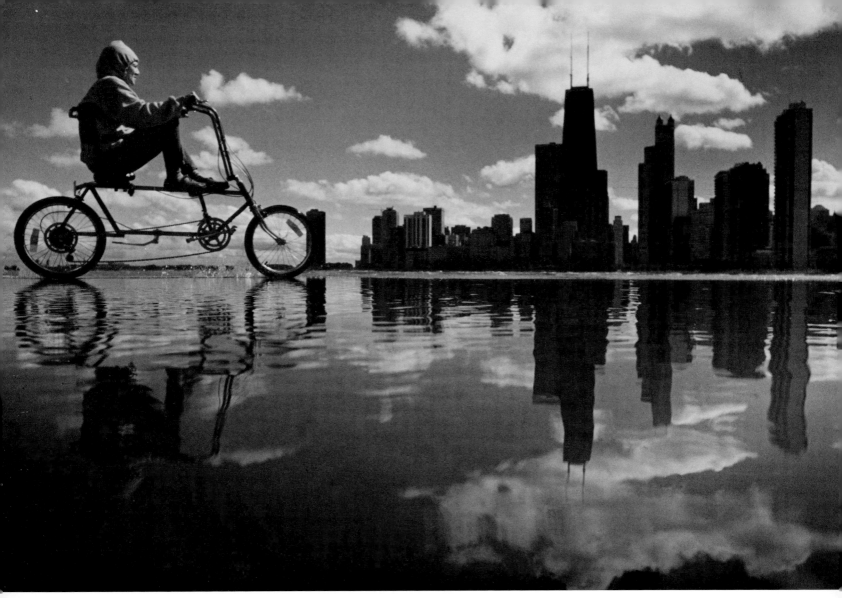

A bicyclist perches high and dry as he crosses a flooded sidewalk.

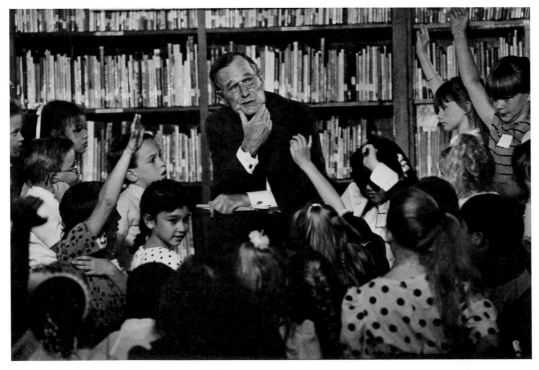

President Bush ponders a pupil's question during a visit to Farnsworth School.

Al Podgorski, Chicago Sun Times

3RD PLACE, NEWSPAPER PHOTOGRAPHER OF THE YEAR

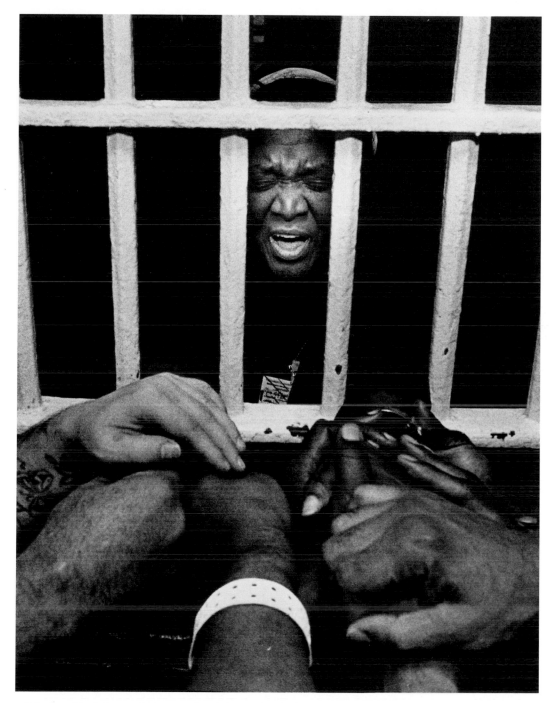

Mother York is a volunteeer chaplain at Cook County Jail. She laughingly calls her work there a personal life sentence given to her by God.

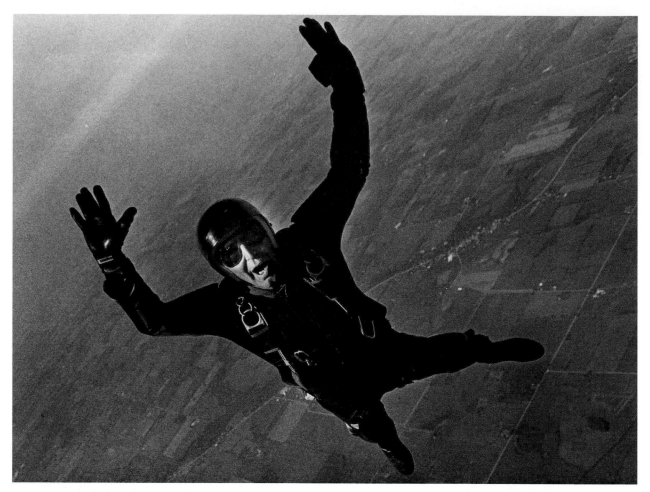

Skydiver Chuck Spidell of Kokomo, Ind., hasn't let age slow down his sport. The 62-year-old has been jumping since he was 16. Spectators (below) watch the International Skydivers Convention in Illinois.

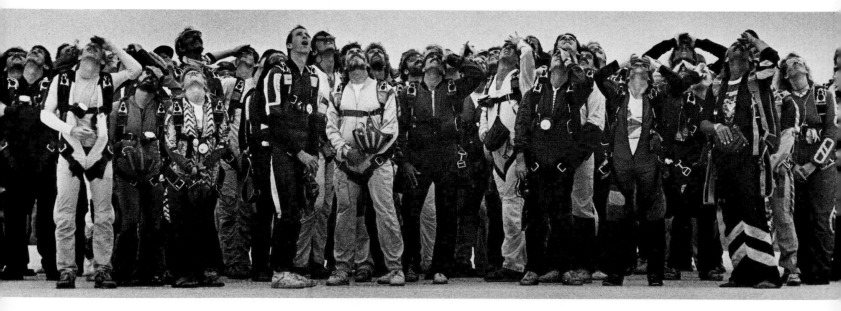

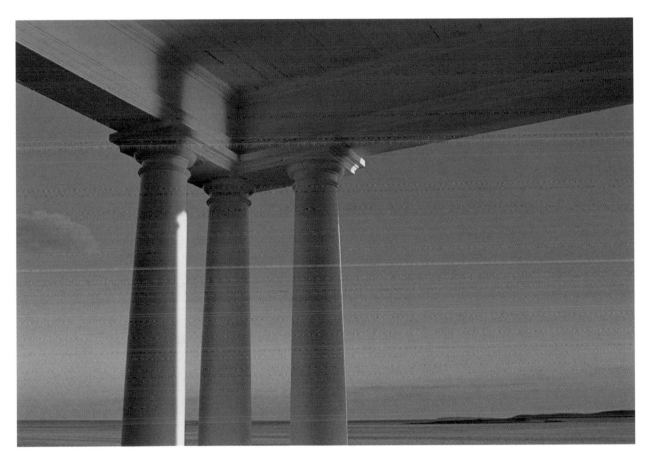

MAGAZINE, 1ST PLACE
Jim Gensheimer, San Jose Mercury News
"Pillars and Clouds"

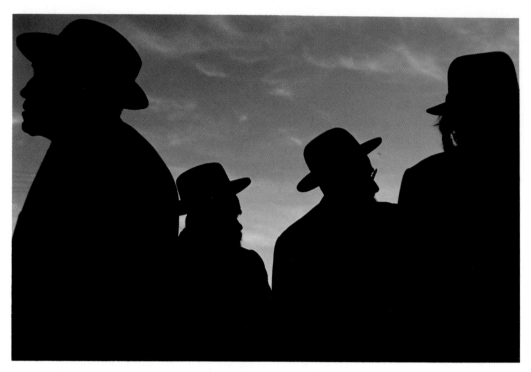

MAGAZINE, 3RD PLACE
David H. Wells, JB Pictures
"Orthodox Jews at Sunset"

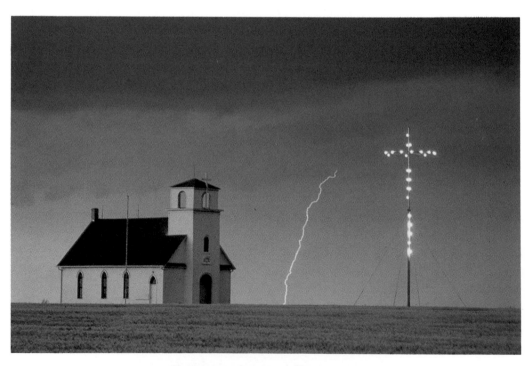

NEWSPAPER, AWARD OF EXCELLENCE
Chris Ochsner, Topeka (Kan.) Capital-Journal
"At Heaven's Gate"

NEWSPAPER, 1ST PLACE
Rob Clark Jr., free-lance for The Cincinnati Post
"Racer Repairs"

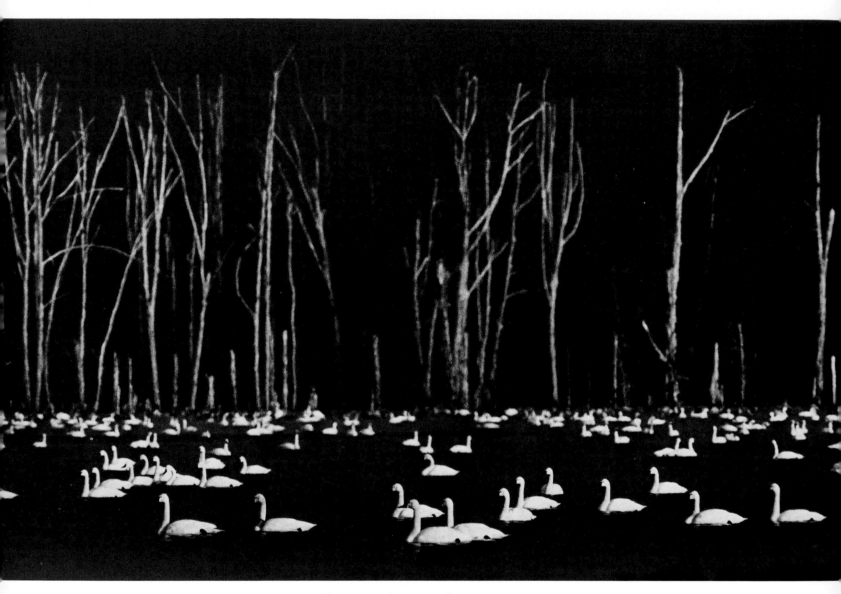

NEWSPAPER, AWARD OF EXCELLENCE
Bill Uhrich, Reading (Pa.) Eagle/Times
"Swans"

NEWSPAPER, 2ND PLACE
Guy Reynolds, Baton Rouge (La.) Morning Advocate/State-Times
"Moving Wall on the Move"

Following page:
MAGAZINE, 2ND PLACE
Jodi Cobb, National Geographic
"Steamy Streets"

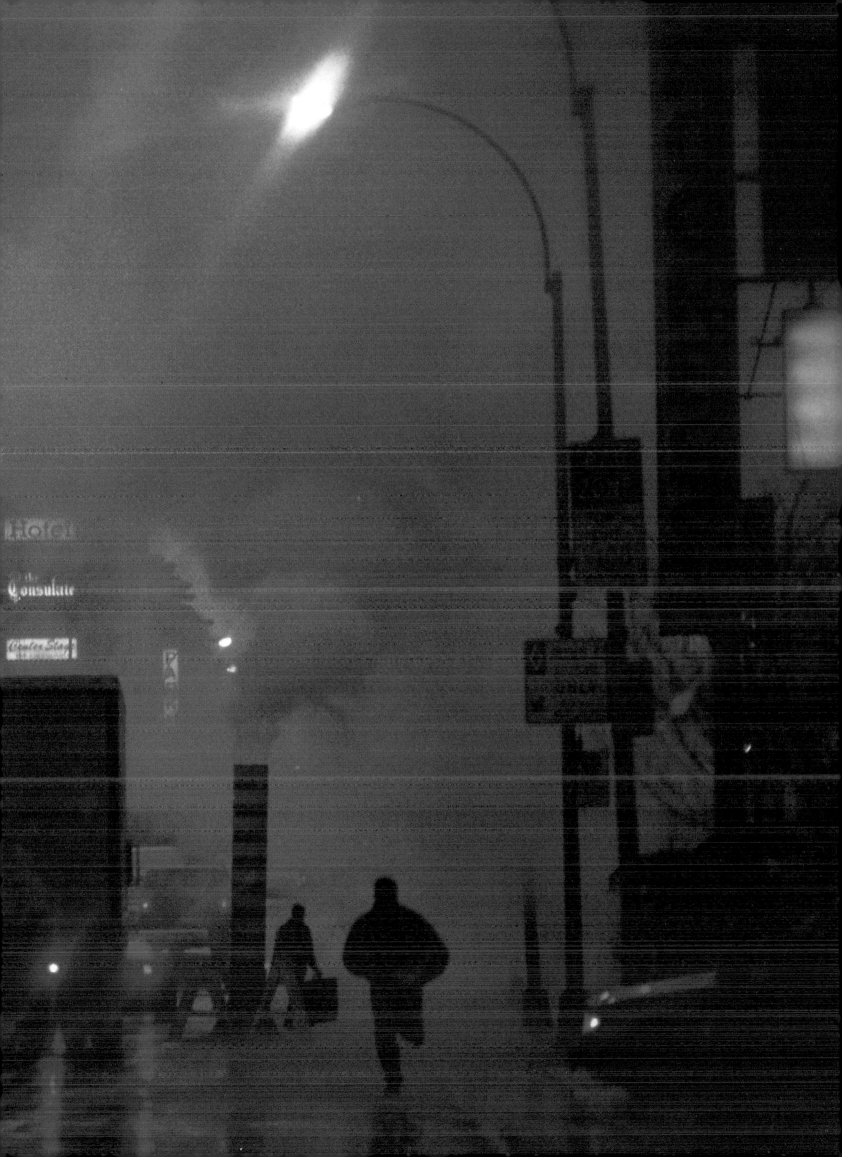

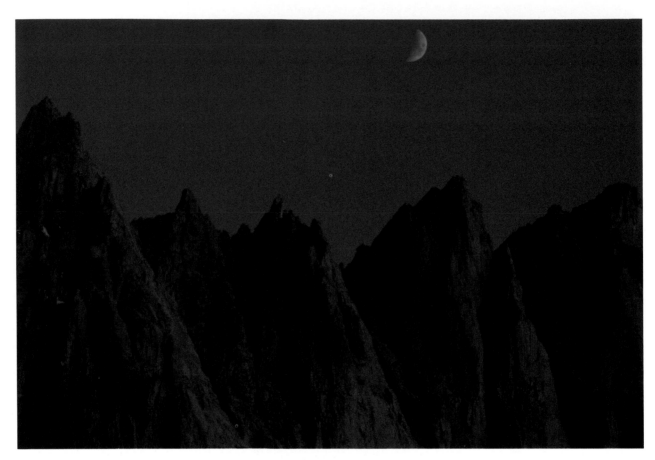

MAGAZINE, AWARD OF EXCELLENCE
Peter J. Menzel, free-lance
"Mount Whitney With Moon"

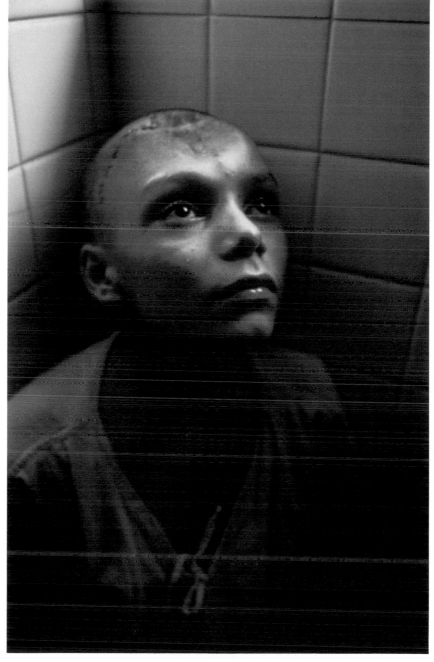

NEWSPAPER, 1ST PLACE
John Mottern, free-lance
Dreaming of helping the rebels, this 12-year-old boy ran down a street in
San Salvador brandishing an AK-47. Government troops put two bullets
in his head and left him for dead, but he survived.

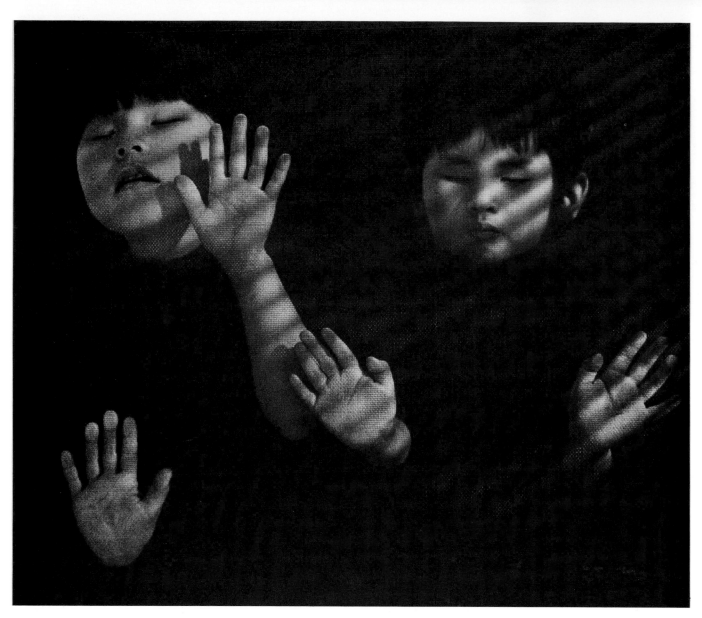

NEWSPAPER, 2ND PLACE
Brian Masck, The Muskegon (Mich.) Chronicle
Both blind from birth, Karen and Matthew Johnson became siblings by being adopted by a Muskegon couple.

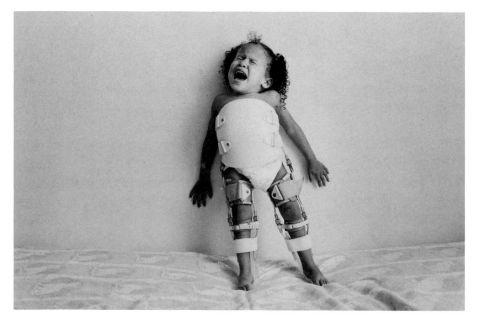

NEWSPAPER, AWARD OF EXCELLENCE
Sean Dougherty, Fort Lauderdale News/Sun-Sentinel
Tyana, 3, was born with spina bifida. She wears a brace for support.

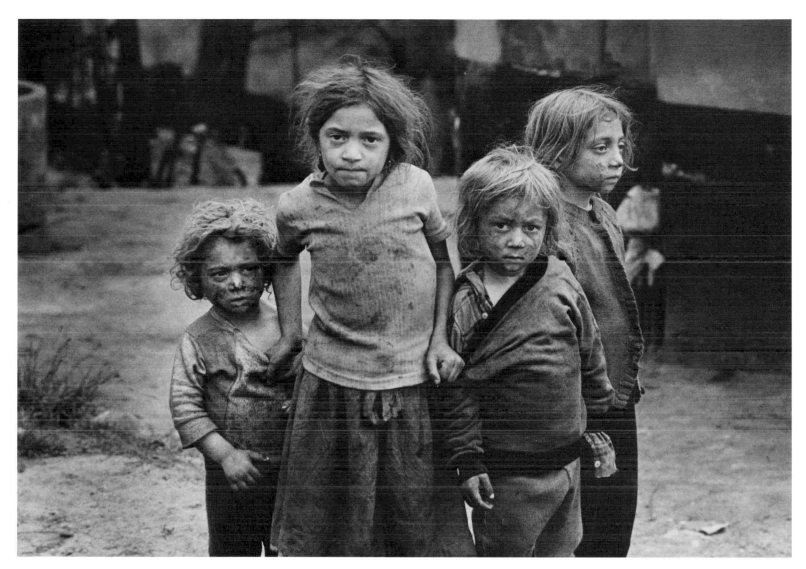

NEWSPAPER, 3RD PLACE
Kathi Lipcius, free-lance
Suffering from the effects of pollution and malnutrition, four sisters stand their ground in Copsa Mica, Romania.
The area has some of the worst environmental problems in the world.

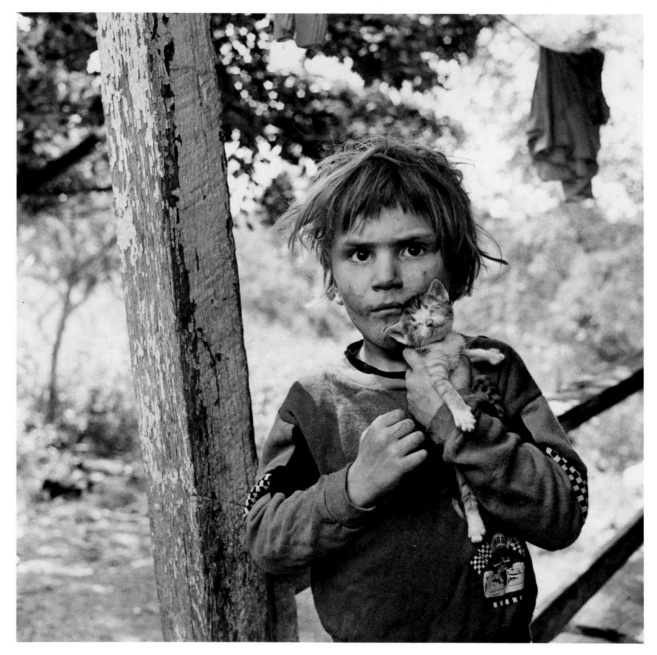

MAGAZINE, 1ST PLACE
Mary Ellen Mark, Fortune
Christopher Wayne Grey of Sandgap, Ky., a community with a population of five.

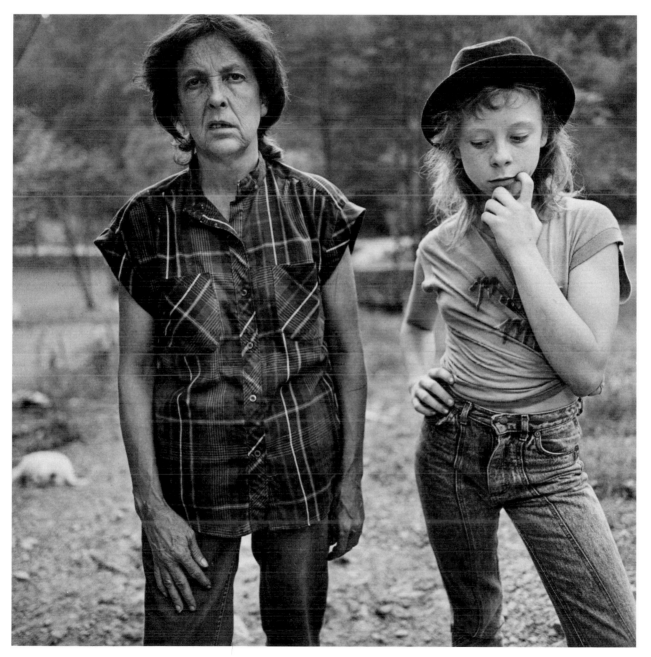

MAGAZINE, 2ND PLACE
Mary Ellen Mark, Fortune
Jean Rowland, 43, and her 12-year-old daughter, Peggy, stand outside their trailer in McKee, Ky.
Rowland has eight children.

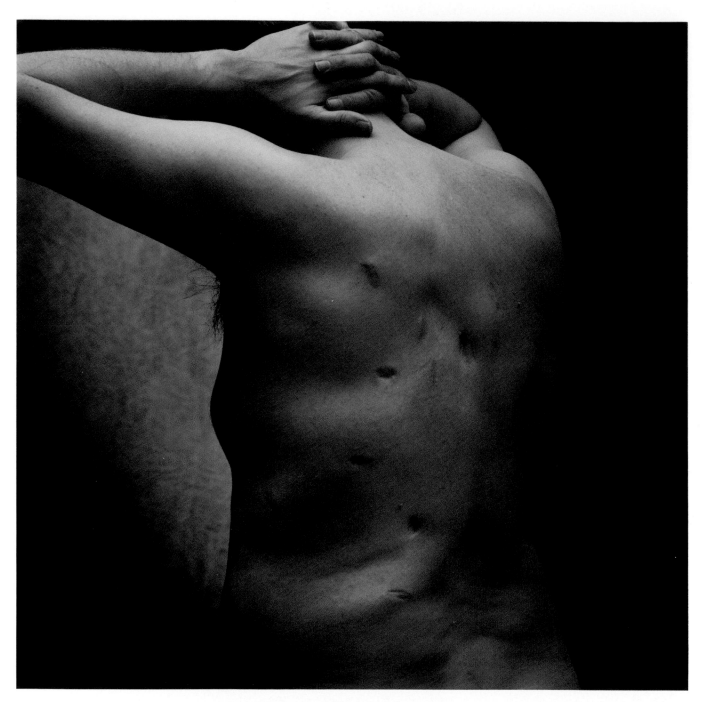

NEWSPAPER, AWARD OF EXCELLENCE
Mark Sluder, The Charlotte (N.C.) Observer
Gay Bashing: Three years after this man was stabbed 21 times, he still is healing.

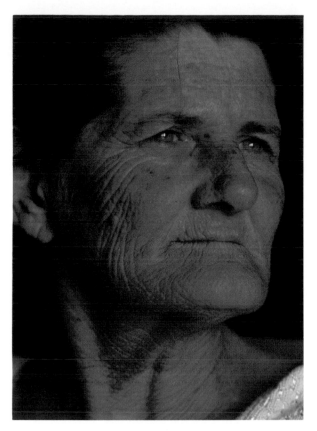

MAGAZINE, AWARD OF EXCELLENCE
**Linda L. Creighton,
U.S. News & World Report**
Hard life in a poor southern Mississippi town has
aged this 49-year-old woman.

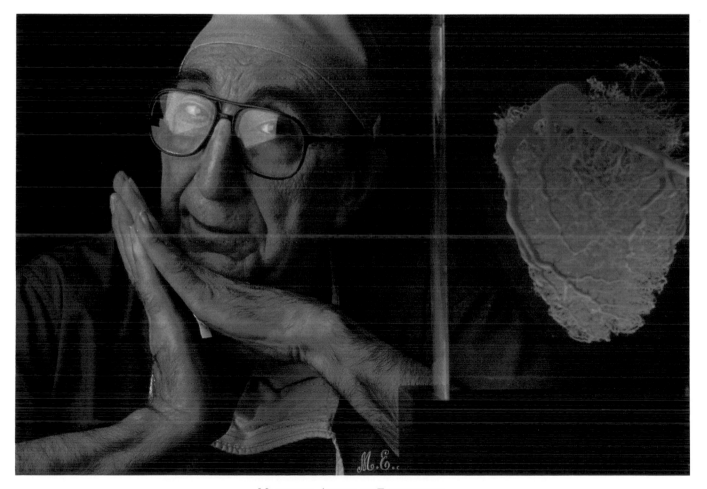

MAGAZINE, AWARD OF EXCELLENCE
Robb Kendrick, Fortune
Dr. Michael De Bakey, pioneer heart surgeon.

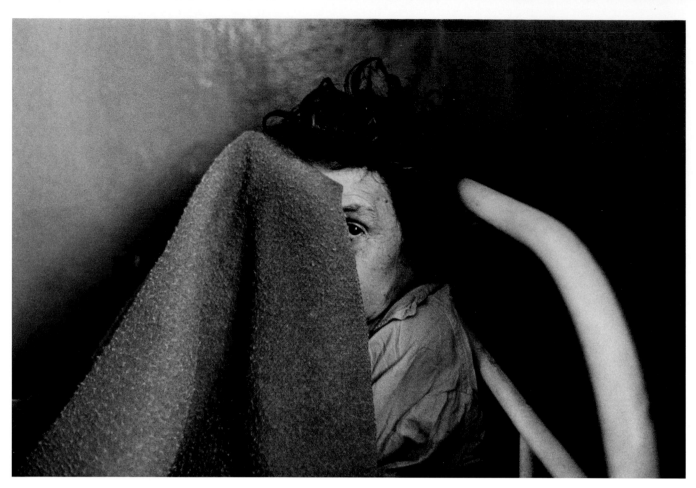

MAGAZINE, 3RD PLACE
James Nachtwey, Magnum
An insane woman hides behind a blanket.

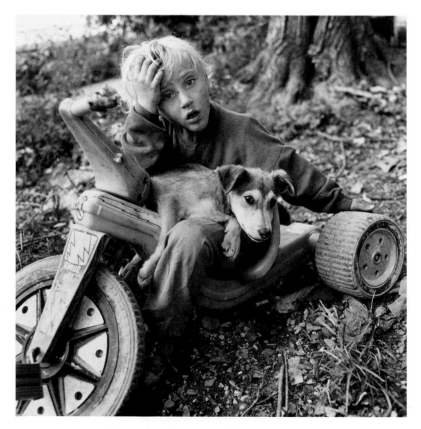

MAGAZINE, AWARD OF EXCELLENCE
Mary Ellen Mark, Fortune
John Grey, 4, of Sandgap, Ky.

1ST PLACE

Paul Kuroda, The Orange County Register

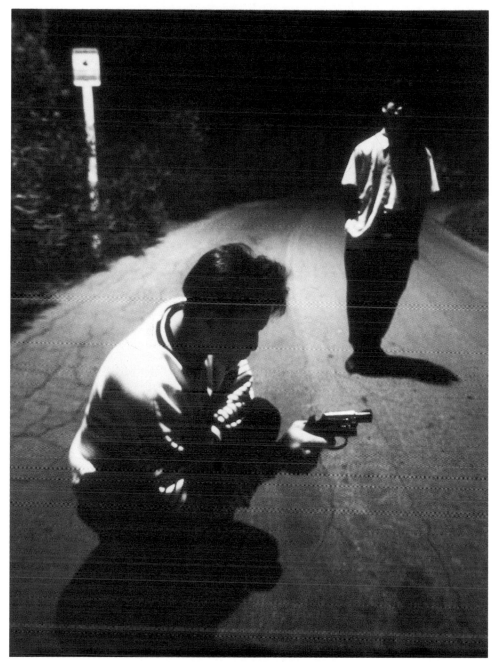

Tony Tran and Tuan Nguyen hang out in La Habra Heights. Both are now serving sentences for car theft.

Vietnamese Gangs

Teen-age runaways make up most of the 40 known Vietnamese gangs in Orange County, Calif. Few of the youths are hardened criminals, but their street survival techniques range from shoplifting to stealing cars, arson, extortion, robbery or murder.

A 1989 Congressional report for the Senate Permanent Subcommittee on Investigations described Vietnamese gangs as highly mobile and better armed than most city gangs.

"The growing level of violence . . . makes them a national concern," the report says.

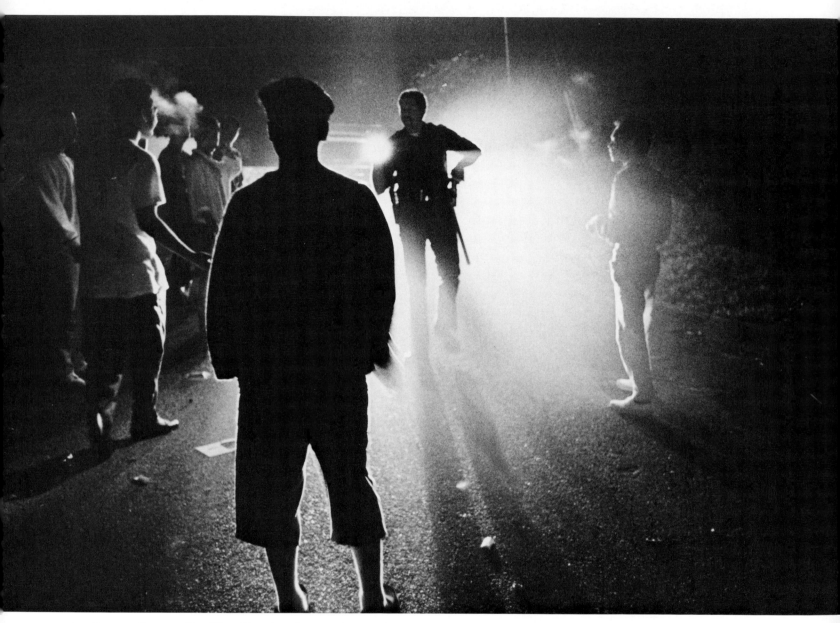

An Orange County Sheriff's officer breaks up a late-night gathering. The gang members all were questioned and searched.

Paul Kuroda, The Orange County Register

1ST PLACE, NEWSPAPER FEATURE PICTURE STORY

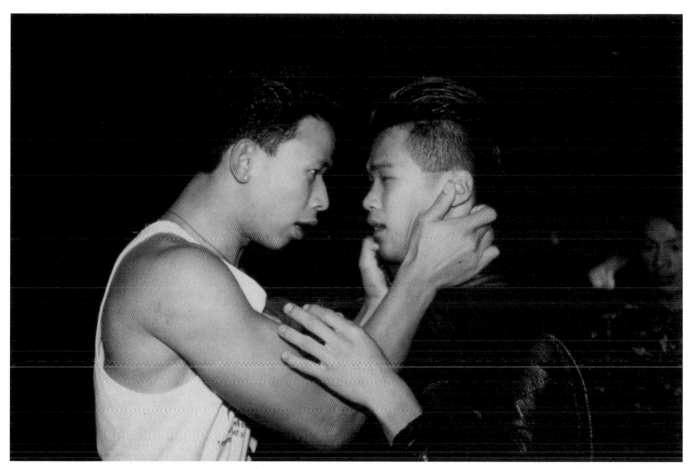

An intense confrontation between two gang members. The incident quickly shut down a church dance in Tustin, Calif.

A gang sign is flashed to a friend in another car.

Tuan Nguyen displays his nationality with a homemade tatoo.

Paul Kuroda, The Orange County Register

1ST PLACE, NEWSPAPER FEATURE PICTURE STORY

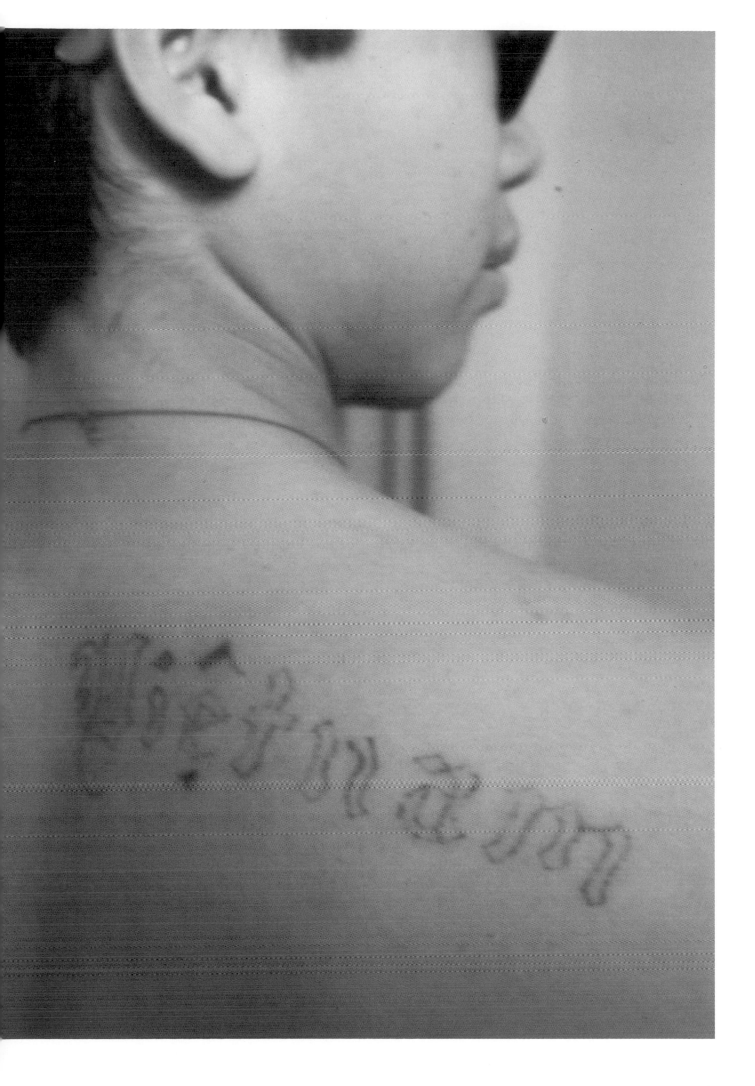

Paul Kuroda, The Orange County Register

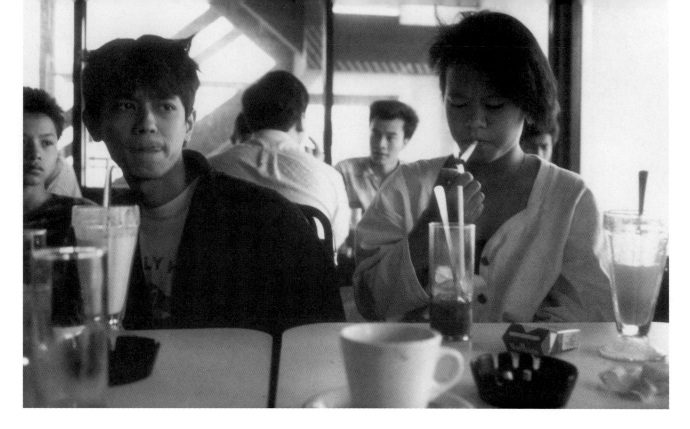

Chanh Long and Sunny Xuan, both 16, rendezvous with the gang for breakfast at one of the many Vietnamese cafes. They had just been thrown out of a hotel for having too many guests.

Fifteen youths sleep in one hotel room. The gangs move often to make it more difficult for police to find them. Michele Nguyen and Lucy Tran (left photo) pose for Tony Tran during a light moment.

Paul Kuroda, The Orange County Register

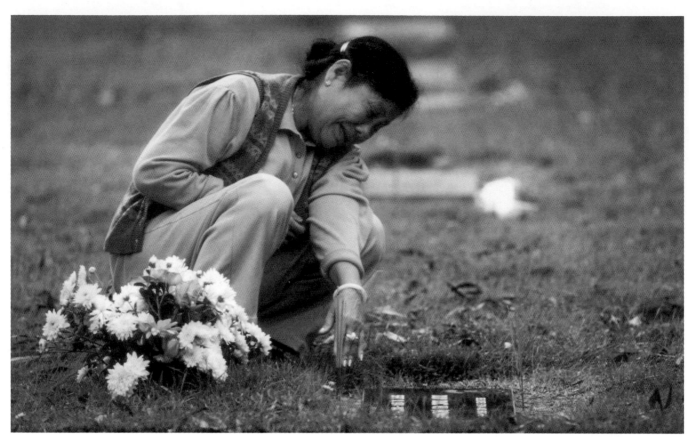

Pham Thi Luot mourns her son, Duy Duc Vu, who was killed in a gang shooting. Peter Nguyen, 23, (below) imprisoned for killing a gang rival, visits friends through a handset at Orange County Jail.

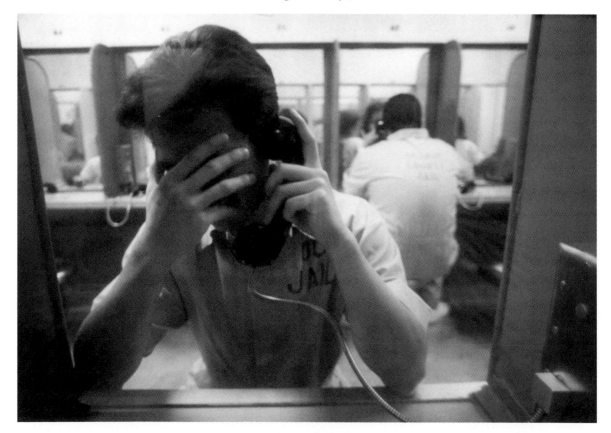

2ND PLACE

Ronald Cortes, The Philadelphia Inquirer

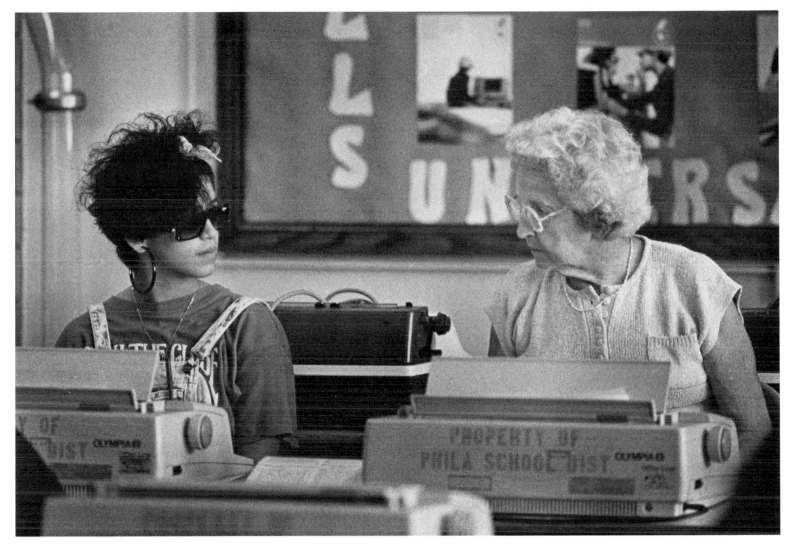

On the first day of school, Anna McDaniel (left) doesn't quite know what to make of her fellow student, Marie Dingas.

A Senior Senior

Sixty years after starting high school, Marie Dingas received her diploma from Olney High in Philadelphia. She had dropped out at 14 to help support her family during the Depression.

Marie outlived three husbands, reared five sons, and enjoyed grandchildren and great-grandchildren.

But at the age of 72, she still wanted to finish high school.

So, when she read about a program for full-time adult students, Marie signed up.

"My boys all went to Olney, so I thought it'd be pretty neat if I graduated from there, too," she says.

Through her two-year stint at the school, her sons rewarded her, as she had them, with $1 for each "A" and 50 cents for each "B" that she earned.

She became friendly with the bus driver she met on a senior-class trip to the Poconos. He was her date for the prom.

She took the expected courses: math, English, typing. She even dissected a pig in biology. But she got away without having to take a gym class.

Marie leaves school at the end of the day, intent on homework. "I watched very little television," she says.

Ronald Cortes, The Philadelphia Inquirer

2ND PLACE, NEWSPAPER FEATURE PICTURE STORY

Ronald Cortes, The Philadelphia Inquirer

2ND PLACE, NEWSPAPER FEATURE PICTURE STORY

Marie fretted over exams. "After all, it had been 60 years," she says.

Ronald Cortes, The Philadelphia Inquirer

2ND PLACE, NEWSPAPER FEATURE PICTURE STORY

The senior senior didn't join the trend of Walkmans and backpacks, as fellow student Maurice Harrid did.

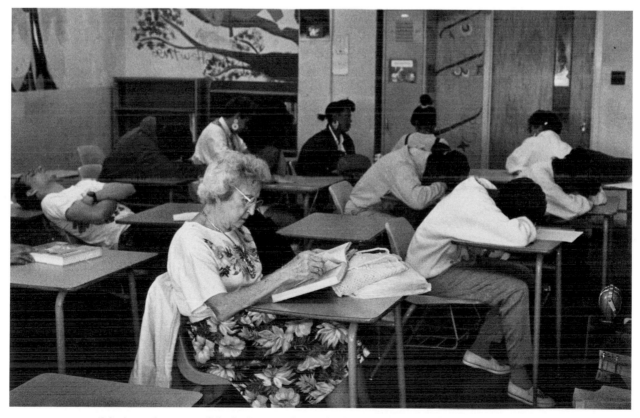

Marie makes use of slack time at the end of an English class to study for a test.

Ronald Cortes, The Philadelphia Inquirer

2ND PLACE, NEWSPAPER FEATURE PICTURE STORY

Marie and Ann Jones, another adult student, enjoy a class trip to the Poconos.

Ed Duffy drives Marie, her family and friends to the graduation ceremony. Marie met Ed on a class field trip, and went to the senior prom with him.

Ronald Cortes, The Philadelphia Inquirer

Timmy's Dead-end Street

In the Rockville section of Vernon, Conn., an 11-year-old boy named Timmy Smith lives on the edge of trouble.

His mother is unmarried, and many times Timmy and his siblings must care for themselves at home while she works.

Timmy began smoking when he was 10.

"My mother tells me to stop smoking, and I try," he says. "But it never happens."

His mother imposes no curfew, so on many nights Timmy and his best friend can be found outside on their bikes.

The school bus does not come to Timmy's house, located at the dead end of a street. And rather than walk to the bus stop, Timmy often uses that as a excuse for skipping school.

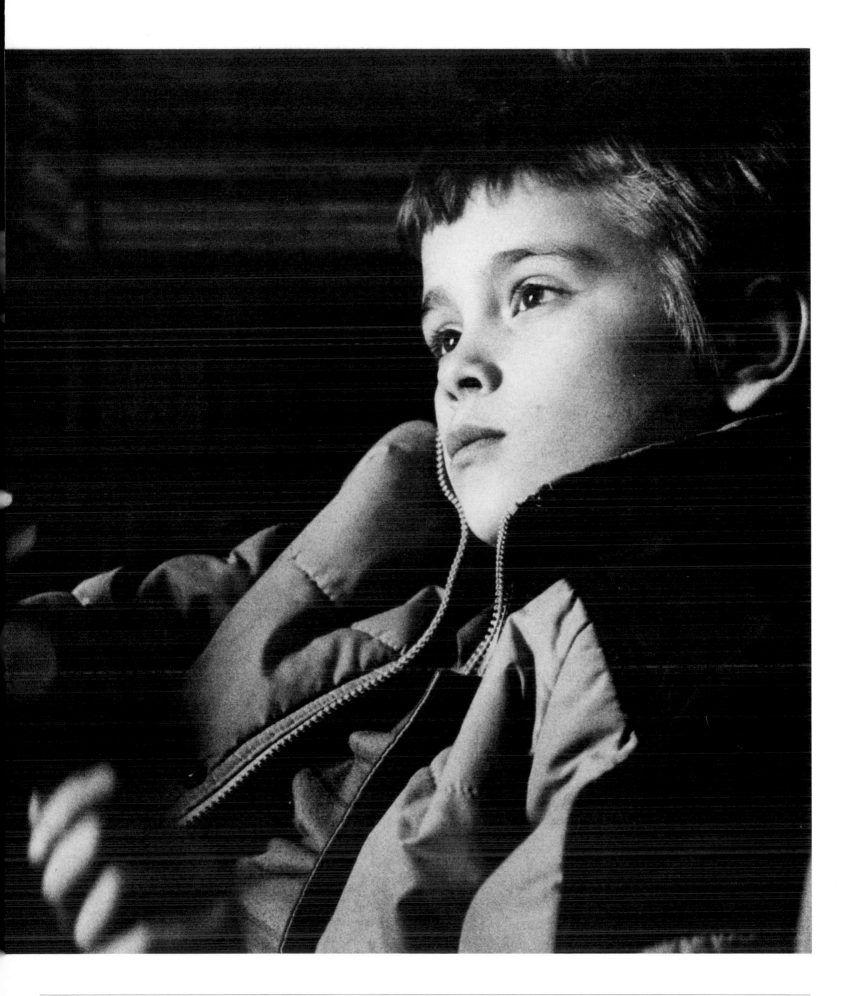

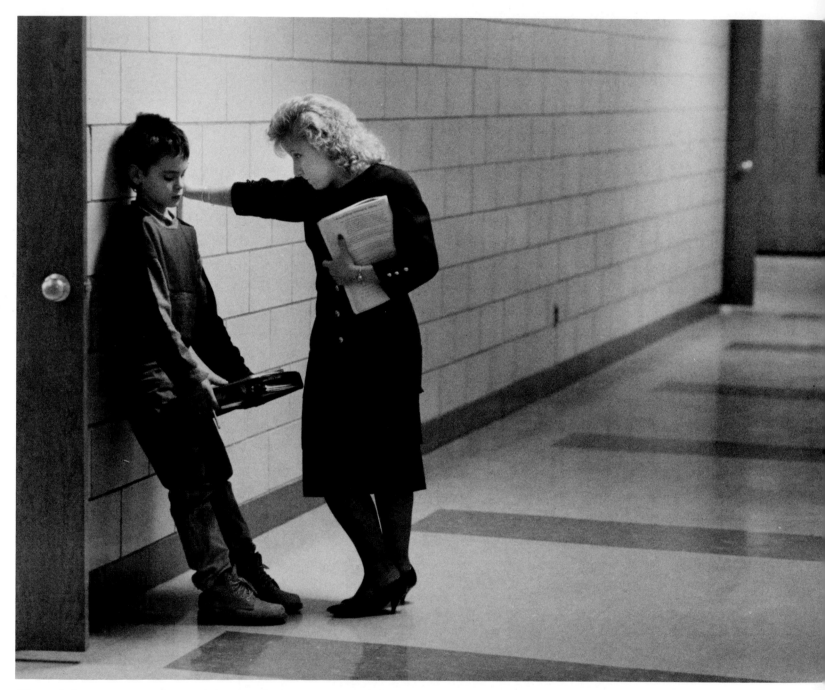

Timmy's homeroom teacher explains that she is not upset with him for breaking up a fight in her classroom. But, she reminds him, he would be better off not to get involved in fights at all.

Richard A. Messina, The Hartford Courant

3RD PLACE, NEWSPAPER FEATURE PICTURE STORY

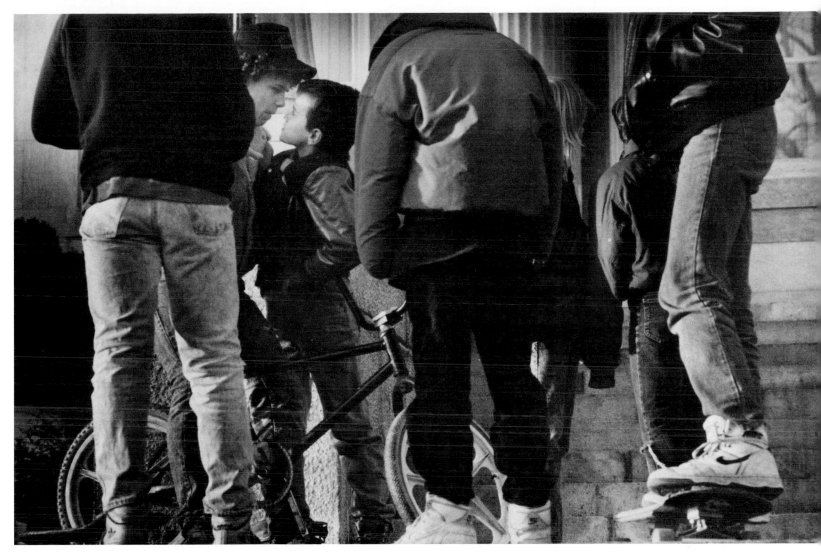

Timmy is confronted by an older boy at the library, where a group gathered for a scheduled fight between two other boys.

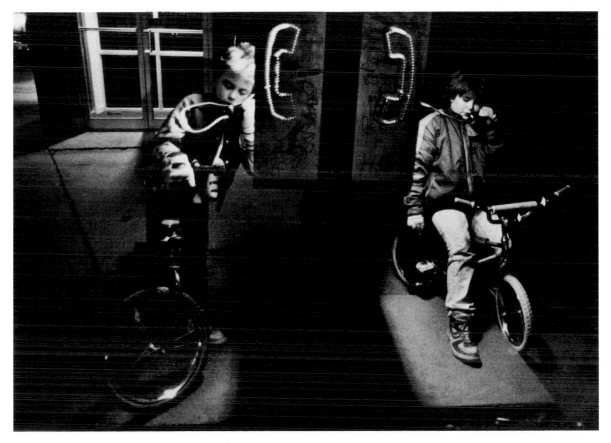

Timmy and his friend, Eric, call their girlfriends from phones outside a bowling alley.

Richard A. Messina, The Hartford Courant

3RD PLACE, NEWSPAPER FEATURE PICTURE STORY

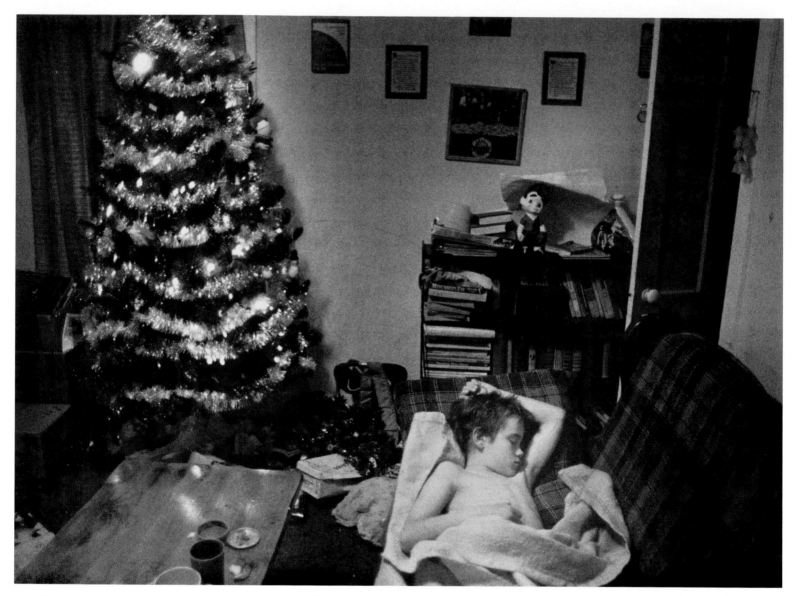

Timmy sleeps on the couch a few weeks before Christmas, after a guest of his mother's told him to quit playing and get to bed.

Richard A. Messina, The Hartford Courant

3RD PLACE, NEWSPAPER FEATURE PICTURE STORY

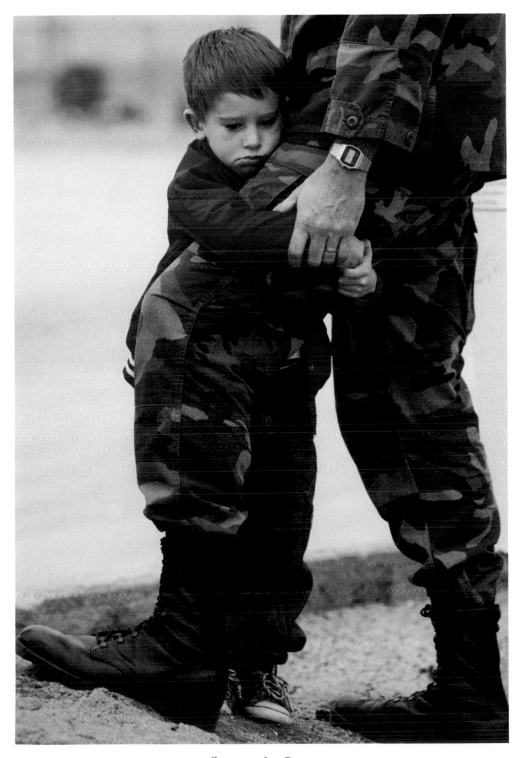

GENERAL, 1ST PLACE
Jeff Tuttle, The Wichita (Kan.) Eagle
Josh McCrary, 4, holds his father, John, by the leg as the elder McCrary prepares to
leave El Dorado, Kan., for the Persian Gulf as part of Operation Desert Shield.

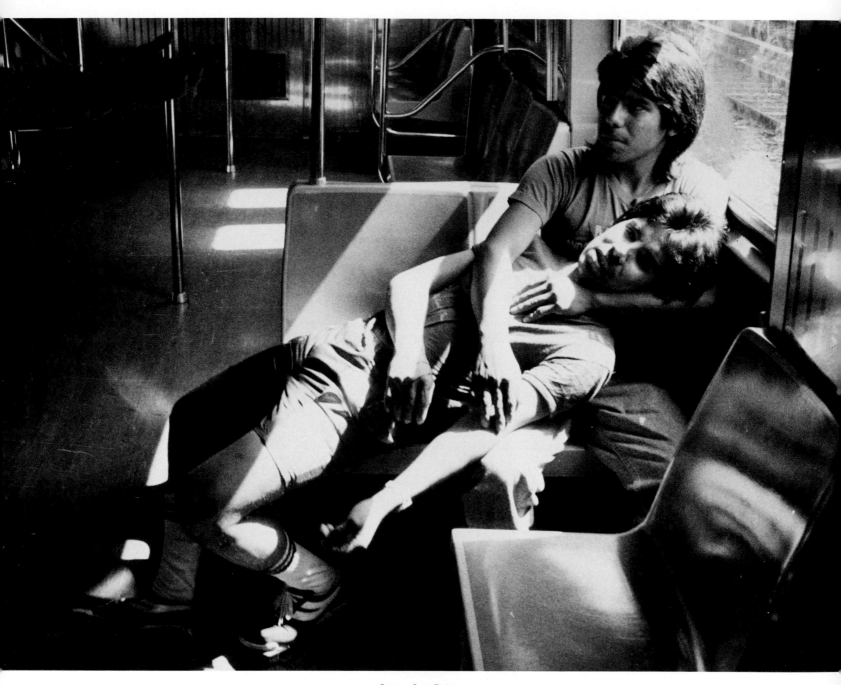

SPOT, 1ST PLACE
Osman Karakas, New York Post
Maximillano Chaves Vidals cradles his brother, Edwardo, who was shot on a subway in Brooklyn.

THE 2ND PLACE AWARD IN THE SPOT NEWS CATEGORY WENT TO MARC HALEVI OF THE
LAWRENCE (MASS.) EAGLE-TRIBUNE. THE PHOTOGRAPH WAS PART OF HIS NEWSPAPER NEWS
PICTURE STORY ENTRY AND IS ON PAGE 213.

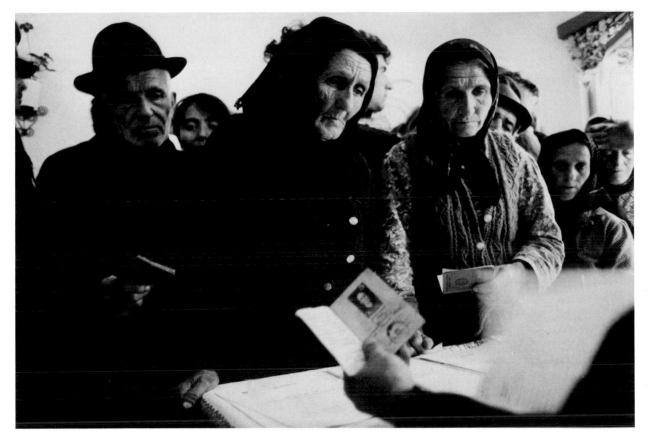

GENERAL, 2ND PLACE
William Snyder, The Dallas Morning News
An 89-year-old Romanian shows an official her identity papers in order to vote in the country's
first free election in over 40 years.

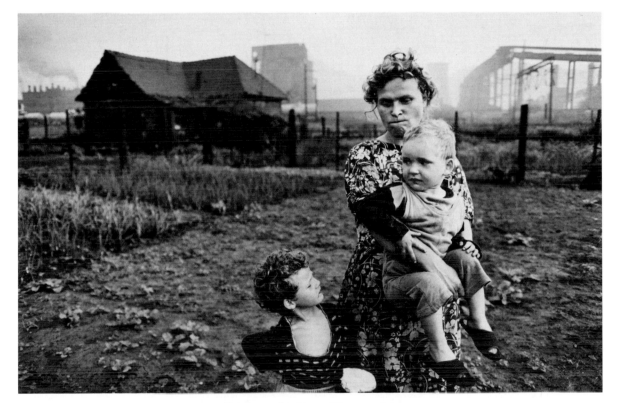

GENERAL, AWARD OF EXCELLENCE
William Snyder, The Dallas Morning News
A woman in Copsa Mica, Romania, stands in her garden with her children. The pollution from the
town's factories has been called the worst in Europe. The garden yields little produce.

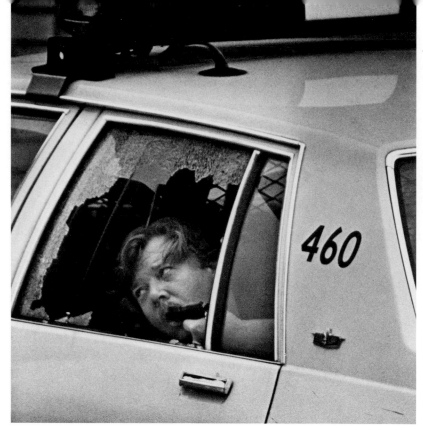

SPOT, AWARD OF EXCELLENCE
Brian Masck, The Muskegon (Mich.) Chronicle
Billy Ray Youngblood threatens suicide from the back seat of a
Muskegon police cruiser. He later surrendered.

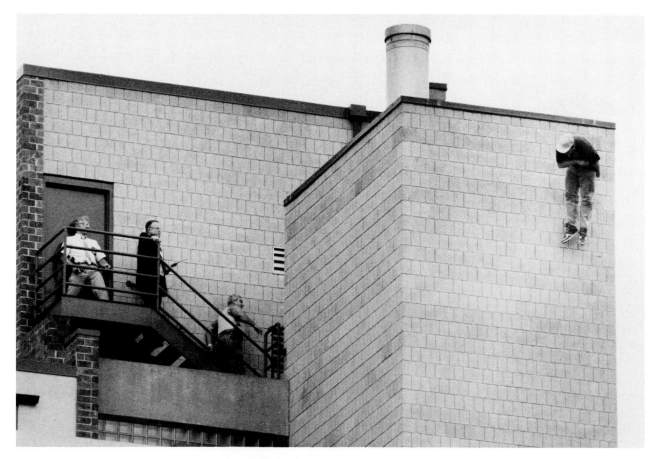

SPOT, AWARD OF EXCELLENCE
Thomas Ondrey, The Pittsburgh Press
A man's body falls from a 14-story apartment building after a five-hour ordeal in which he fired randomly on
the streets below in an effort to attract police gunfire. He finally shot himself.

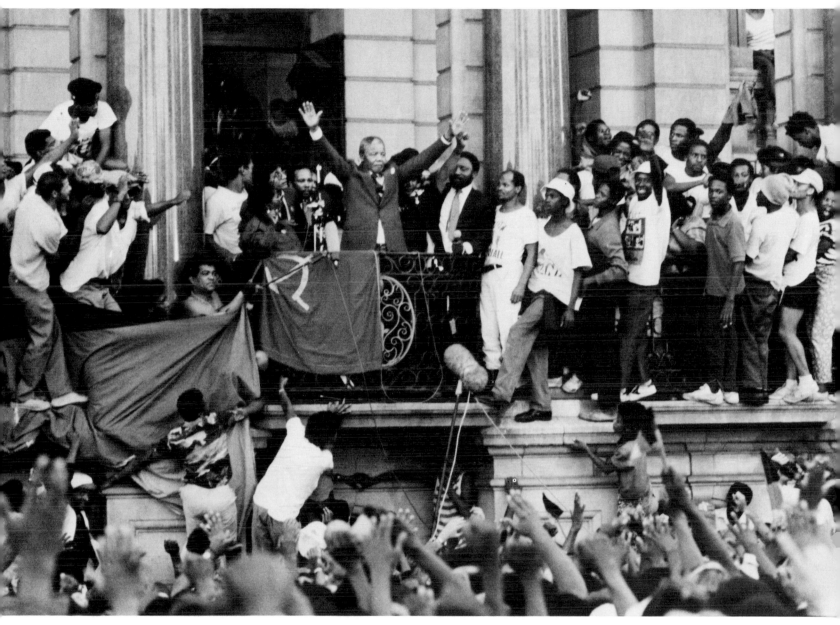

GENERAL, 3RD PLACE
John H. White, Chicago Sun Times
Shortly after being released from prison in Cape Town, South Africa, Nelson Mandela makes his first public appearance. The African
National Congress leader had been imprisoned for 27 years for taking up arms against white-minority rule.

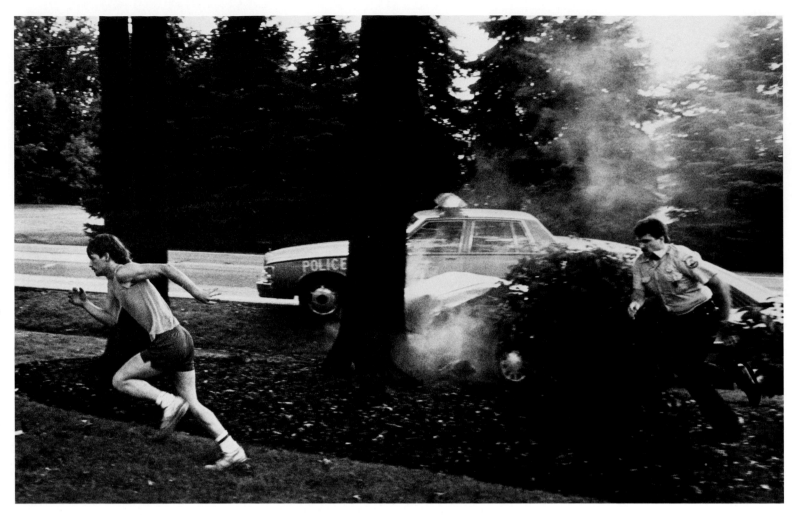

SPOT, 3RD PLACE
David E. Dale, The Sharon (Pa.) Herald
Richard Zaboroski flees from Sharon police Officer Jeff Jennings after crashing his car during a police chase. A moment later,
Zaboroski was stopped by Jennings, another officer and a passer-by.

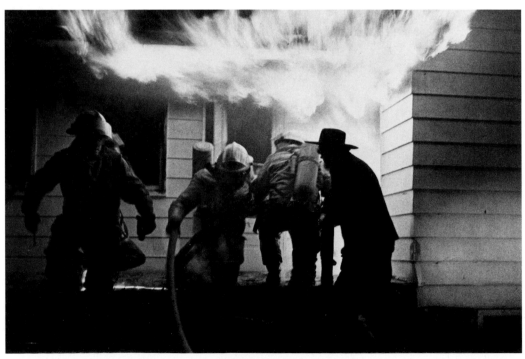

SPOT, AWARD OF EXCELLENCE
Bill Lyons, New Castle (Pa.) News
New Wilmington volunteer firefighters retreat from flames that exploded through a
window at the home of an Amish farmer in Pennsylvania.

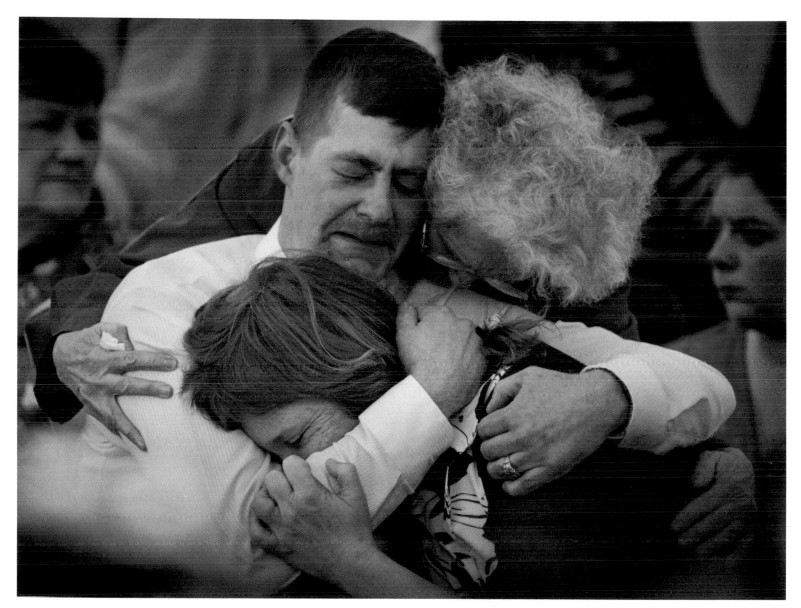

GENERAL, AWARD OF EXCELLENCE
Robert Cohen, The Memphis (Tenn.) Commercial Appeal
John Read holds his ex-wife, Deborah Read, at the funeral of their slain 8-year-old daughter, Ashley. The other woman is unidentified.

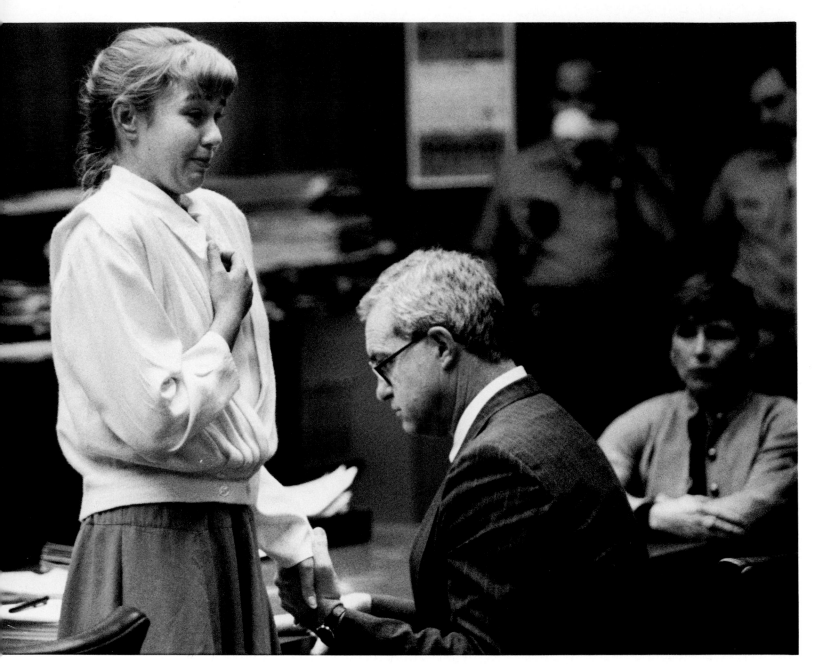

GENERAL, AWARD OF EXCELLENCE
David Schreiber, The Torrance (Calif.) Daily Breeze
A 19-year-old woman apologizes in court to the family of a pregnant woman she killed in a traffic accident while high on LSD.

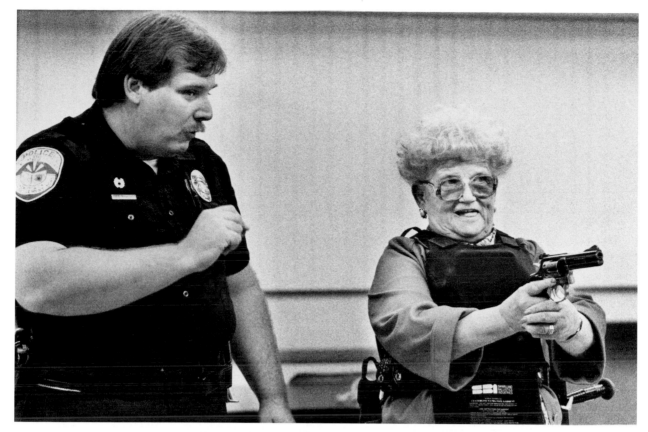

GENERAL, AWARD OF EXCELLENCE
Christine Keith, The Arizona Republic
Youngtown police Officer Robert Hawkins shows Jean Westveld how to aim a handgun. The two were participating in a "citizen's academy" designed to familiarize residents with police work.

SPOT, AWARD OF EXCELLENCE
David Handschuh, New York Daily News
Three hundred feet above Grand Central Station, New York police Officer Andy Nugent talks to a 14-year-old girl who was threatening suicide. The girl was brought down safely.

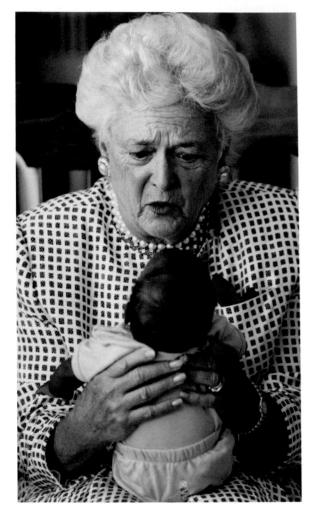

GENERAL, AWARD OF EXCELLENCE
Sean Dougherty,
Fort Lauderdale News/Sun-Sentinel
First Lady Barbara Bush visits a Florida nursery
that cares for children with AIDS.

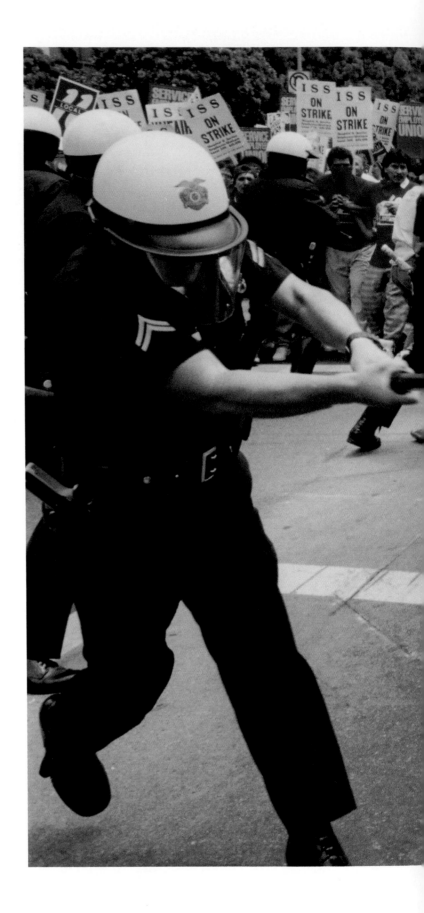

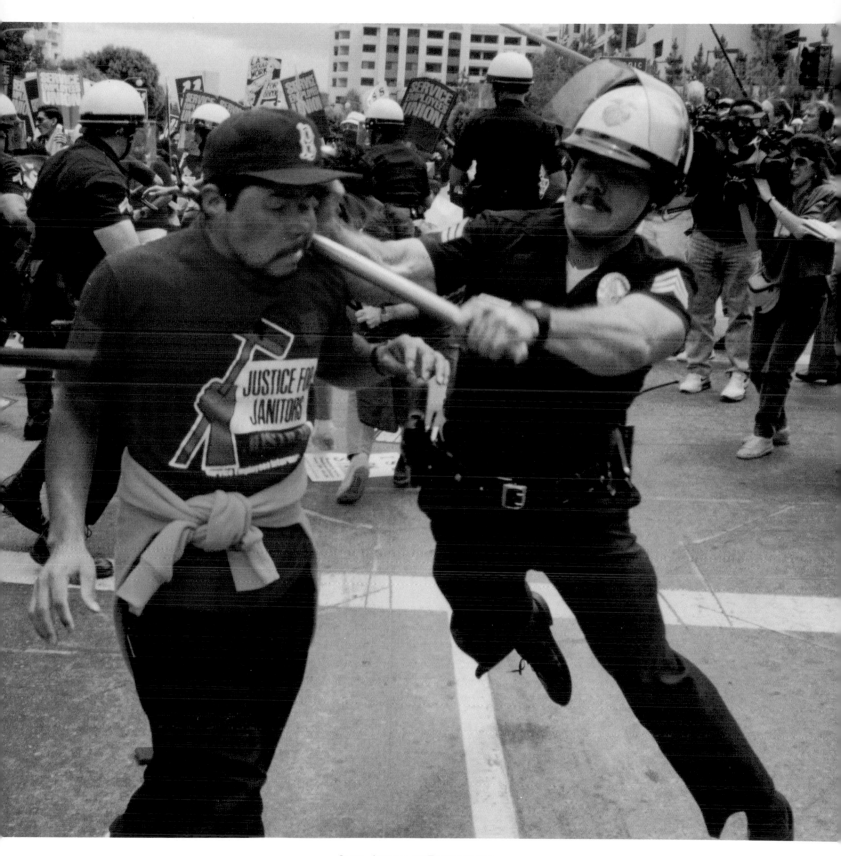

SPOT, AWARD OF EXCELLENCE
Bernardo Alps, The Santa Monica (Calif.) Outlook
A striking janitor is clubbed by Los Angeles Police officers after breaking through police lines during a protest march. The janitors, who clean Century City high-rise buildings, were trying to establish a union.

SPOT, AWARD OF EXCELLENCE
Michele McDonald, The Boston Globe
A man struggles with a woman after she robbed another woman who had just cashed her paycheck.

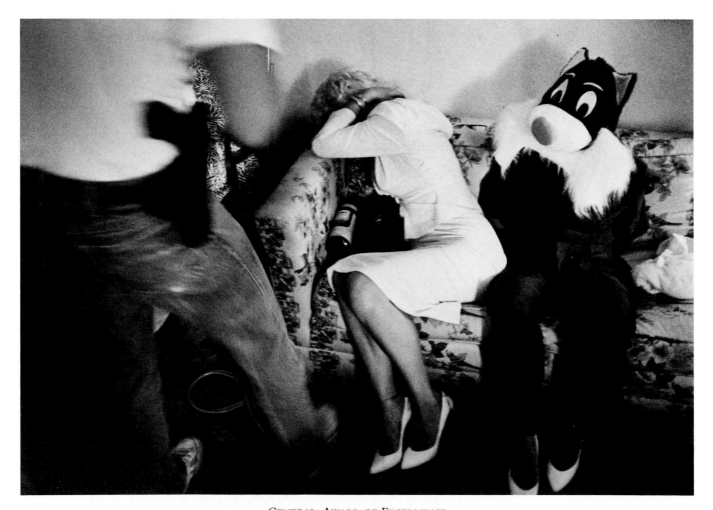

GENERAL, AWARD OF EXCELLENCE
Jeff Greene, The West Palm Beach Post
The Palm Beach County Sheriff's Organized Crime Bureau raids the A-About-Town escort service. The woman at right wears a Sylvester mask on calls to hide her identity.

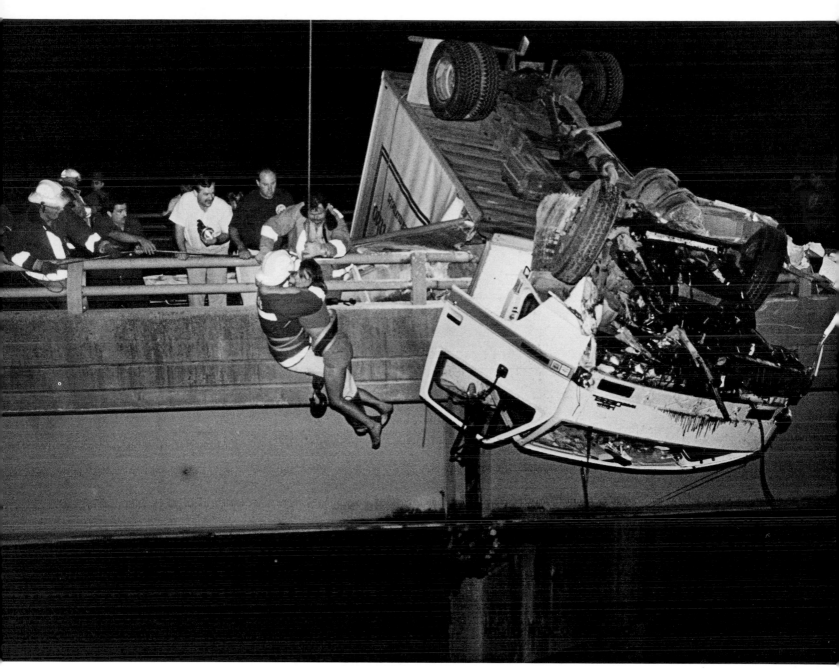

SPOT, AWARD OF EXCELLENCE
Chris Taylor, Bristol Herald-Courier Virginia Tennessean
Linda St. Germain clings to Bristol Life Saving Crew member Jerry Fleenor as they are pulled to safety from the wreckage of St. Germain's truck.

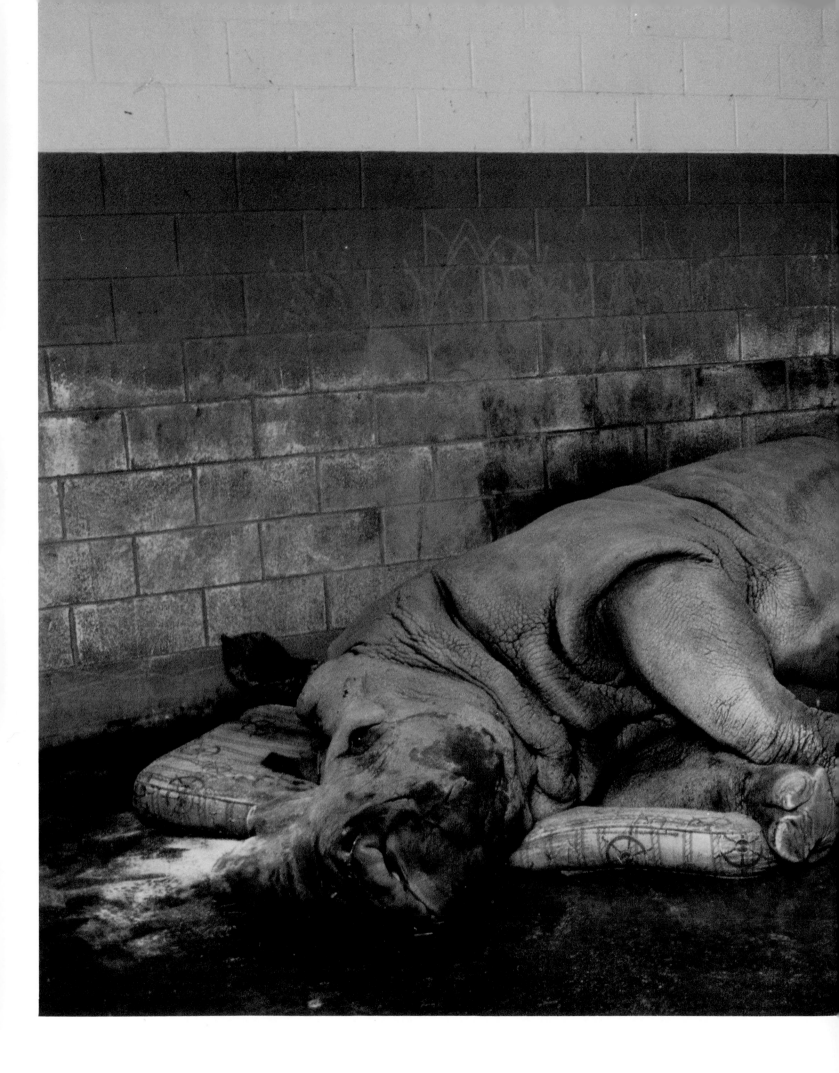

114

Bryan Berteaux, The New Orleans Times-Picayune
Audubon Zoo officials discuss the death of a female rhinoceros. Hoping to encourage breeding, the workers anesthesized the animal to trim her horn. She died during surgery.

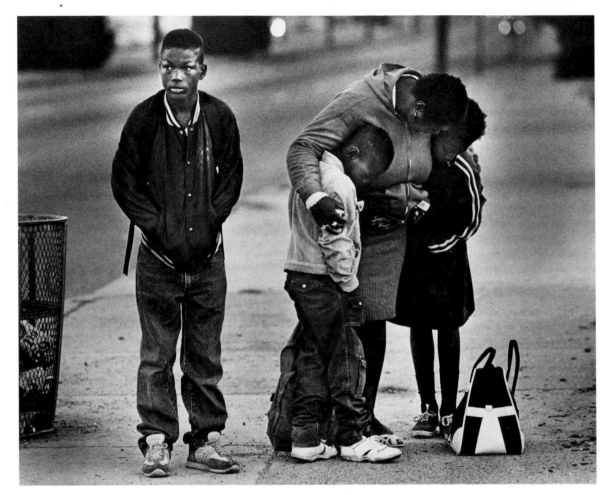

GENERAL, AWARD OF EXCELLENCE
Bill Tiernan, The Norfolk Virginian-Pilot/Ledger-Star
Daisy Mayes shields two of her children against an autumn wind as her older son watches for the
public bus. The family is homeless.

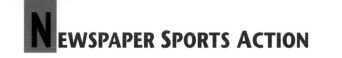

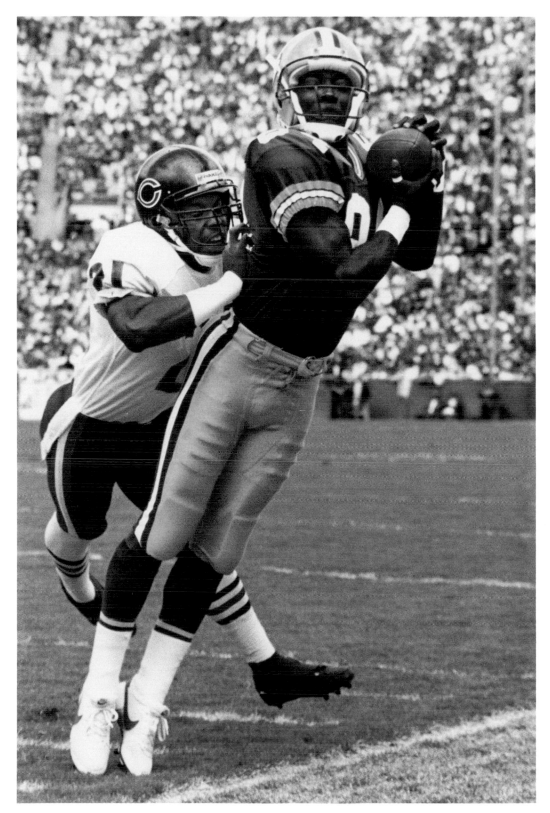

1ST PLACE
Mark Welsh, Arlington Heights (Ill.) Daily Herald
Green Bay Packer Sterling Sharpe makes a tippy-toe catch in bounds for the first down as
the Chicago Bear's Donnell Woolford defends at Lambeau Field in Green Bay, Wis.

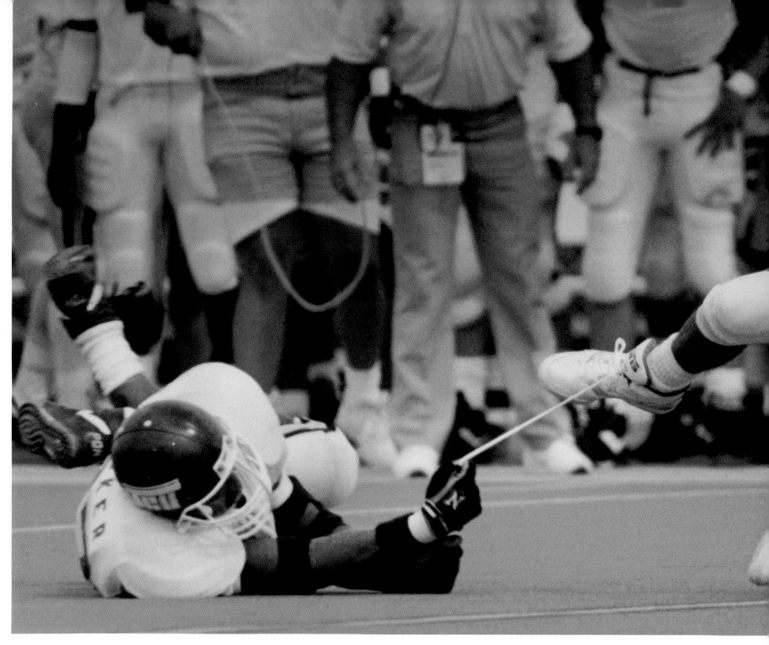

Donna Bagby, Dallas Times Herald
Texas Christian University's Richard Booker tackles Southern Methodist University's Mike Romo during a game in Dallas.

Frank Niemeir, Atlanta Journal-Constitution
St. Louis Cardinal third baseman Terry Pendleton watches a loose bat
coming his way during a game against the Atlanta Braves.

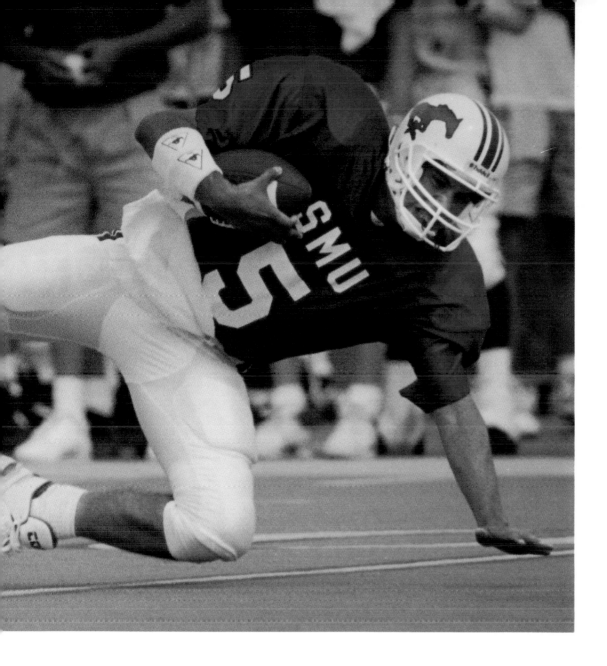

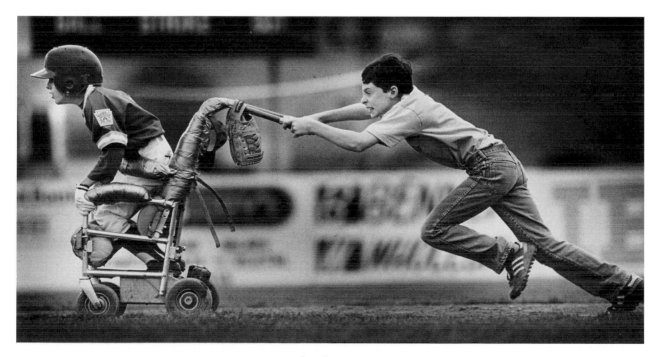

3RD PLACE
Eric Hegedus, Binghamton (N.Y.) Press & Sun-Bulletin
Keith Darling (left), 10, heads for third base, powered by his brother, Greg, 12, during a Challenger
Division Little League baseball game in Vestal, N.Y.

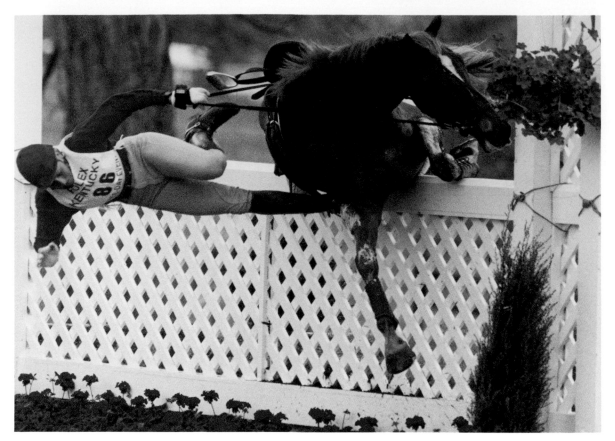

AWARD OF EXCELLENCE
Ron Garrison, The Lexington (Ky.) Herald-Leader
Moira Laframboise and her steed part company during the Rolex Three-Day Event
at Kentucky Horse Park.

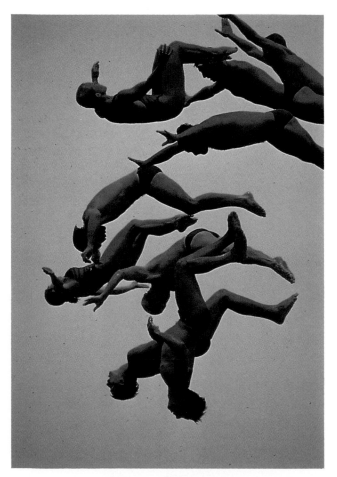

AWARD OF EXCELLENCE
Michael Ging, The Arizona Republic
A diving exhibition at Sea World in San Diego.

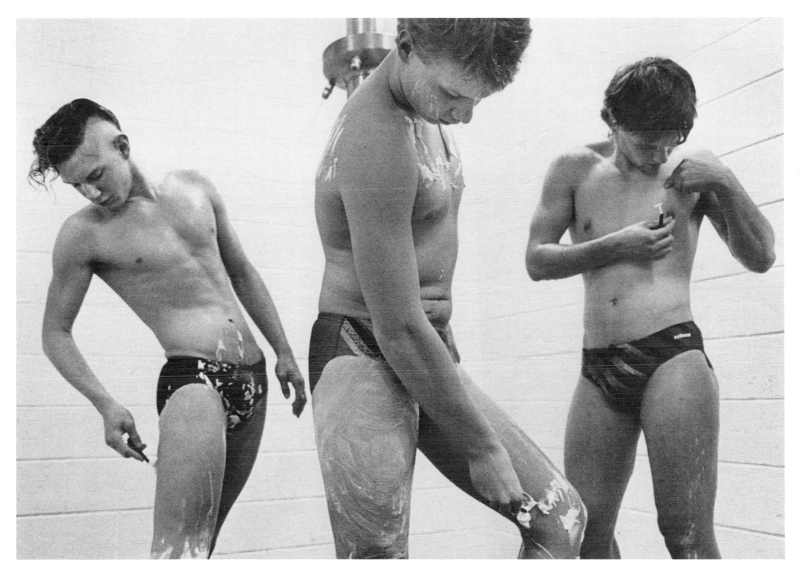

1ST PLACE
Kurt Wilson, Missoula (Mont.) Missoulian
Missoula Big Sky High School swimmers (from left) Shane Nicolet, Chet Hammill and Mike Brault "shave down" before the Montana state high-school meet in Missoula.

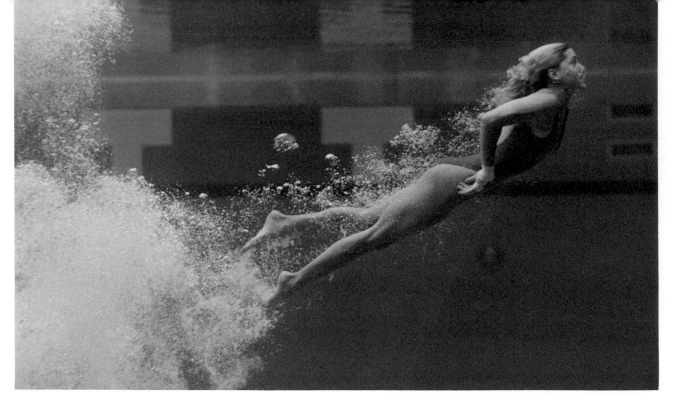

George Wilhelm, Los Angeles Times
Wendy Lian Williams swims to the surface after a dive in the 10-meter platform competition at the U.S. Olympic Festival in Minneapolis. She took the gold medal in the event.

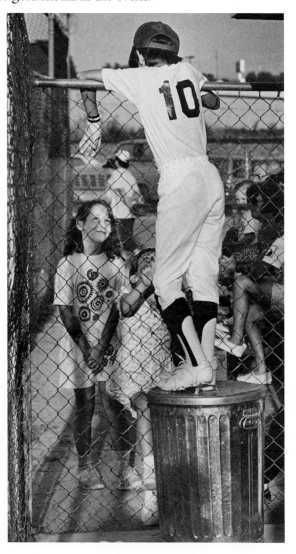

2ND PLACE
Chris Seward, The Raleigh News & Observer
Little Leaguer Jason Faucette chats with fan Margie Rabb during a game in Fuquay-Varina, N.C.

1ST PLACE
Gerard Lodriguss, The Philadelphia Inquirer

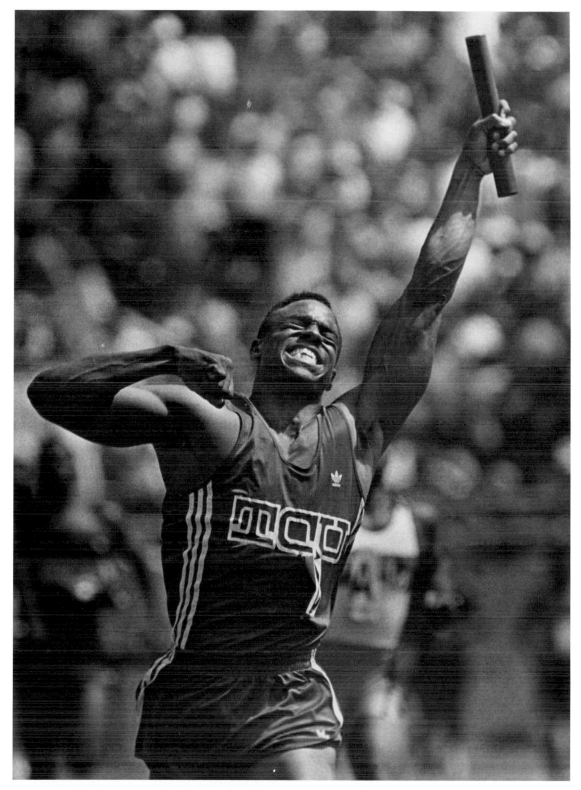

Jonathon Drummond of Texas Christian University finishes first in the 400-meter relay
at the Penn Relays.

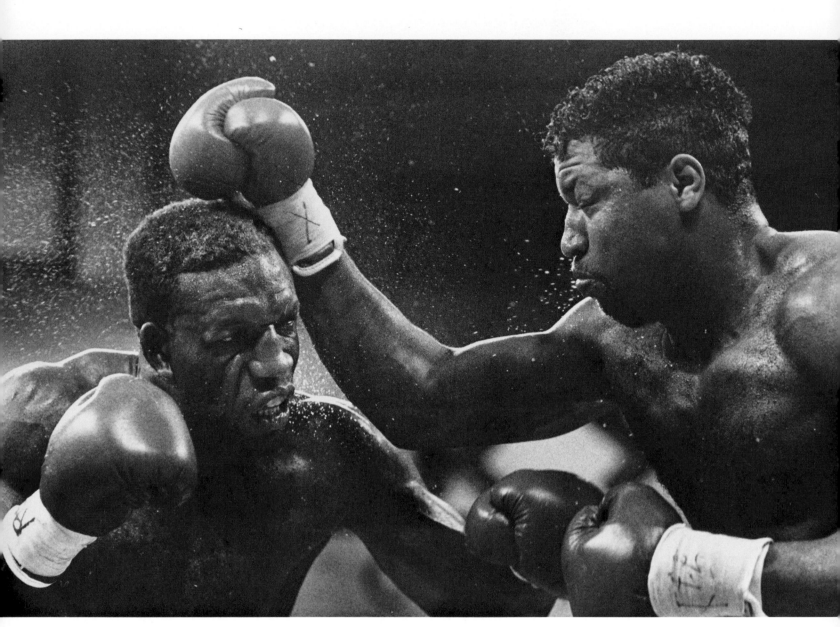

Heavyweight boxer Ray Mercer (right) pounds opponent Wesley Watson.

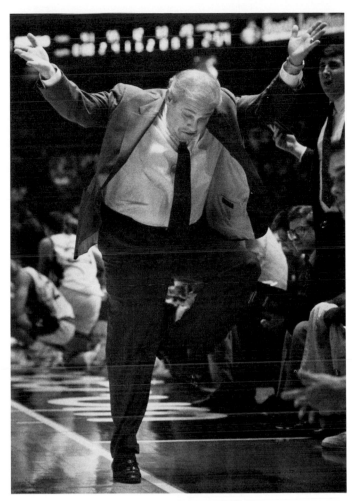

Villanova University coach Rollie Massamino disagrees with a referee's call during a game against Georgetown University.

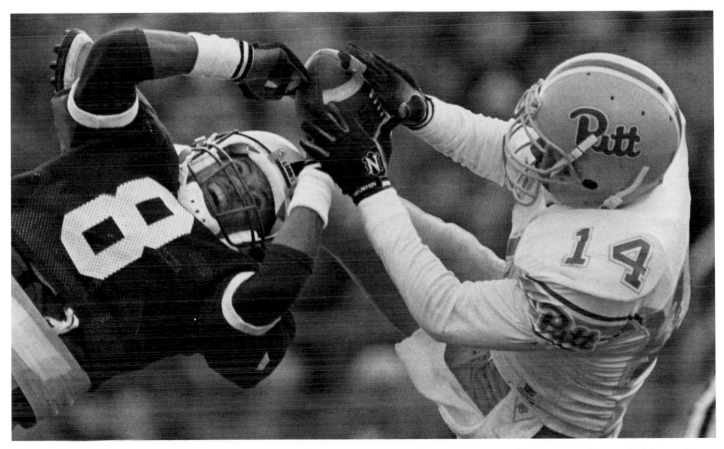

University of Pittsburgh defensive back Marcus Washington (14) knocks the ball out of the hands of intended Penn State receiver Terry Smith.

Gerard Lodriguss, The Philadelphia Inquirer

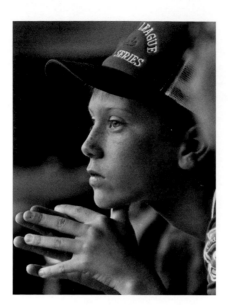

Canadian player Jayson Bay.

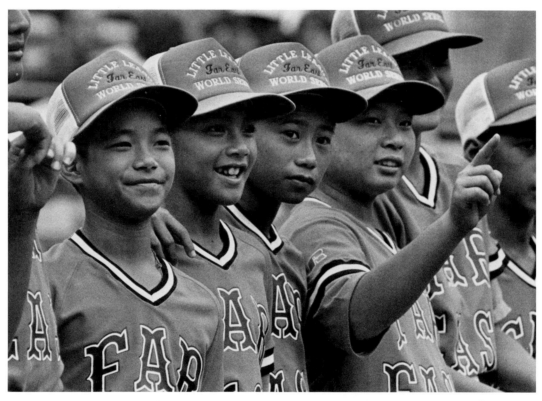

A team from Taiwan represents the Far East in the series.

Little League World Series

America's game has become an international one. Little League teams from around the world converged on Williamsport, Pa., in August to compete for the world championship.

The finals pitted Taiwan against Shippensburg, Pa. After two games were delayed by rain, 12-year-old Taiwan pitcher Sun Chao-Chi pitched a two-hitter and struck out 16 in a 9-0 victory.

The win was Taiwan's 14th Little League World Series championship in 17 appearances. The game was attended by more than 40,000 fans.

Gerard Lodriguss, The Philadelphia Inquirer

1ST PLACE, NEWSPAPER SPORTS PORTFOLIO

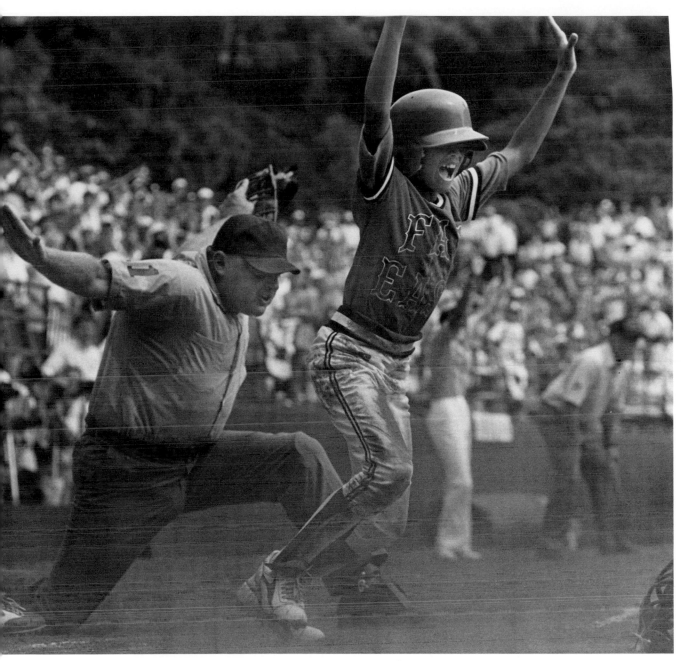

Far East's Chen Chang-Ming scores a run on a wild pitch. Pitcher Sun Chao-Chi embraces Chen (below, left) after winning the championship. Europe's James Lowry (below) wipes a tear after losing to the Far East team.

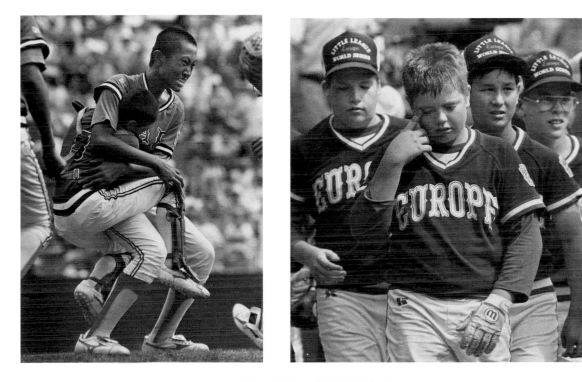

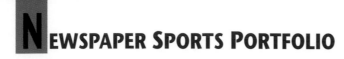

2ND PLACE

Louis DeLuca, Dallas Times Herald

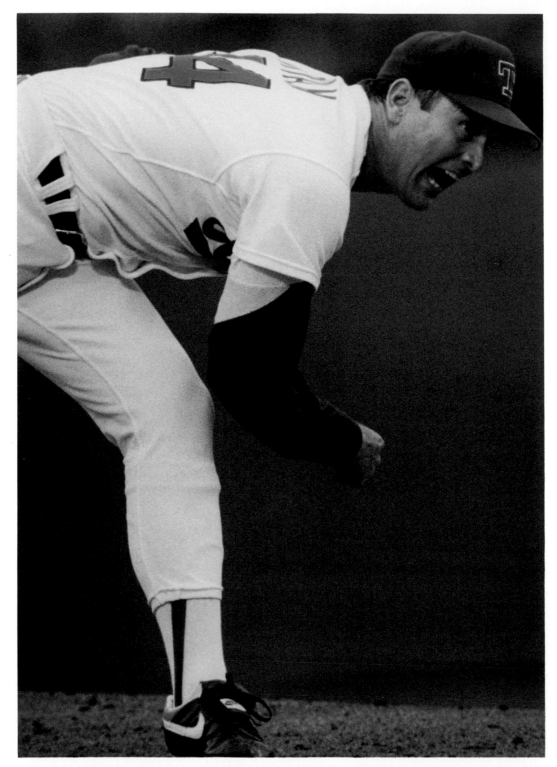

Texas Ranger Nolan Ryan hurls a pitch against the New York Yankees in his quest for his 300th career win. The goal eluded him during that game.

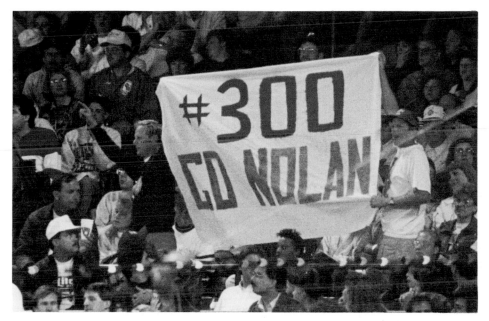

Even Milwaukee fans cheer for Nolan Ryan as his team plays the Brewers. The Rangers beat Milwaukee, 11-3, giving Ryan his 300th victory.

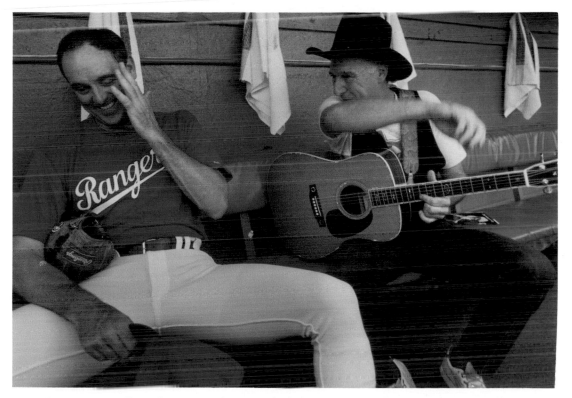

Singer Jerry Jeff Walker serenades Ryan before a game at Arlington Stadium in Texas.

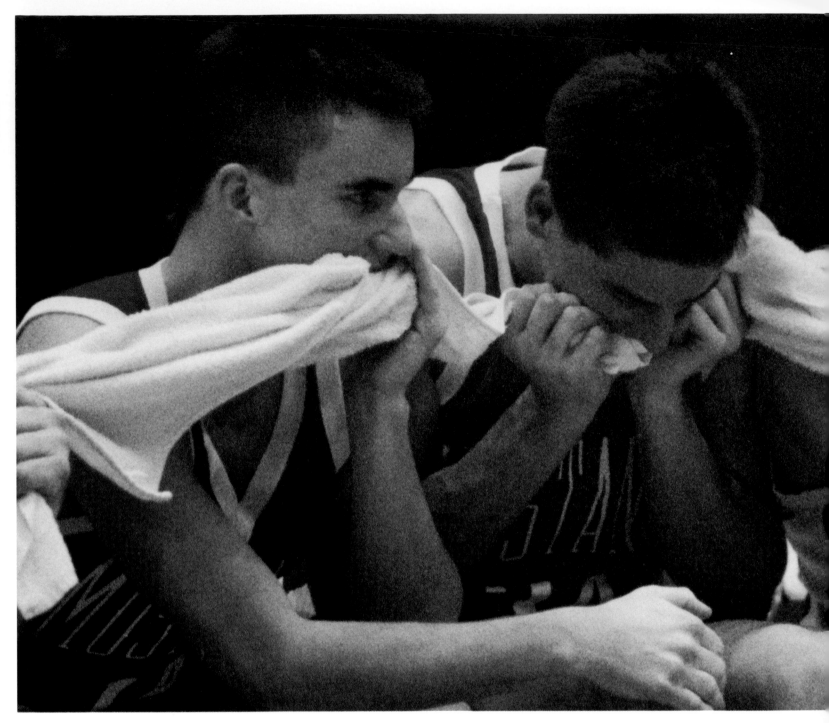

Members of the Richardson Pearce High School basketball team watch tensely as their teammates win a playoff game in Dallas.
After missing the catch on a foul ball (right photo), Texas Ranger Chad Kreuter watches
Chicago's Eric King and Tracy Woodson make the play in the dugout.

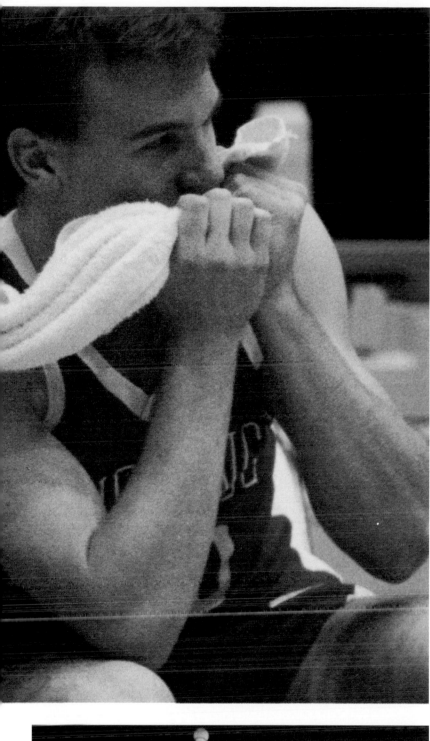

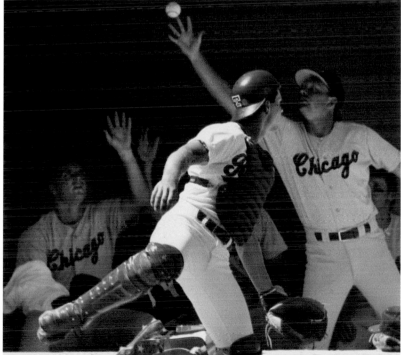

NEWSPAPER SPORTS PORTFOLIO

3RD PLACE

Kurt Wilson, Missoula (Mont.) Missoulian

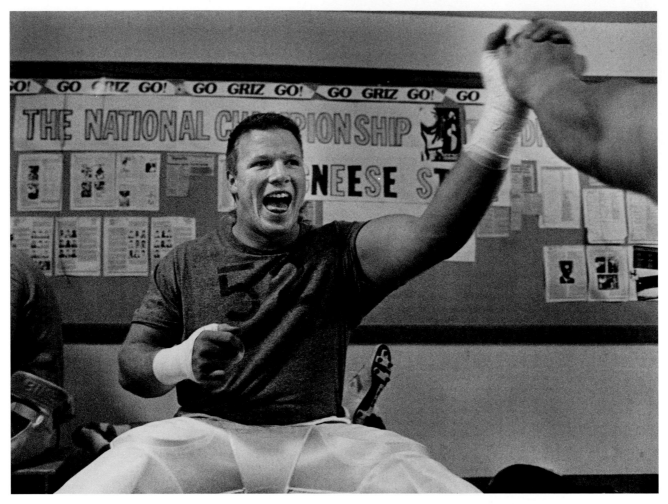

Defensive end Kirk Murphy is psyched for victory before the Grizzlies' third game.

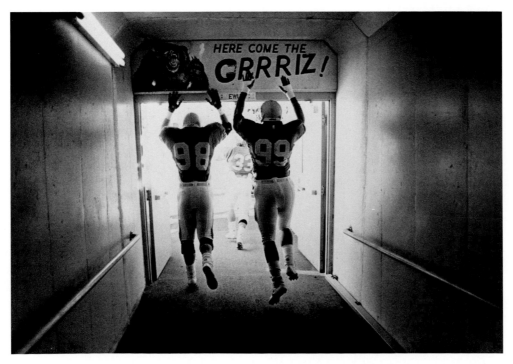

Team members run onto the field for Homecoming, bolstered by their highest
ranking ever: second in the nation.

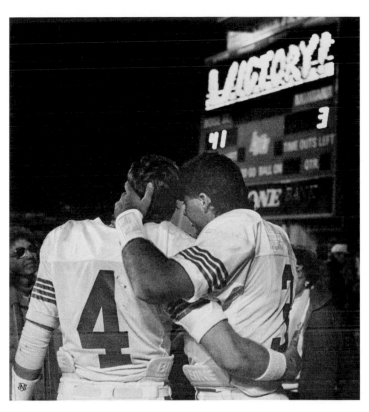

A Grizzly Season

G oing into the '89-'90 season, University of Montana football coach Don Read thought his team would see its best year ever. The previous season had been outstanding, and he was ready for an encore.

But after a bold start that brought the Grizzlies to second-place national ranking, the growling became less fierce.

The team lost its Homecoming game, then suffered its worst loss ever, as Boise State beat the Grizzlies, 41-3.

As more losses piled up, the team fell out of the top 20 rankings. Coach Read's hopes for a championship were dashed.

Quarterbacks console each other after losing to Boise State.

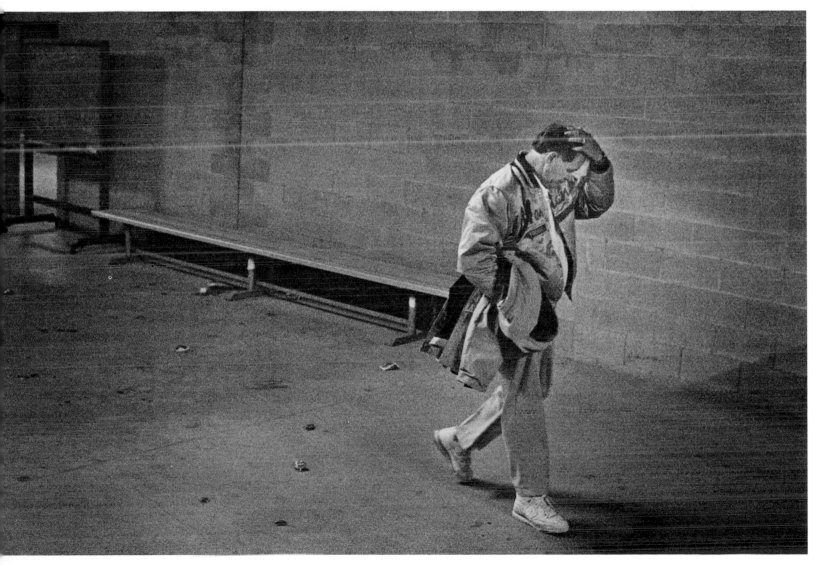

Two losses later, Coach Read gives up on his playoff dream.

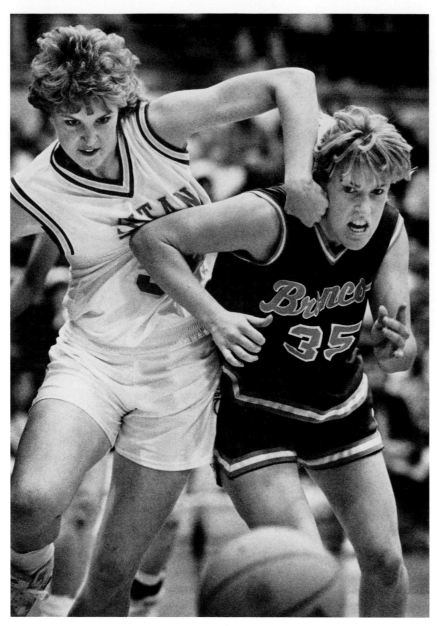

University of Montana's Linda Mendel (left) and Boise State University's
Becky Sievers fight for a loose ball.

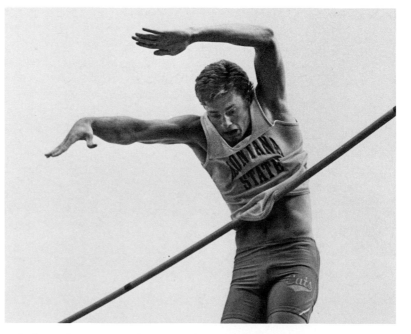

Pole vaulter Brian Schweyen of Montana State University misses
clearing the bar at 17 feet, 6 inches by a shirttail.

Kurt Wilson, Missoula (Mont.) Missoulian

3RD PLACE, NEWSPAPER SPORTS PORTFOLIO

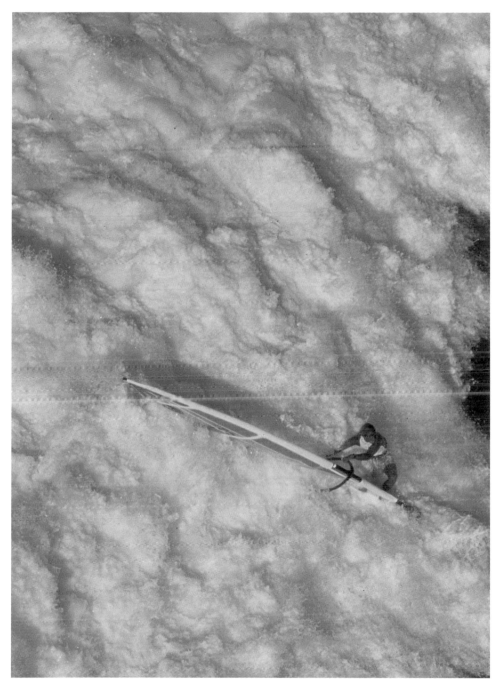

1ST PLACE
Jonathan Weston, Sports Illustrated
Mike Eskimo rides the waves of Hookipa Beach in Hawaii.

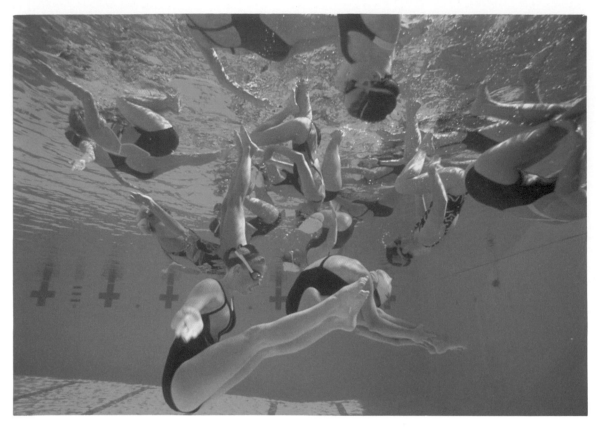

2ND PLACE
Budd Symes, free-lance
Meracquas synchronized swim team performs in Irvine, Calif.

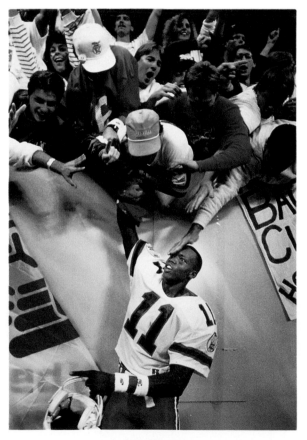

3RD PLACE
Bill Frakes, Sports Illustrated
University of Miami's Dale Dawkins is cheered
after a Sugar Bowl win against the University of
Alabama.

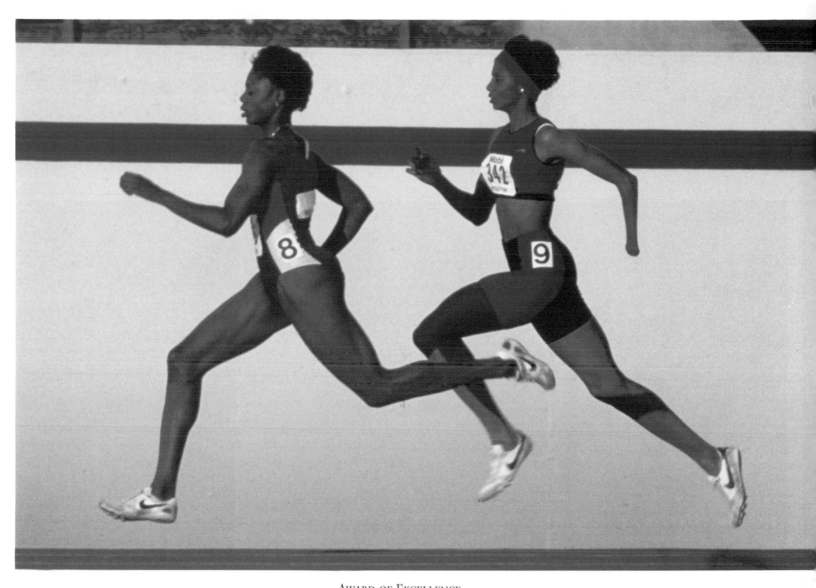

AWARD OF EXCELLENCE
Tim DeFrisco, Allsport USA
Maciel Malone (left) and Arlise Emerson run the 400-meter race at the Athletics Congress 1989 national championships in Houston.

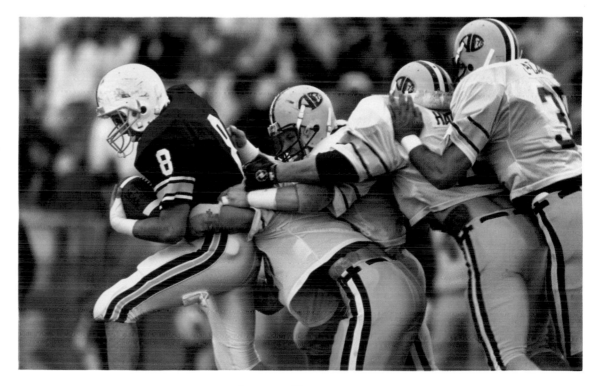

AWARD OF EXCELLENCE
Damian Strohmeyer, free-lance
Lycoming University's Matt Harvey is tackled by Allegheny University defenders

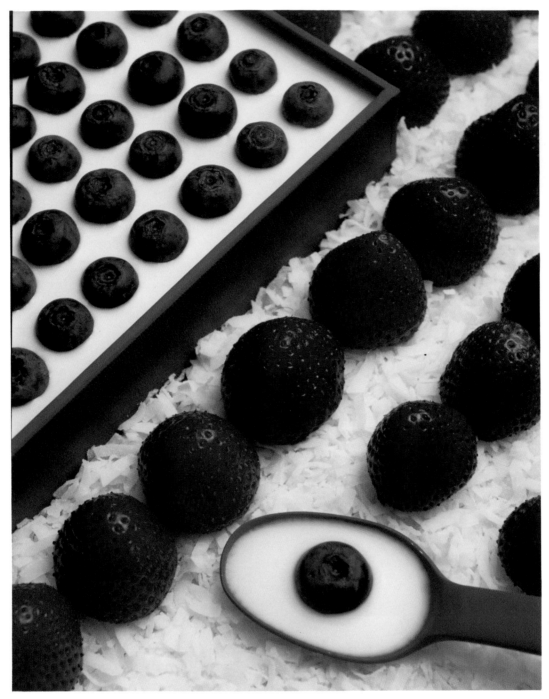

2ND PLACE
Robert Cohen, The Memphis (Tenn.) Commercial Appeal
"The Fourth of July"

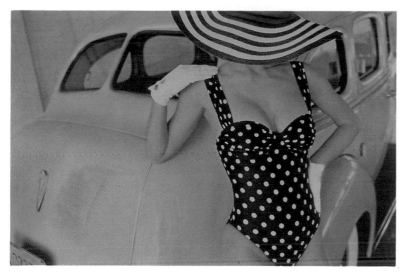

AWARD OF EXCELLENCE
Mary M. Kelley, Colorado Springs Gazette Telegraph
"Forties Style Suits"

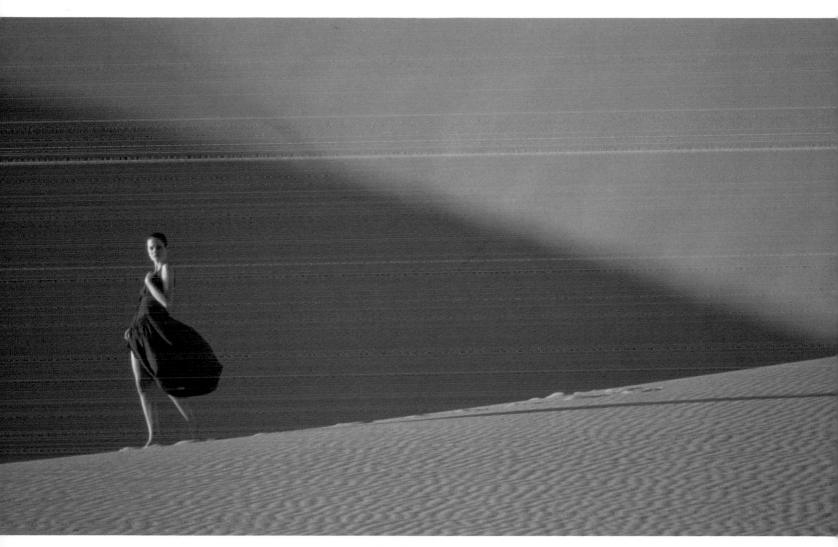

1ST PLACE
Daniel Anderson, The Orange County (Calif.) Register
"Dune Magic"

AWARD OF EXCELLENCE
Leilani Hu, The Sacramento Bee
"Shades of Summer"

2ND PLACE
Daniel Anderson, The Orange County (Calif.) Register
"Socks Appeal"

3RD PLACE
Daniel Anderson, The Orange County (Calif.) Register
"Sundress Sweet"

AWARD OF EXCELLENCE
**Guy Reynolds, Baton Rouge (La.) State Times/
Morning Advocate**
"From Sofas to Sundresses"

AWARD OF EXCELLENCE
Ted Jackson, The New Orleans Times-Picayune
"The Tracy Look"

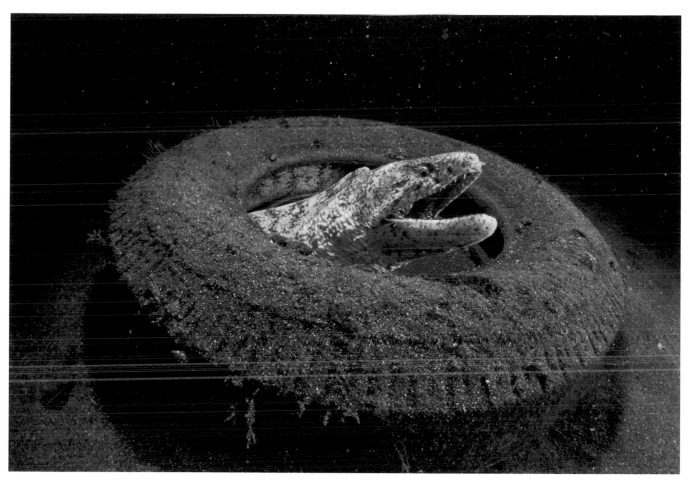

2ND PLACE
David Doubilet, National Geographic
"Nightmare flat tire" — Home to a moray eel

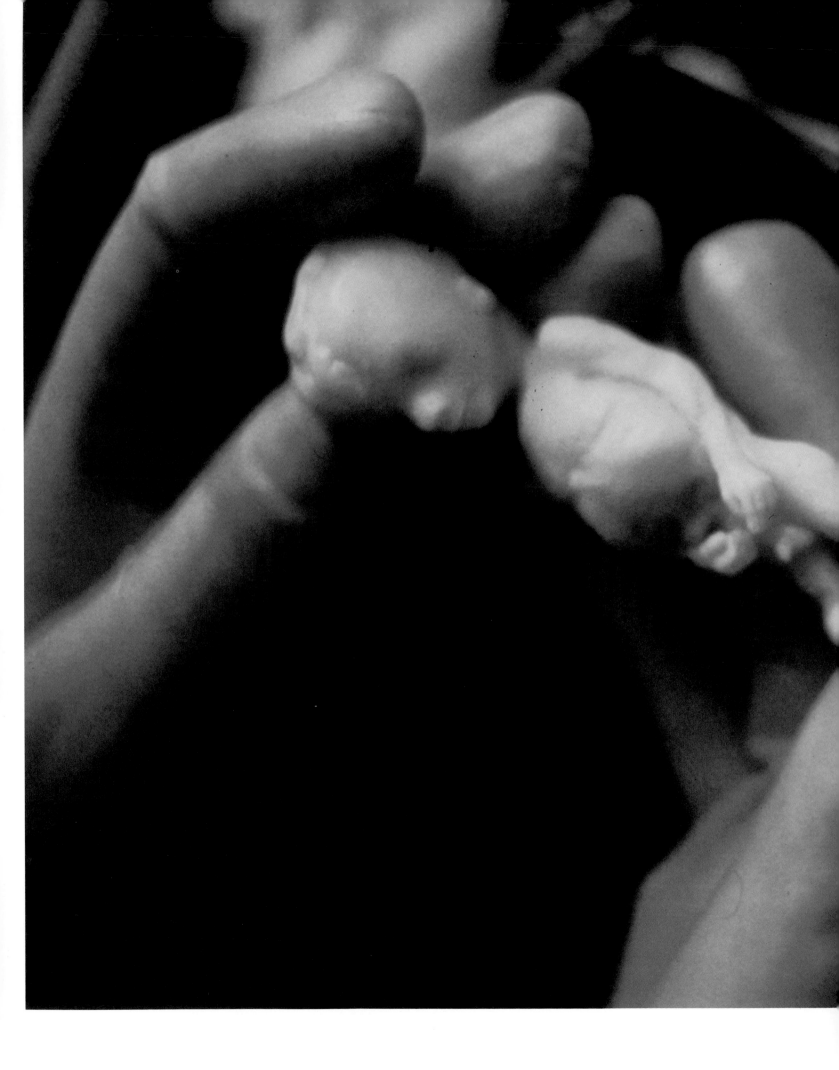

1ST PLACE
Igor Kostin, Time
"Chernobyl Fetus"

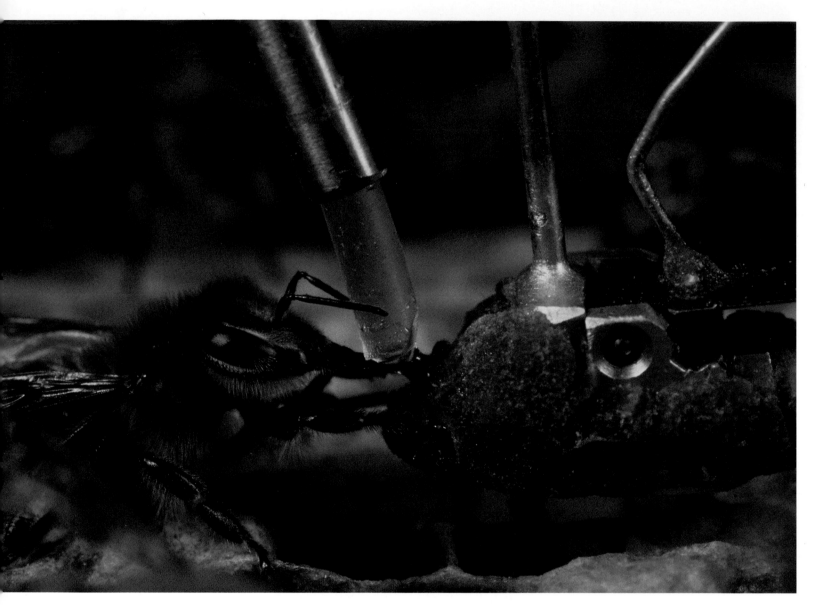

3RD PLACE
Mark Moffett, National Geographic
"Robot Feeds Honeybee"

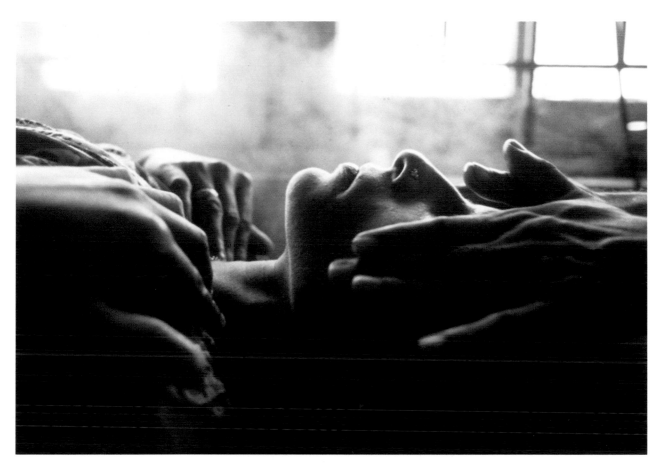

AWARD OF EXCELLENCE
Dilip Mehta, Contact Press Images
"Laying-on Hands" — Ayurvedic Medicine in Bombay

AWARD OF EXCELLENCE
J. B. Diederich, Contact Press Images
"Texas Oil Spill" — Galveston Bay

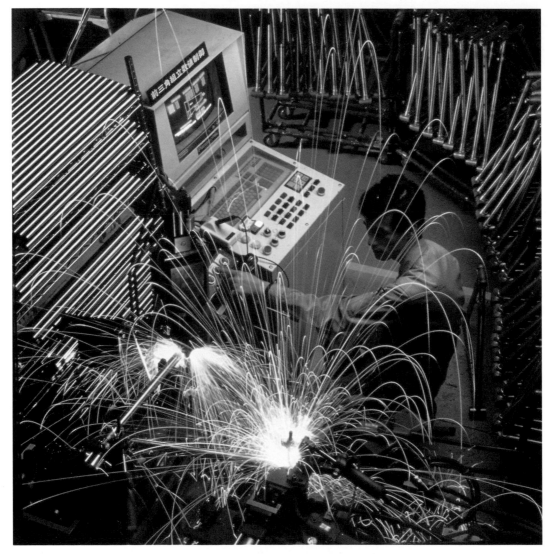

AWARD OF EXCELLENCE
Louis Psihoyos for Fortune
"Computer Customization" — A Japanese bicycle factory

1ST PLACE

James Nachtwey, Magnum

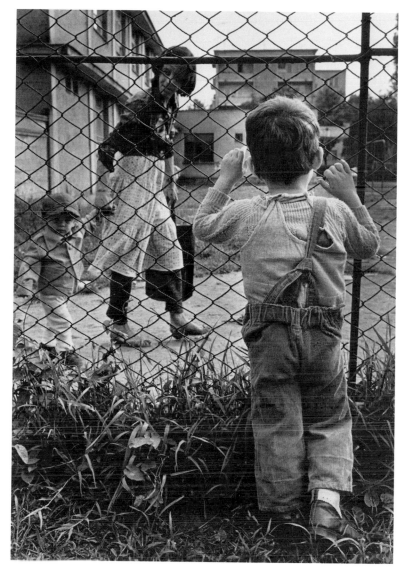

A youngster watches a mother and child walk past the orphanage.

Ceausescu's Legacy

In 1966, Romanian leader Nicolae Ceausescu declared abortion illegal for any woman under the age of 45 who had not yet borne four children. Yet his economic measures made it nearly impossible for parents to support those children.

Ceausescu's regime has fallen, but his mark has been made: About 100,000 youths are in the care of the state, many confined to poorly run, filthy institutions for the handicapped or mentally "irrecoverables." AIDS is epidemic among those children, and the future, even for those less afflicted, is not bright.

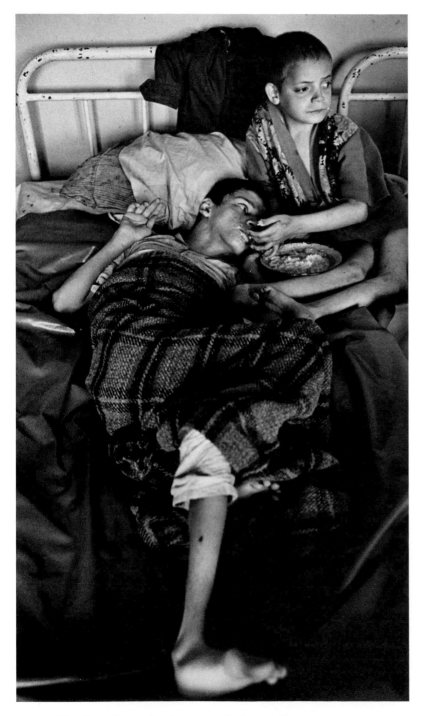

One boy does what he can to help another, even more
unfortunate boy.

James Nachtwey, Magnum for The New York Times Magazine

1ST PLACE, MAGAZINE PICTURE STORY

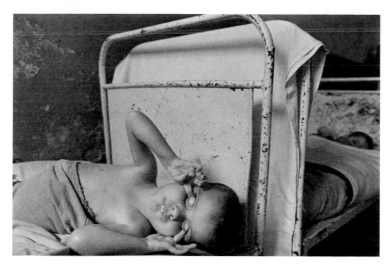

An "irrecoverable" obsessively rolls his eyes into his head.

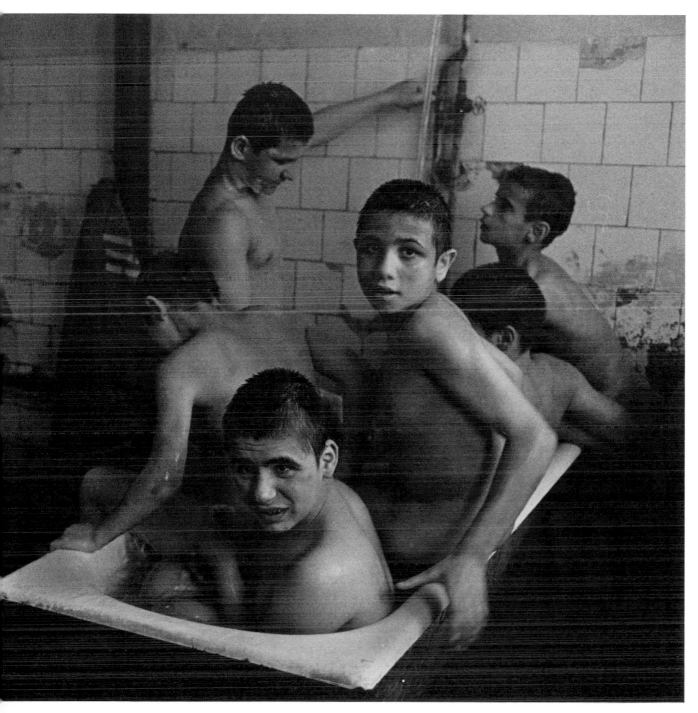

The youths at Nirlau Home Hospital have hot water for two hours, three days a week. They must share two bathtubs.

James Nachtwey, Magnum for The New York Times Magazine

1ST PLACE, MAGAZINE PICTURE STORY

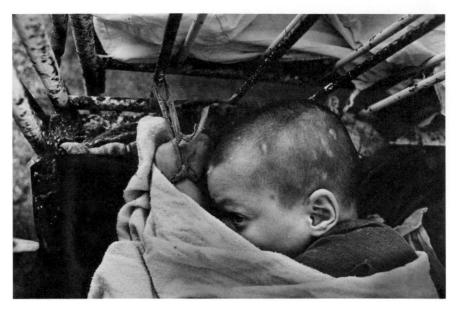

A child at Sacsa Psychiatric Hospital is tied to a crib, a common practice. At this hospital, unlike the homes for "irrecoverables," the patients will receive some therapy.

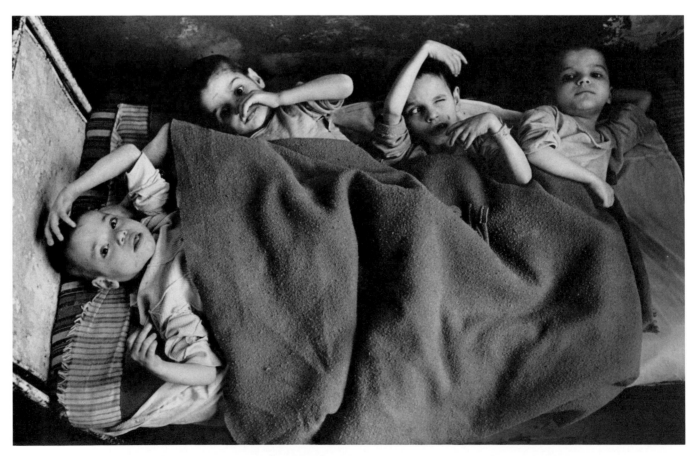

Handicapped mentally and physically, these children share a bed day and night.

James Nachtwey, Magnum for The New York Times Magazine

1ST PLACE, MAGAZINE PICTURE STORY

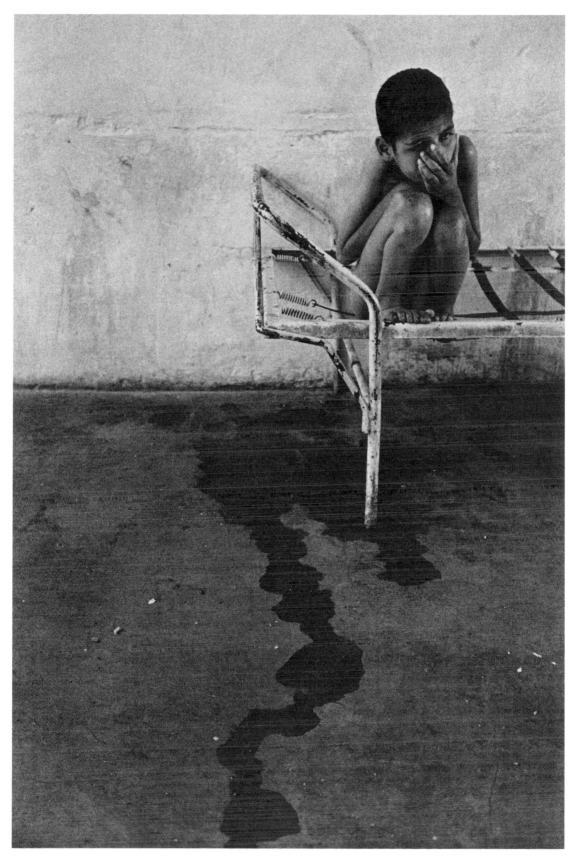

An institutionalized child lives naked on bare bed springs and relieves himself on the concrete floor. Many of the handicaps these Romanian children suffer are thought to be the results of failed abortion attempts.

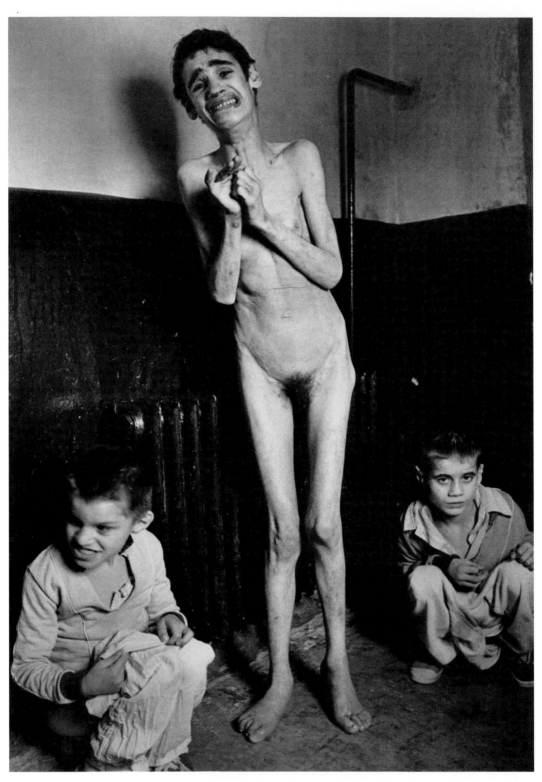

Bathroom facilities for "irrecoverables."

3RD PLACE

Eugene Richards, Magnum

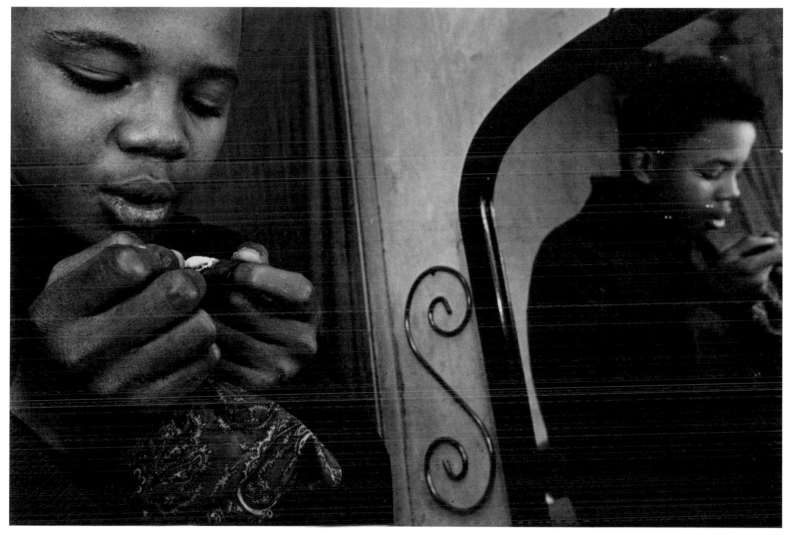

In North Philadelphia, a 12-year-old boy makes "skeedoodle," fake crack cocaine, to sell on the streets.

THE 2ND PLACE WINNER FOR MAGAZINE PICTURE STORY WAS JANE EVELYN ATWOOD. HER ENTRY, WHICH ALSO WON THE CANON PHOTO ESSAYIST AWARD, IS ON PAGES 215-228.

Children of the Damned

Faces of North Philadelphia:

A 12-year-old boy who dropped out of school two years ago makes a living by producing fake crack cocaine.

A 16-year-old girl becomes a prostitute to finance her addiction. She brings her 1-year-old child with her while turning tricks.

A 13-year-old dealer on a good night can sell $100 in crack in one hour on the streets.

A young dealer flees a deal turned bad, dropping thousands of empty crack vials. Other children consider them playthings.

A young man called "Ruthless," the toughest enforcer around, has no hope for the future and no care for anyone's life, not even his own.

North Philadelphia: Welcome to the Land of Oz.

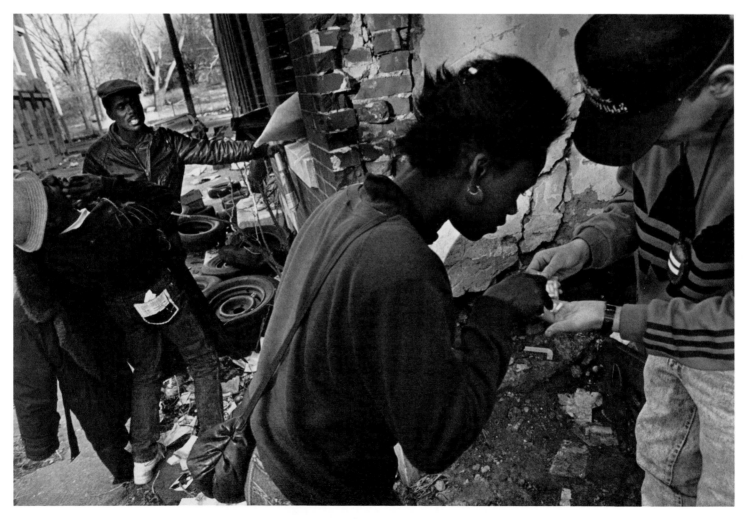

A 13-year-old crack dealer lets a user inspect his product.

3RD PLACE, MAGAZINE PICTURE STORY

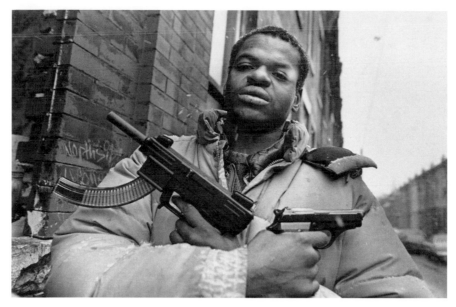

They call him "Ruthless."

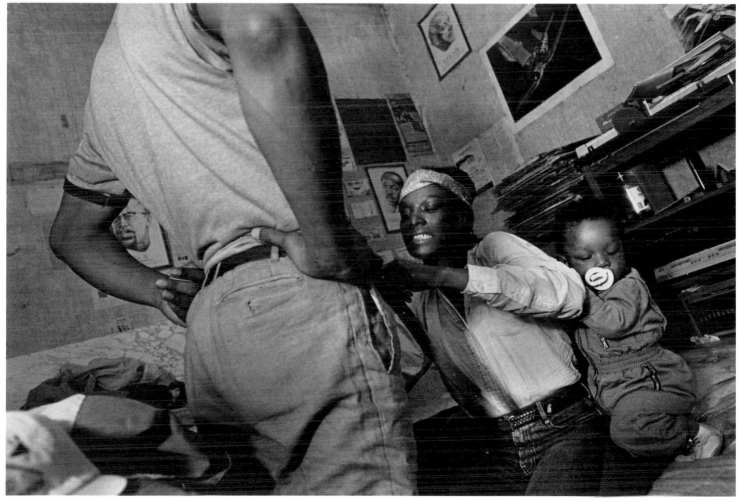

A 16-year-old addict turns tricks with her child in tow.

Eugene Richards, Magnum

3RD PLACE, MAGAZINE PICTURE STORY

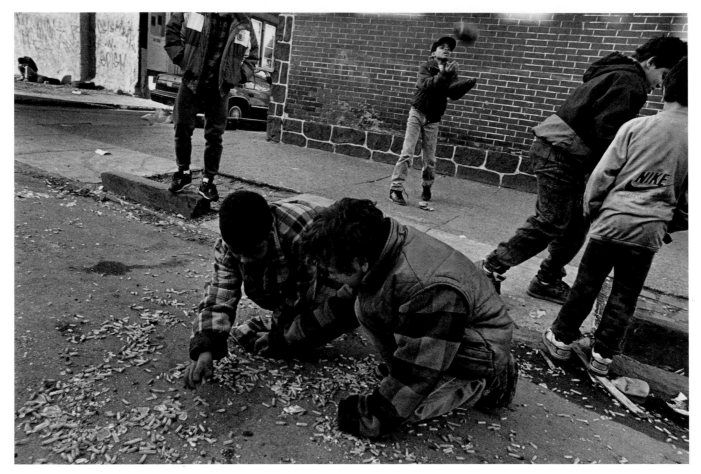

On the way to a game of sandlot football, children stop to play amid thousands of empty crack vials. The vials were dropped by a young dealer as he fled from other dealers he had robbed.

Eugene Richards, Magnum

3RD PLACE, MAGAZINE PICTURE STORY

4TH PLACE

Tomas Muscionico, Contact Press Images

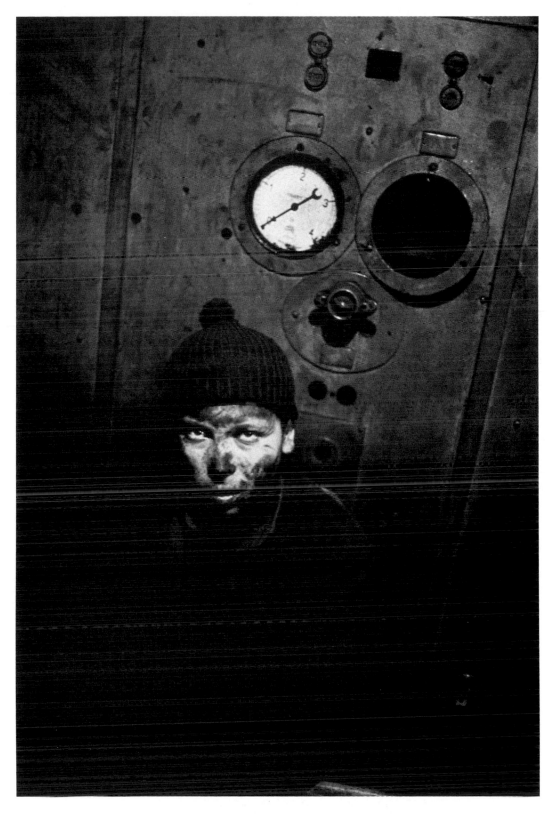

A factory worker in Copsa Mica, Romania, is covered with soot. The town of 10,000 has two factories that spew out about 30,000 tons of pollutants each year. In 1980, industrial production was stepped up in order to pay off the nation's debt. But the factories were not updated, and waste-disposal techniques were not adequate. The chemical factory dumped hazardous wastes into the water and onto the ground. Black smoke billowed from the tire factory, destroying the area's air quality. Since the 1989 revolution against dictator Nicolae Ceausescu, the government has begun taking steps to correct these errors. But the road will be a long one.

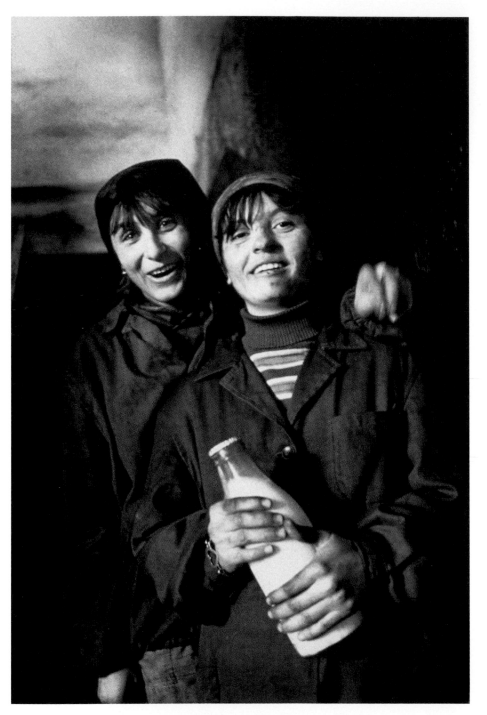

Two women pause from their work at a factory.

Tomas Muscionico, Contact Press Images

4TH PLACE, MAGAZINE PICTURE STORY

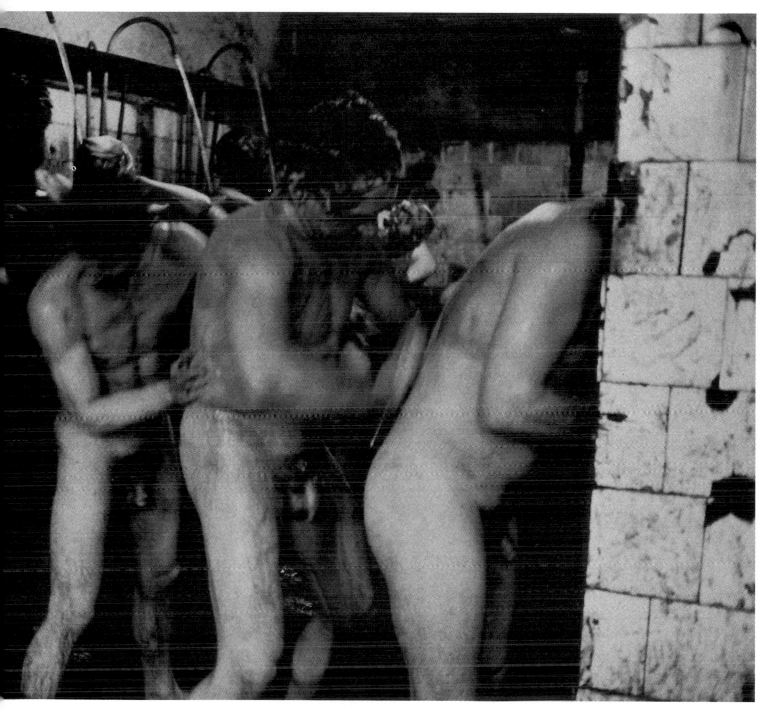

Employees shower before leaving the factory.

These posters of politicians, like everything else in Copsa Mica, are dingy with soot.

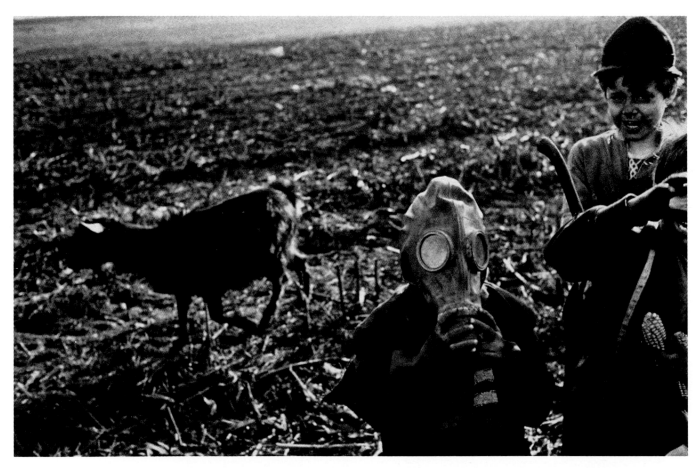

A child plays with a gas mask. When the wind is strong, it is nearly impossible to go outside, residents say.

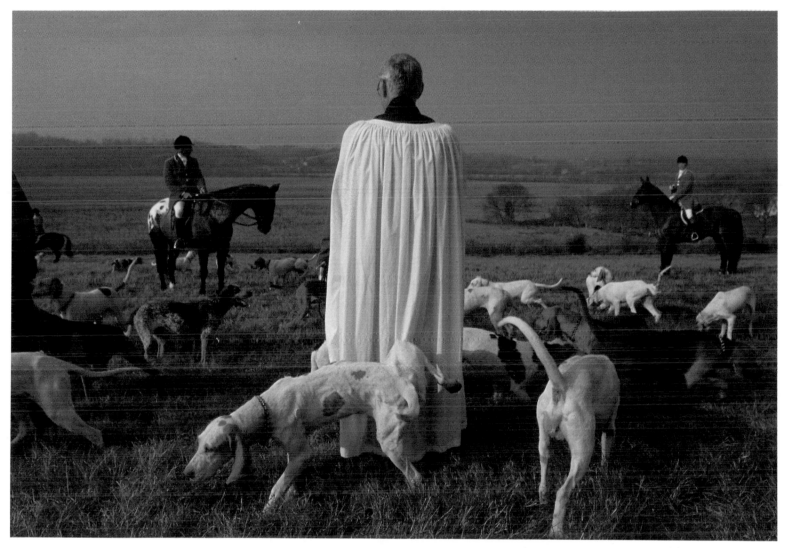

1ST PLACE
Fritz Hoffmann, The Knoxville (Tenn.) News-Sentinel
Unaware of a hound's activity, the Rev. Jim Tubbs prepares to bless the dogs for the opening of fox-hunting season.

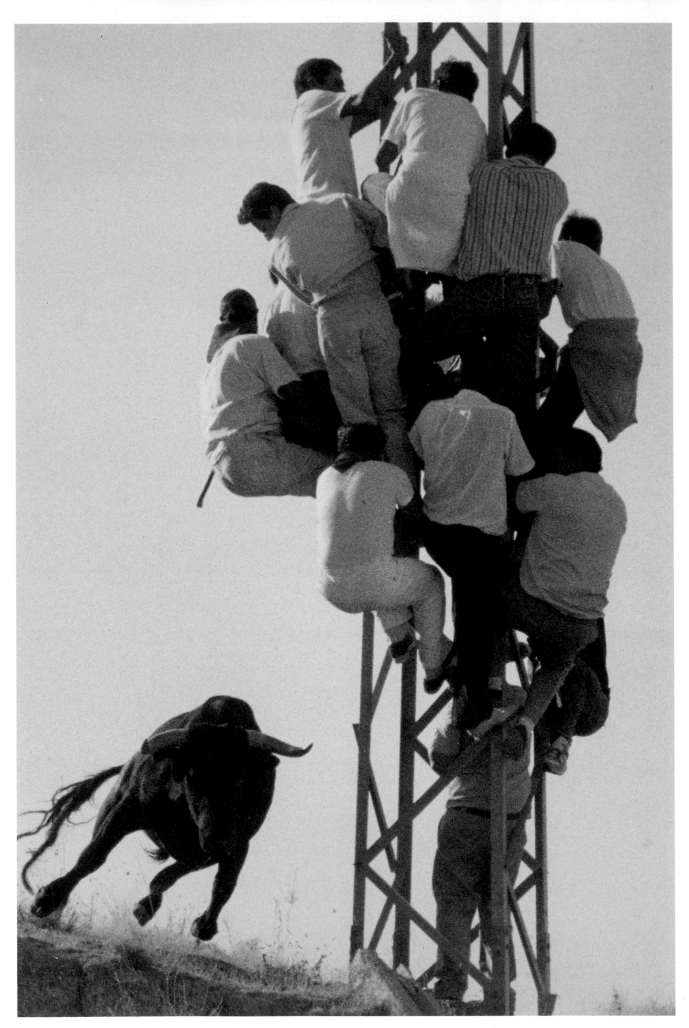

Paul Hanna, Reuters News Pictures
Would-be matadors take refuge during the running of the bulls in Segovia, Spain.

NEWSPAPER FEATURES

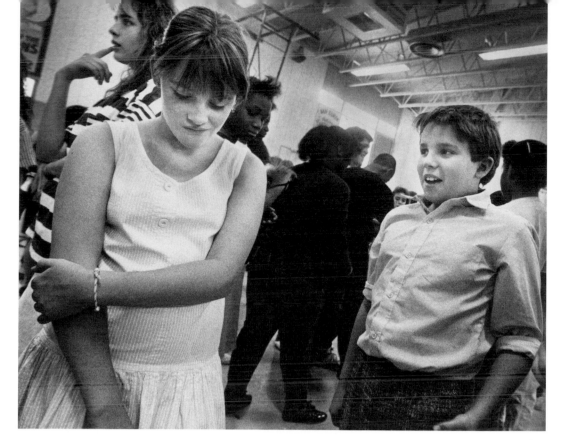

3RD PLACE
Pat Davison, The Pittsburgh Press
Johnny MacAuliffe finally summons up the courage to ask Bonnie Robertson to dance.
Although Bonnie seemed unsure, the two were "going steady" by evening's end.

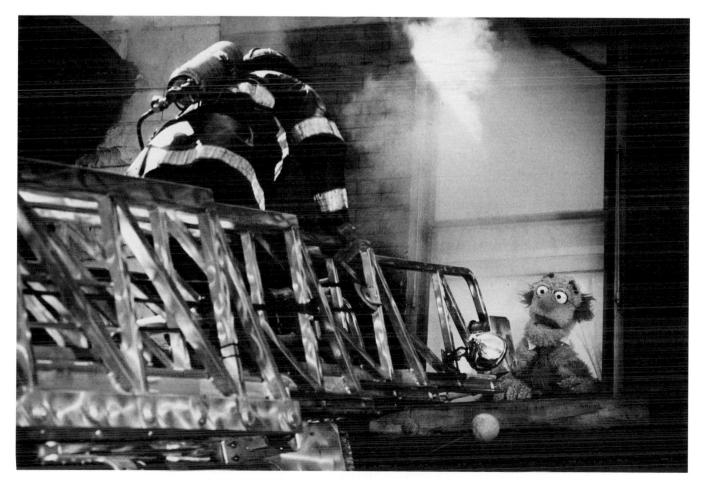

AWARD OF EXCELLENCE
Gerald P. McCrea, The Newark (N.J.) Star-Ledger
Newark, N.J., firefighter Raymond Carriere rescues a *Sesame Street* character during taping of a fire-safety video.

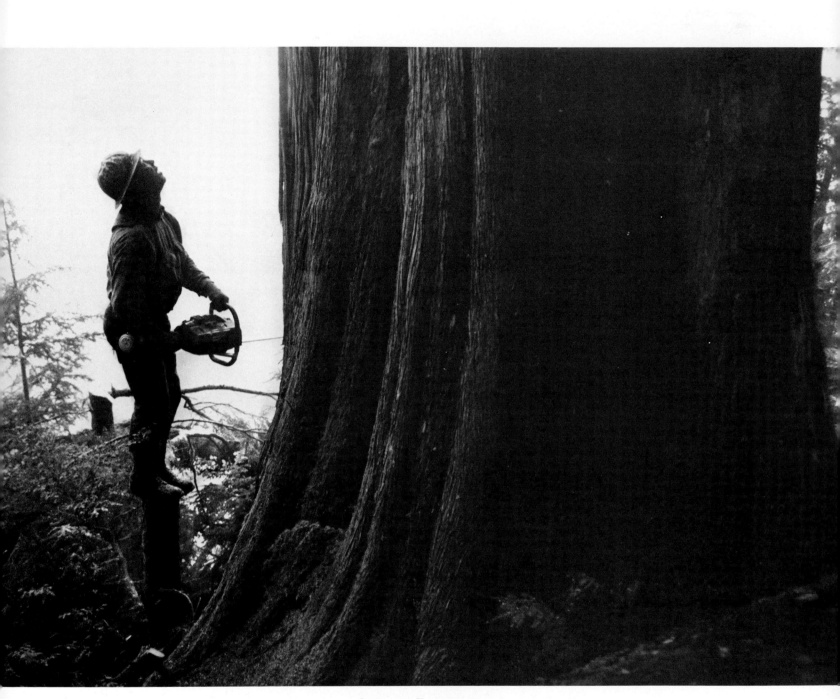

AWARD OF EXCELLENCE
Tom Reese, The Seattle Times
Lumberjack Stan Christie eyeballs a 500-year-old cedar in the Olympic National Forest, deciding where to make his cut.

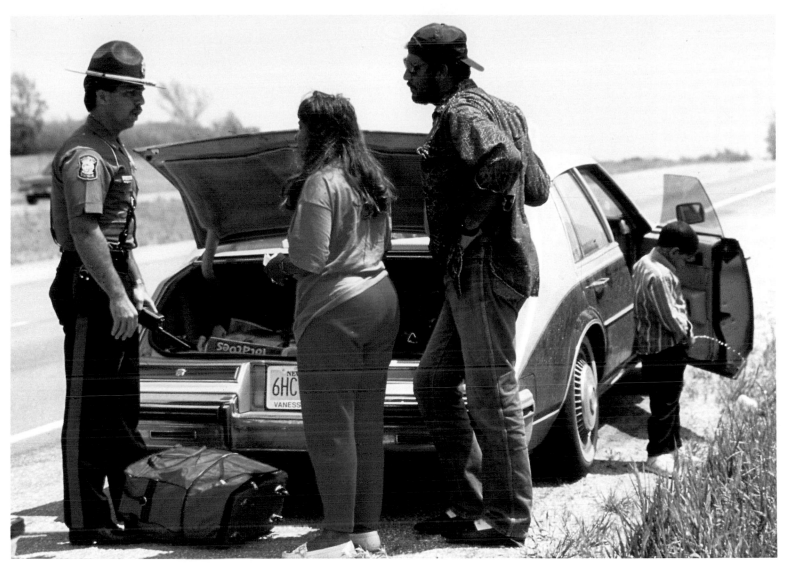

AWARD OF EXCELLENCE
Earl Richardson, Topeka (Kan.) Capital-Journal
A young boy makes a pit stop while a Kansas Highway Patrol officer talks with the driver of the car he pulled over.

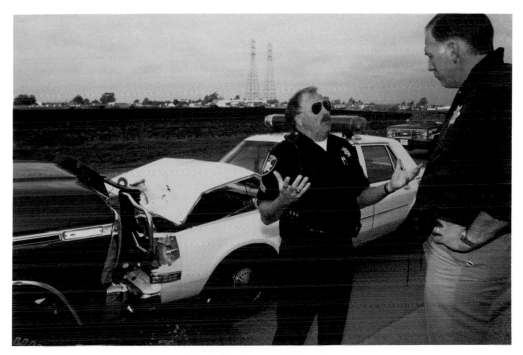

AWARD OF EXCELLENCE
Richard D. Green, Salinas Californian
Salinas police Cpl. Don Watkins explains to Lt. Larry Myers that it wasn't his fault his
car hit a stolen truck head-on during a chase.

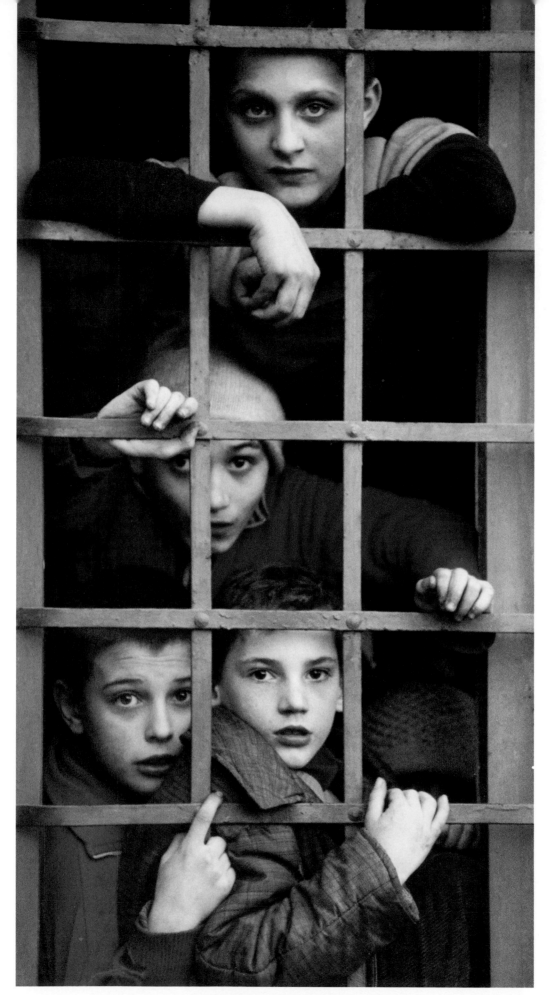

AWARD OF EXCELLENCE
James Skovmand, The San Diego Union-Tribune
Boys look out an orphanage window in Cadea, Romania.

NEWSPAPER FEATURES

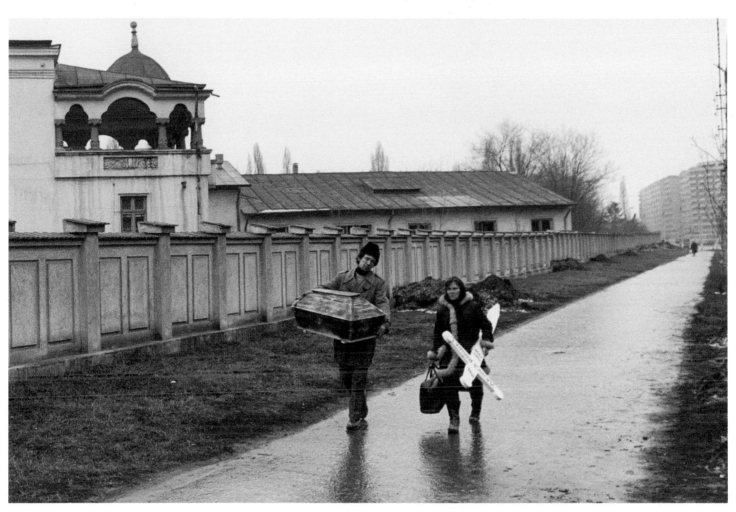

Rady Sighiti, Reuters News Pictures
Romanian parents carry a coffin and cross to a Bucharest hospital to collect the body
of their child, who died of an AIDS-related illness.

Julie Rogers, free-lance
A blond American girl catches the interest of residents in Seoul.

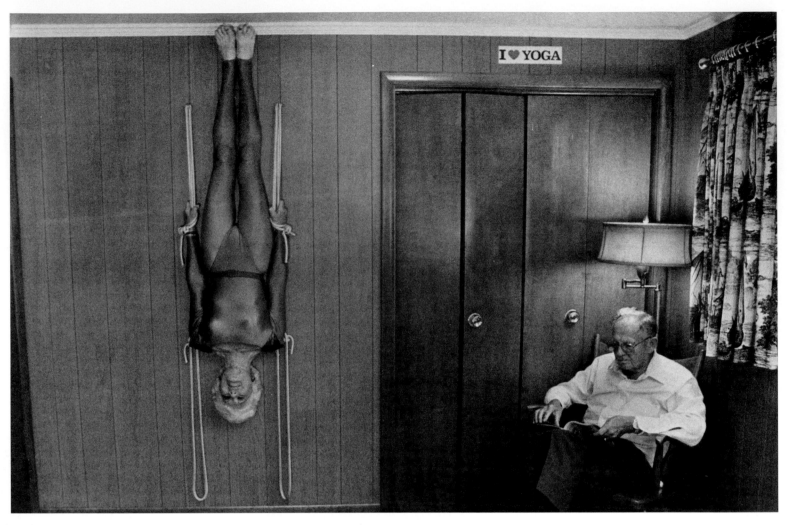

AWARD OF EXCELLENCE
Al Podgorski, Chicago Sun Times
Faith Brandon practices yoga by hanging upside down from ropes.

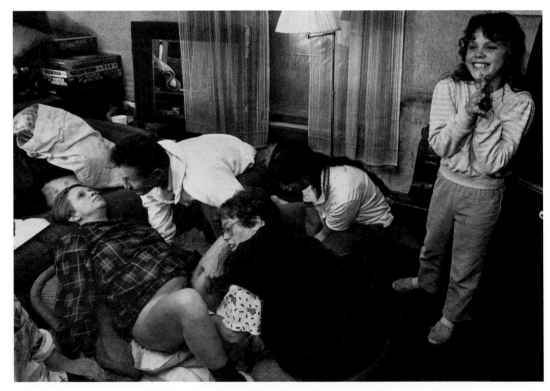

AWARD OF EXCELLENCE
Kent Meireis, The Denver Post
Ali Koen, 8, reacts to the birth of her brother at their Kansas farmhouse.

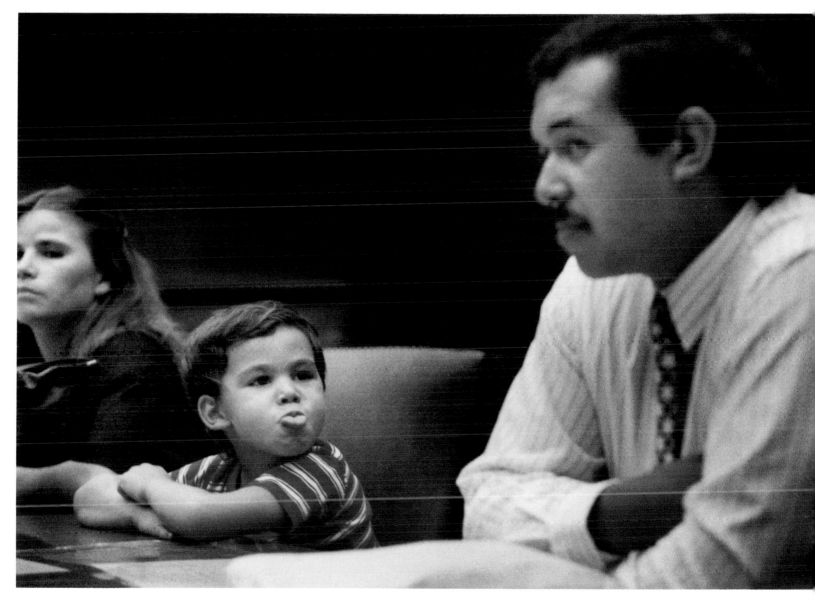

David Schreiber, The Torrance (Calif.) Daily Breeze
Anthony Jones, 4, defiantly sticks out his tongue at his father, Artie, after a Torrance Family Court judge awarded an extra weekend of custody to his mother, Lee Ann.

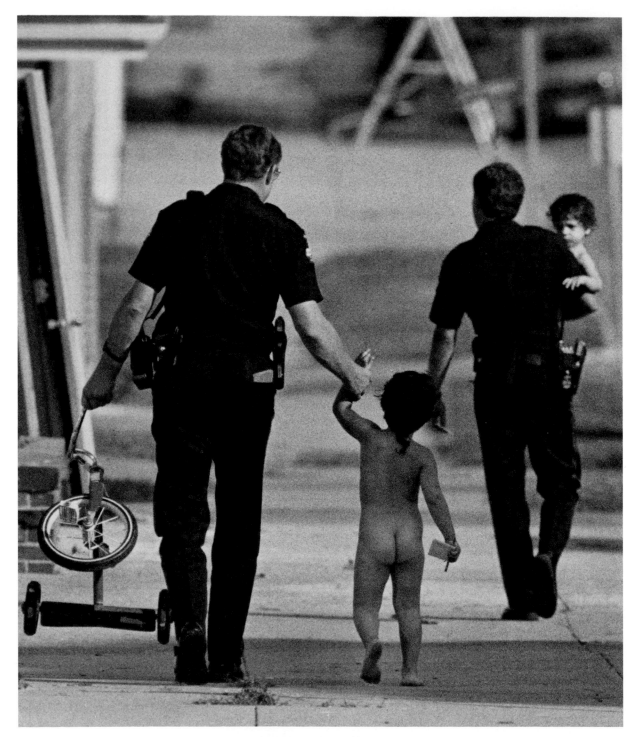

AWARD OF EXCELLENCE
Shaun Zimmerman, Jefferson City (Mo.) News and Tribune
Dad had gone to work and Mom was still in bed when these two tots went out to play. When officers responded to a call from neighbors, they found one child riding the tricycle and the other scribbling on a pad, issuing "tickets."

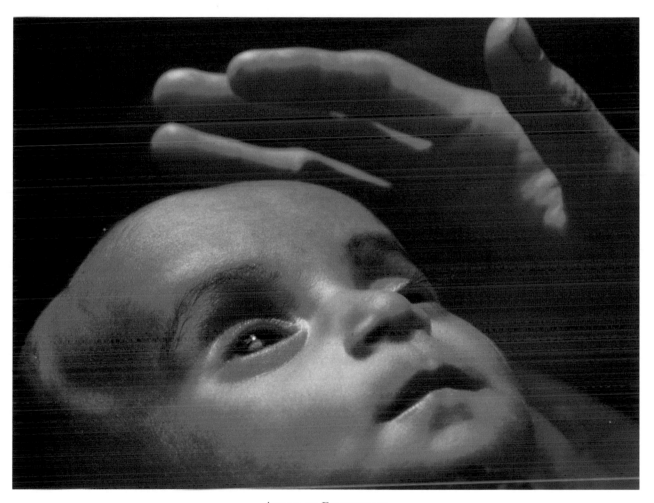

Award of Excellence
John Chiasson, Gamma Liaison for Time
At the International Center for Diarrheal Research in Bangladesh, a baby is near death from pneumonia.

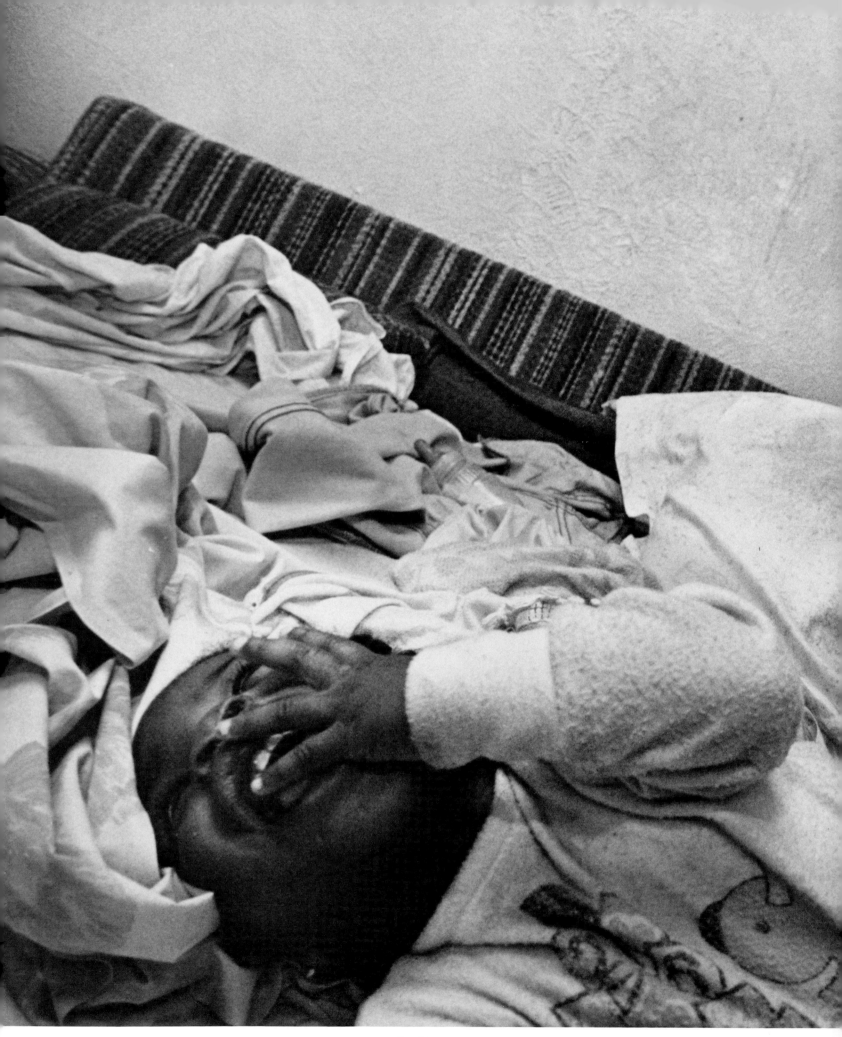

Eugene Richards, Magnum
An addict smokes "crack" cocaine, ignoring the cries of her 1-year-old child.

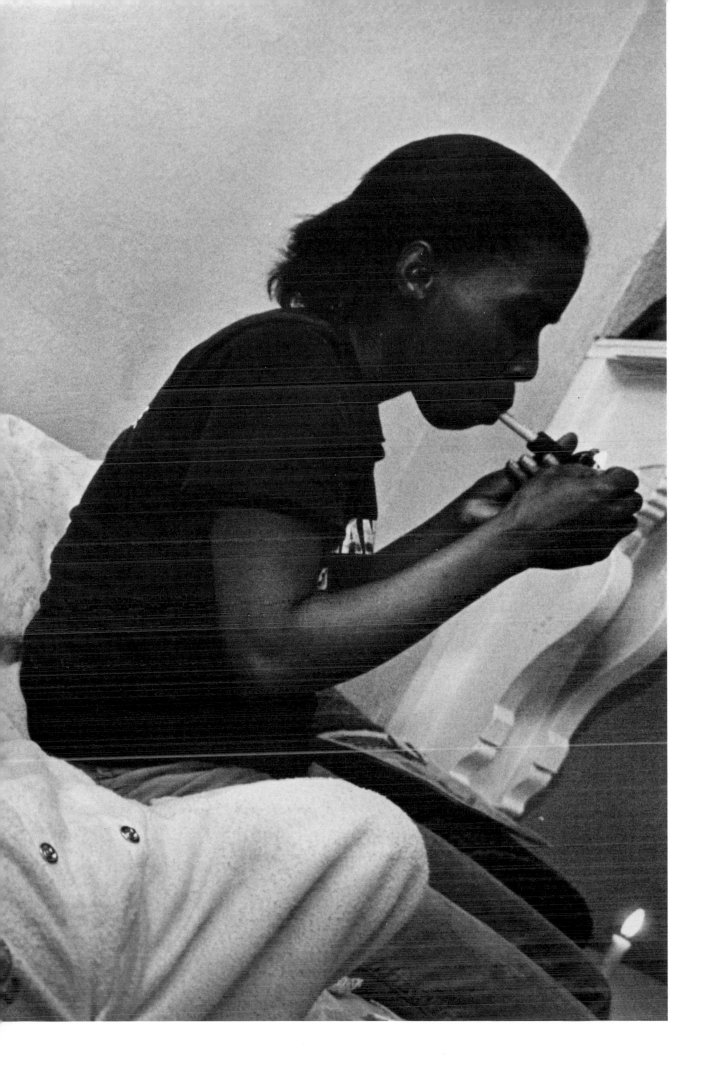

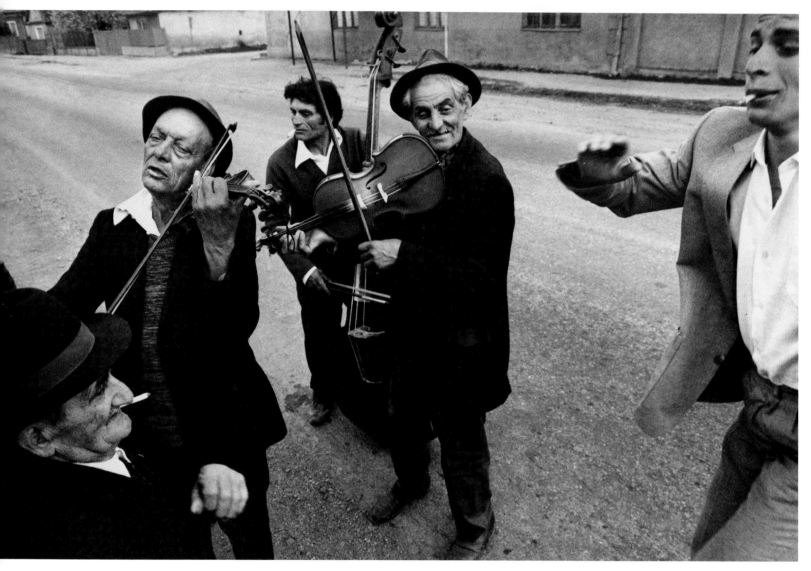

4TH PLACE
Anthony Suau, Black Star for Time
A three-piece band performs on a Romanian street on Easter.

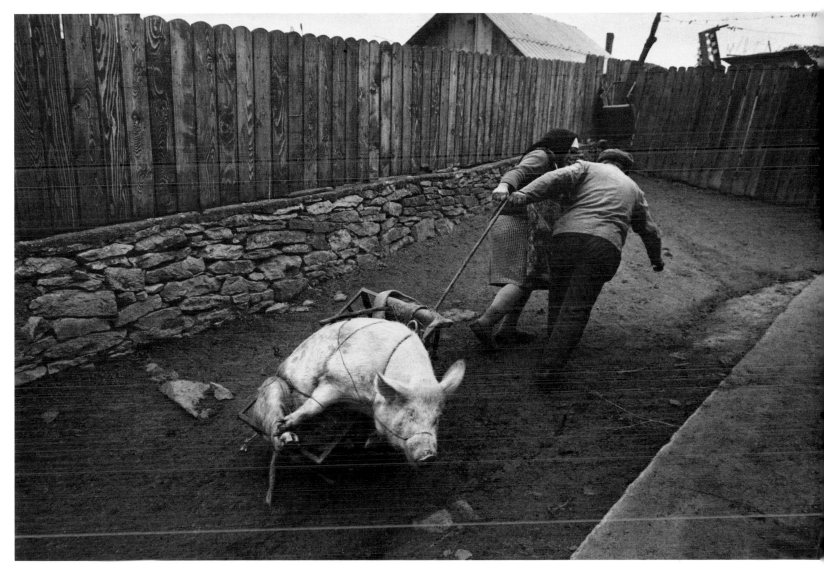

Anthony Suau, Black Star for Time
A Romanian couple haul their pig to a neighbor's farm for breeding.

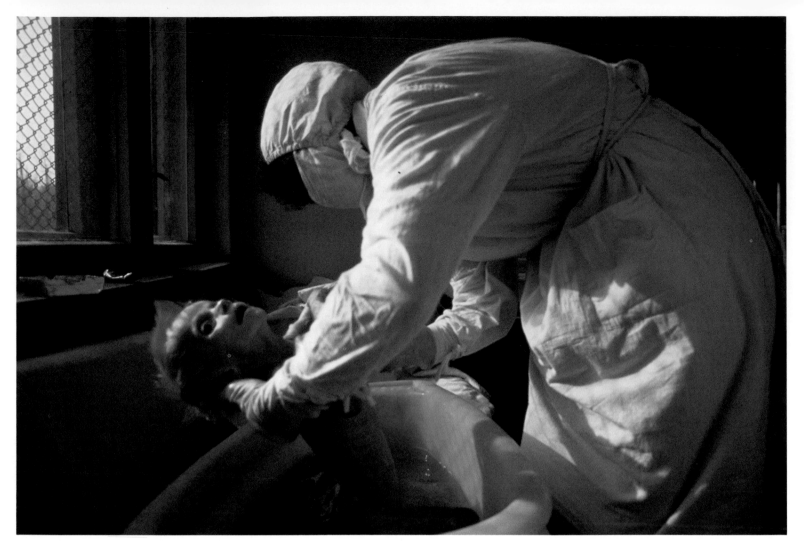

AWARD OF EXCELLENCE
Bernard Bisson, Sygma
A baby with AIDS is treated in Romania.

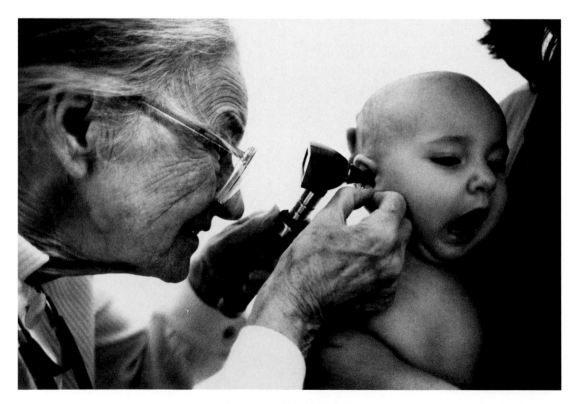

AWARD OF EXCELLENCE
Jerry Valente, Power to Heal
Dr. Leila Denmark, born in 1898, examines Rebekah De Avila. Dr. Denmark was the third
woman to graduate from the Medical College of Georgia, in 1928.

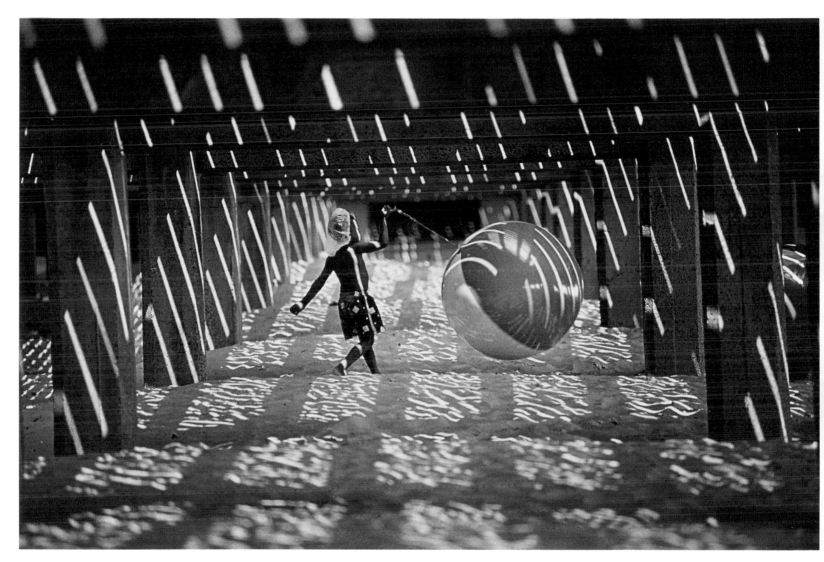

AWARD OF EXCELLENCE
Kenneth Jarecke, Contact Press Images
Under the boardwalk at Coney Island.

Following page:
3RD PLACE
Richard Kozak, Insight
Midshipmen at Annapolis
Naval Academy.

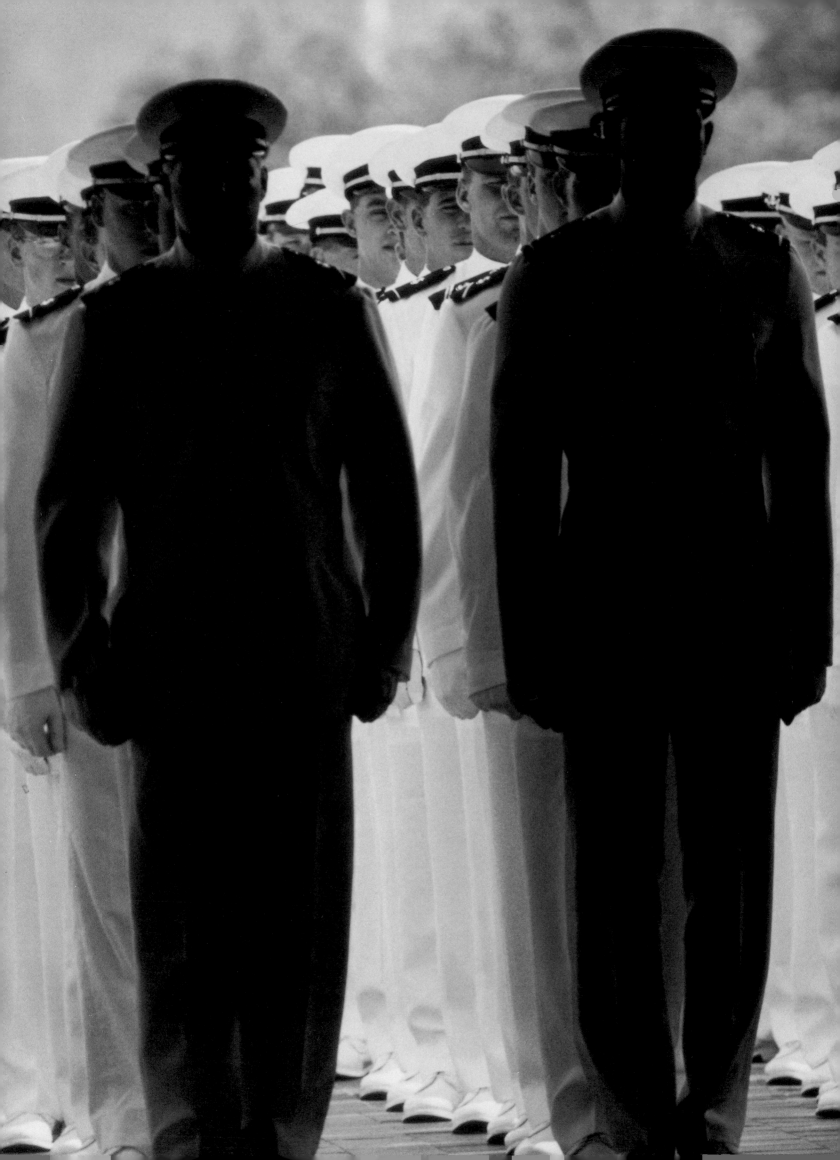

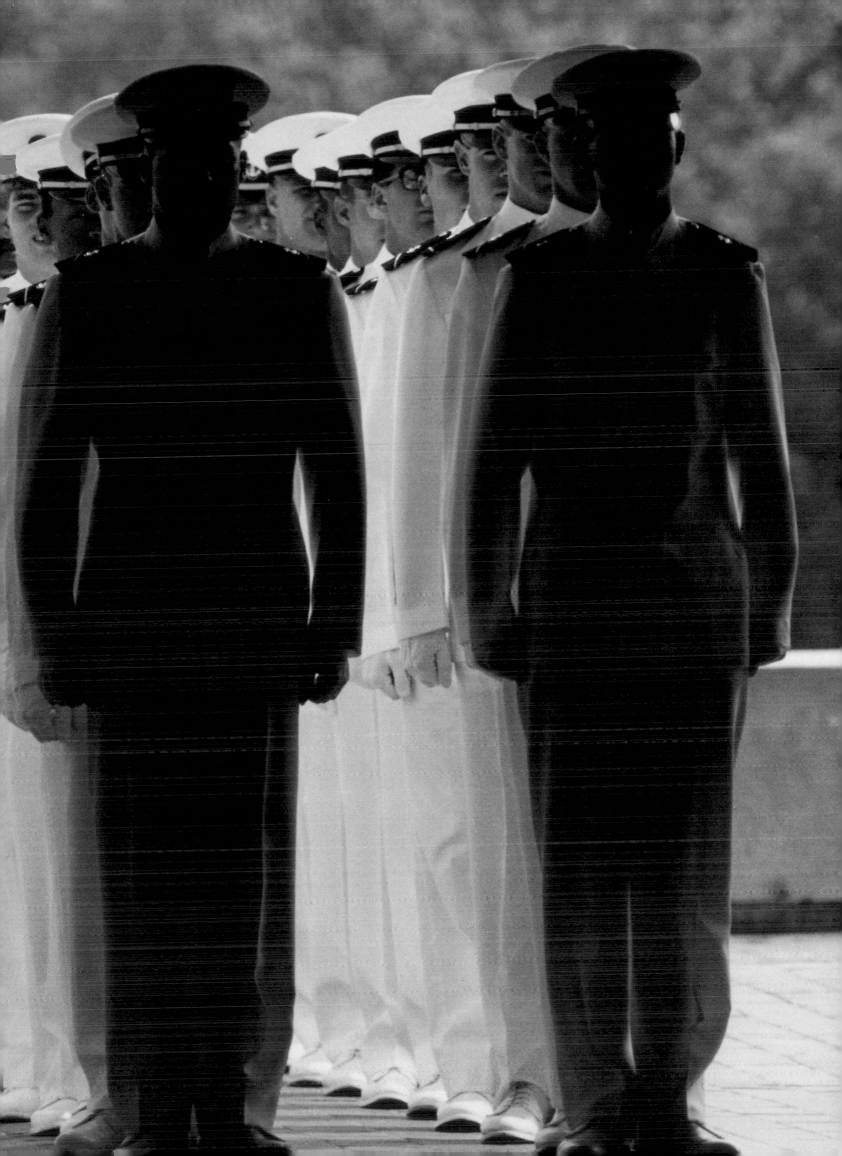

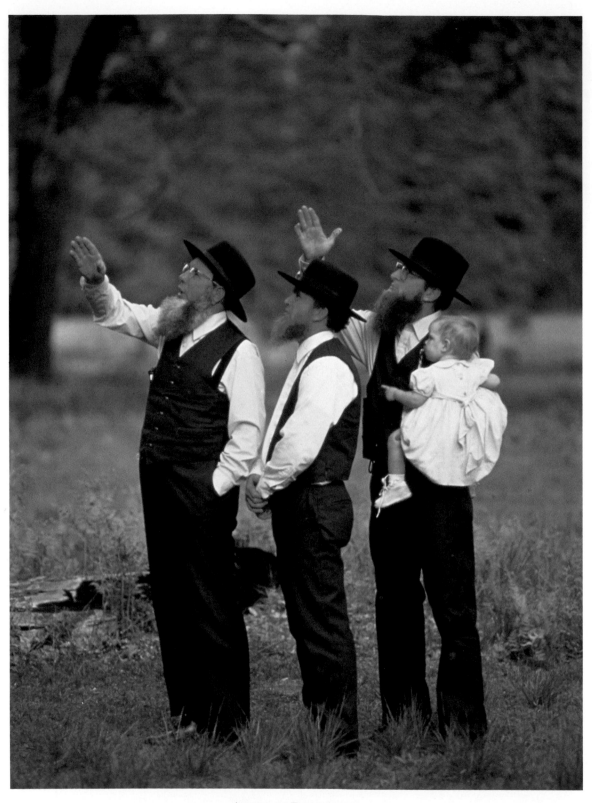

AWARD OF EXCELLENCE
Jay B. Mather, The Sacramento Bee
German Baptists from Pennsylvania marvel at the grandeur of Yosemite National Park.

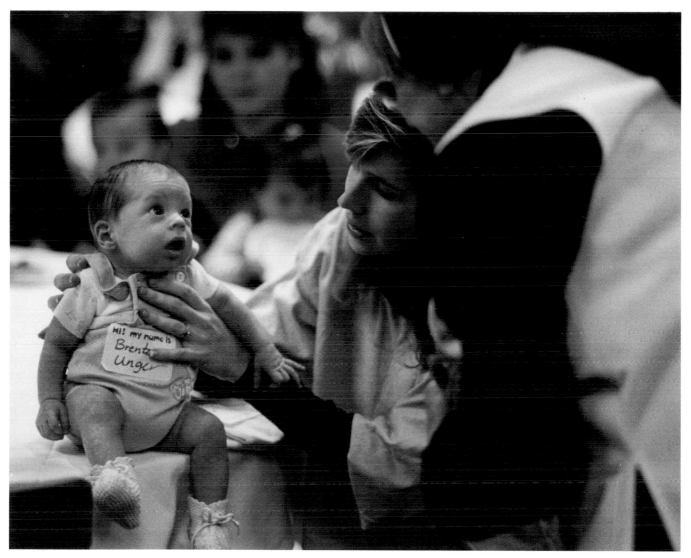

1ST PLACE
Peggy Peattie, Long Beach (Calif.) Press-Telegram
One-month-old Brenton Unger attends a reunion for babies cared for in St. Mary Medical Center's Neonatal Intensive Care Unit. Brenton developed a mild illness after birth, but recovered.

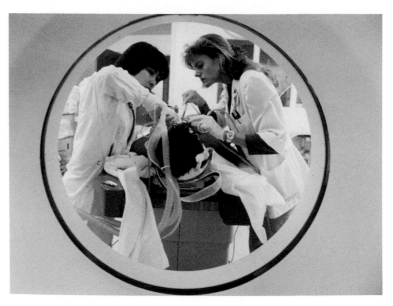

Emergency-room personnel prepare a patient for a CAT scan.

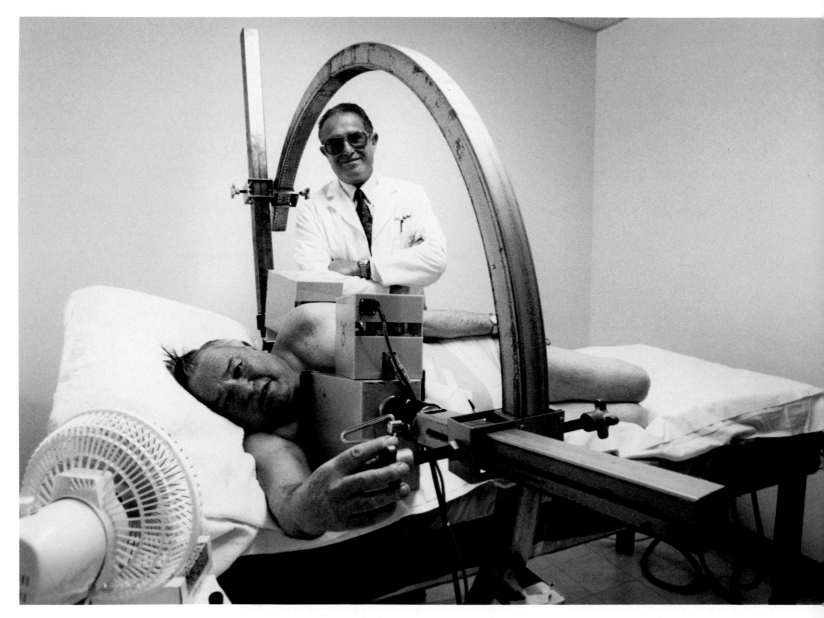

Frank Eller undergoes an experimental treatment for cancer devised by Dr. Haim Bicher (standing).

Peggy Peattie, Long Beach (Calif.) Press-Telegram

1ST PLACE, NEWSPAPER ONE WEEK'S WORK

M.C. Hammer performs at Long Beach Arena.

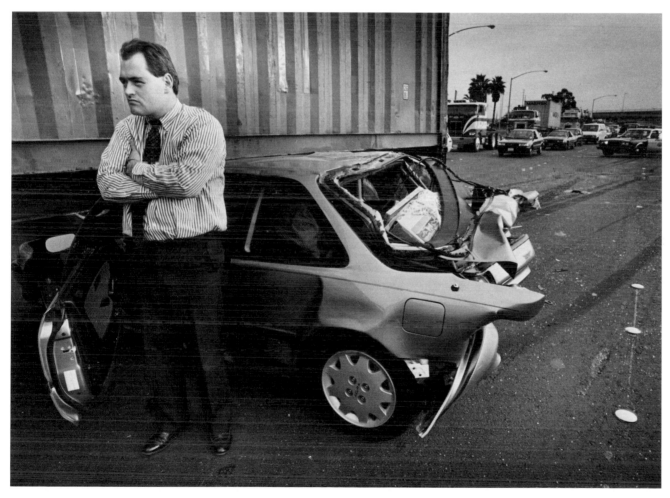

Bart Forrest of Tustin, Calif., waits for a tow truck to dislodge his car from underneath a truck on the Long Beach Freeway. Forrest's car was sideswiped, forcing it into the truck.

Peggy Peattie, Long Beach (Calif.) Press-Telegram
1ST PLACE, NEWSPAPER ONE WEEK'S WORK

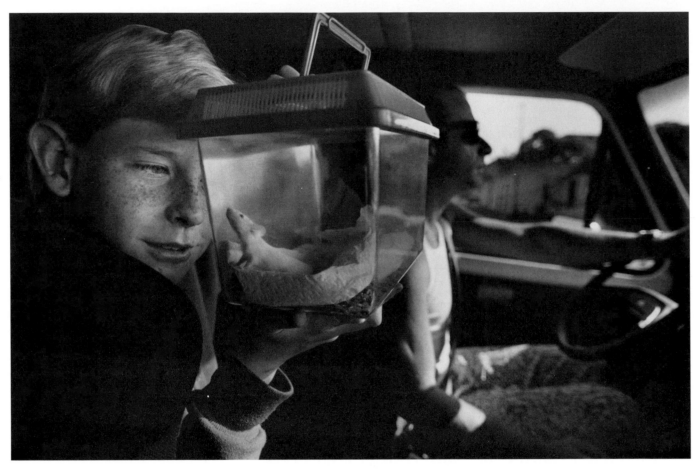

Stephen Schwartz, 12, gets friendly with a mouse he and Craig Jones (driving) bought to feed to Jones' boa constrictor. Jones spends time with Stephen as part of the Big Brother program.

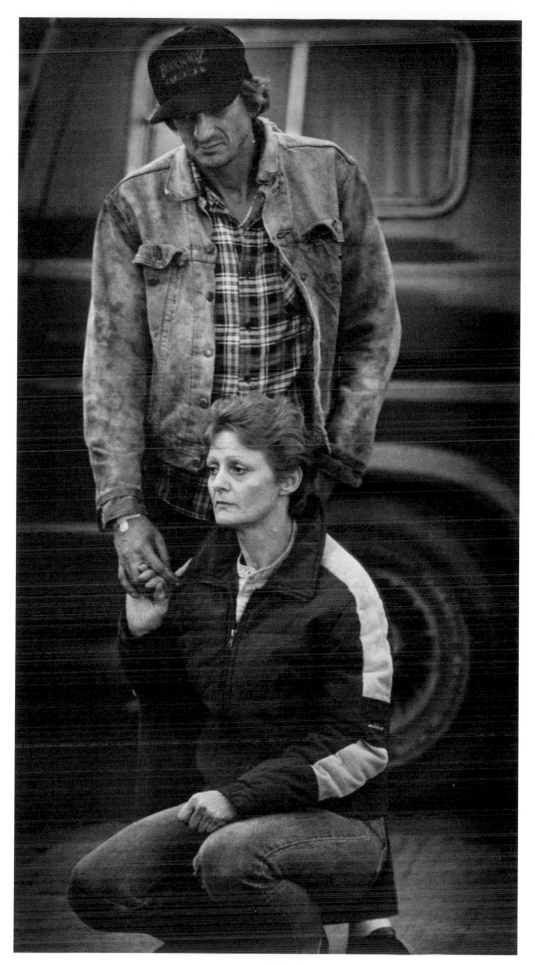

2ND PLACE
Peggy Peattie, Long Beach (Calif.) Press-Telegram
A homeless couple in Wilmington, Calif.

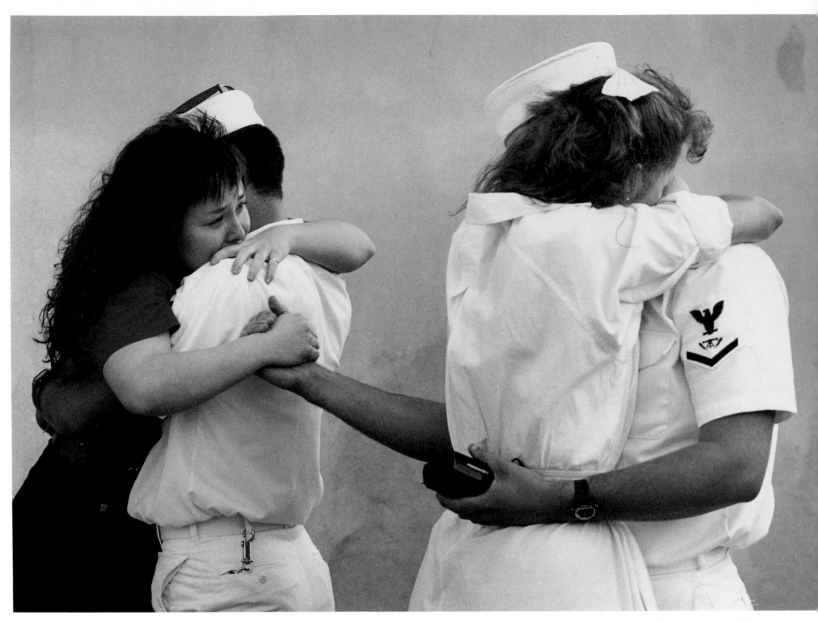

Friends and lovers say goodbye moments before the USS Missouri heads for duty in the Persian Gulf.

Cambodian Savoeur Sy and her daughter, Sandra Seang, share a small apartment with six other relatives.

Wheelchair racers crest the Queensway Bridge during a half-marathon in Long Beach.

Peggy Peattie, Long Beach (Calif.) Press-Telegram

2ND PLACE, NEWSPAPER ONE WEEK'S WORK

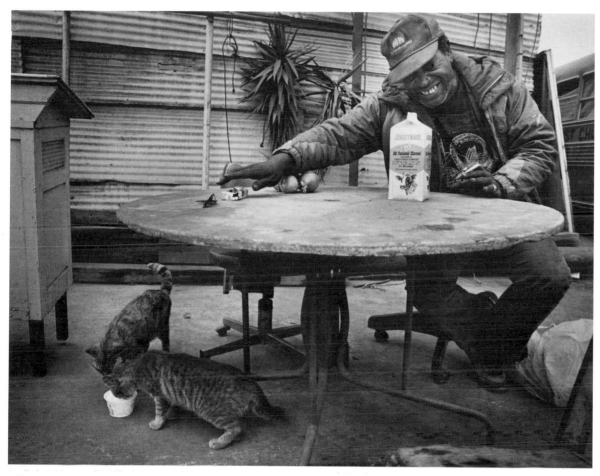

George, a resident of a small community along the railroad tracks near Wilmington, Calif., grimaces from the pain of a broken rib as he reaches for cigarettes.

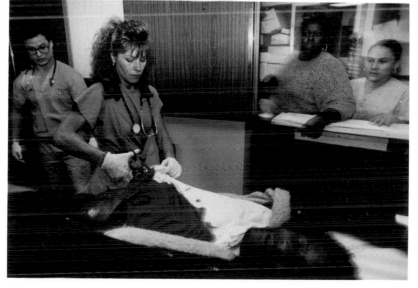

Trauma nurse Patty Tomich starts working on a gunshot victim as he is wheeled down the hall of St. Mary Medical Center.

Peggy Peattie, Long Beach (Calif.) Press-Telegram

2ND PLACE, NEWSPAPER ONE WEEK'S WORK

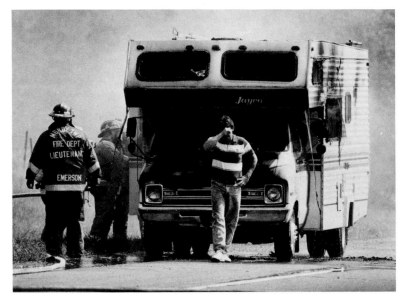

A driver turns his back on the sight of his fire-gutted recreational vehicle, as Mundy Township firefighters extinguish the blaze.

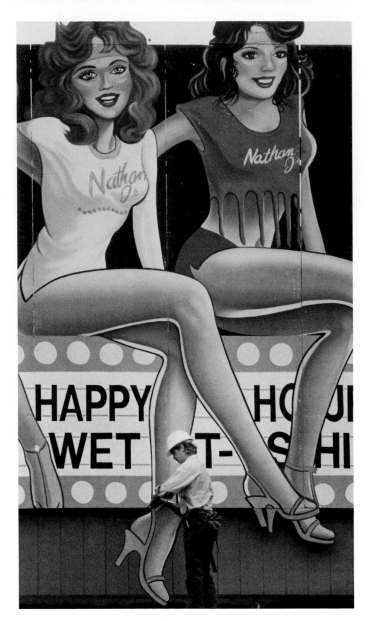

A Gannett Outdoors Co. employee does some leg work on a billboard in Flint.

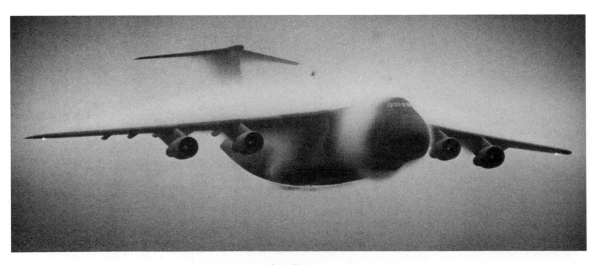

3RD PLACE
Jack Gruber, The Flint (Mich.) Journal
An Air Force C-5A Galaxy transport drops out of low clouds at the Muskegon, Mich., Air Show.

Joe Carpenter, 10, takes off his socks to ease the blisters on his feet after marching in Young Marine drills. Watching is a friend, Nicky Headrick, who came along with others to pick up the boys after a week's session at the camp.

Teenager Kelly Brimms, after missing a putt that would have made her the winner of the girl's division at the Flint Jr. Golf Tournament.

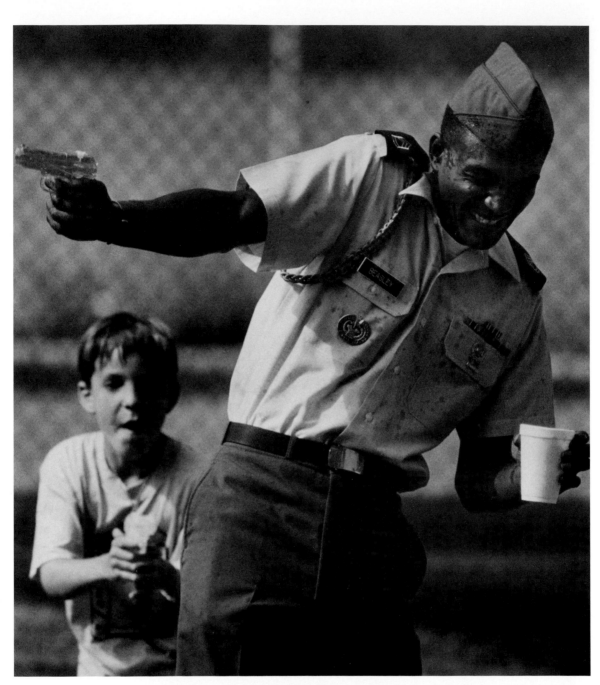

Army Reserve Sgt. Vernon Beasley gets hit by "hostile" water-gun fire from a Flint Boy Scout. The Scouts attended a day camp at the reserve unit.

Jack Gruber, The Flint (Mich.) Journal

3RD PLACE, NEWSPAPER ONE WEEK'S WORK

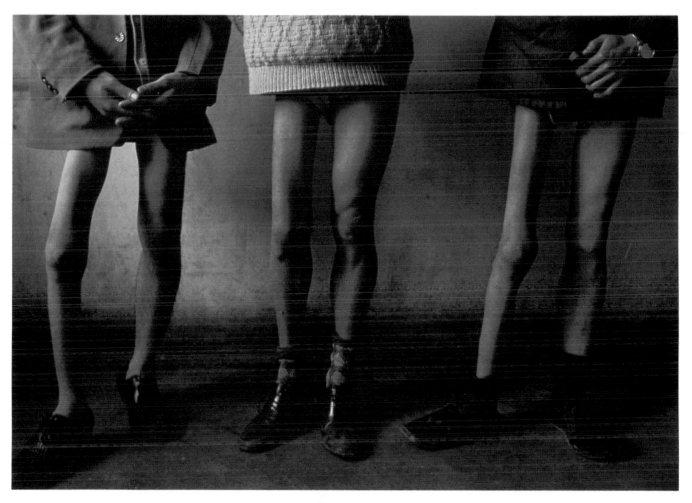

2ND PLACE
Rob Kendrick, free-lance
Polio victims at Binzhou Medical College in China.

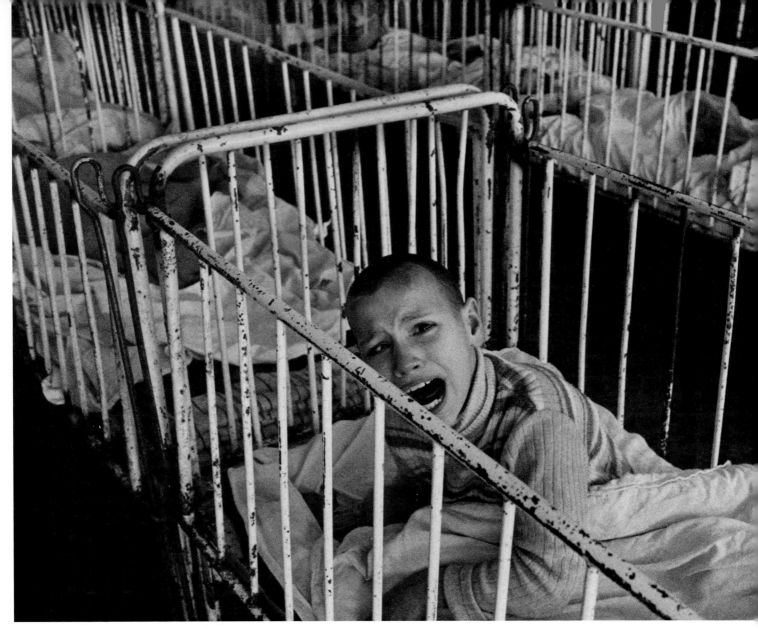

1ST PLACE
James Nachtwey, Magnum for The New York Times Magazine
An "irrecoverably" mentally ill boy is confined to a crib in Romania.

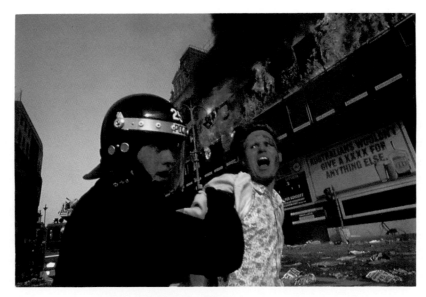

AWARD OF EXCELLENCE
Christopher Morris, Black Star for Time
A protester is led away during a poll-tax riot in London.

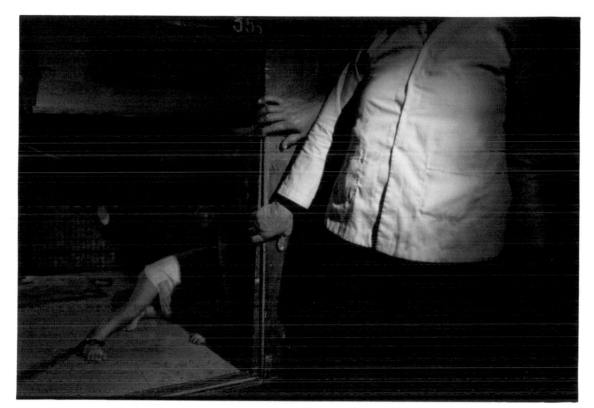

AWARD OF EXCELLENCE
Jodi Cobb, National Geographic
A child is chained to his bunk to keep him from wandering off at a camp for Vietnamese
boat people in Hong Kong.

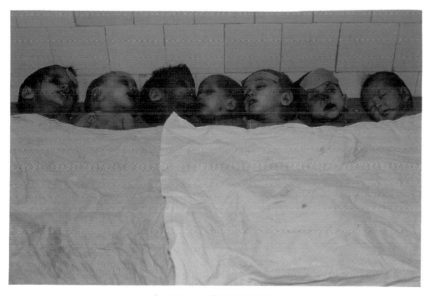

AWARD OF EXCELLENCE
Frank Fournier, Contact Press Images
The bodies of AIDS victims lie unclaimed at a hospital in Romania.

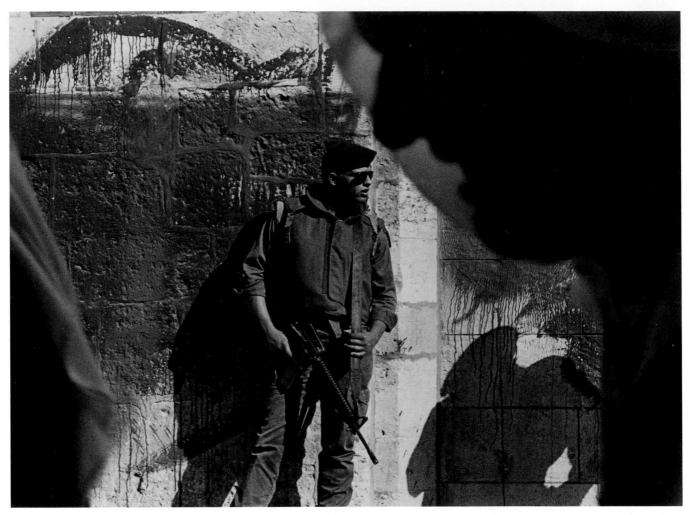

3RD PLACE
David H. Wells, JB Pictures
An Israeli soldier stands watch in the Old City of Jerusalem.

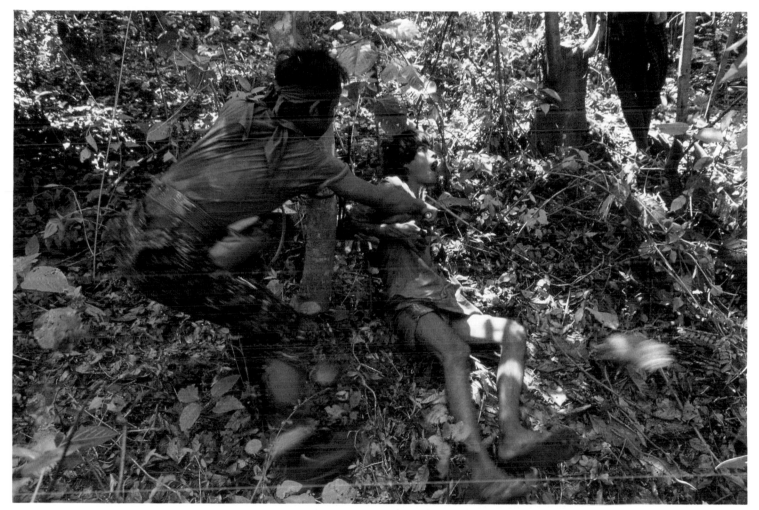

AWARD OF EXCELLENCE
Bruce Haley, Black Star for U.S. News & World Report
A rebel with the Karen National Liberation Army executes a man suspected of collaborating with the government in Burma.

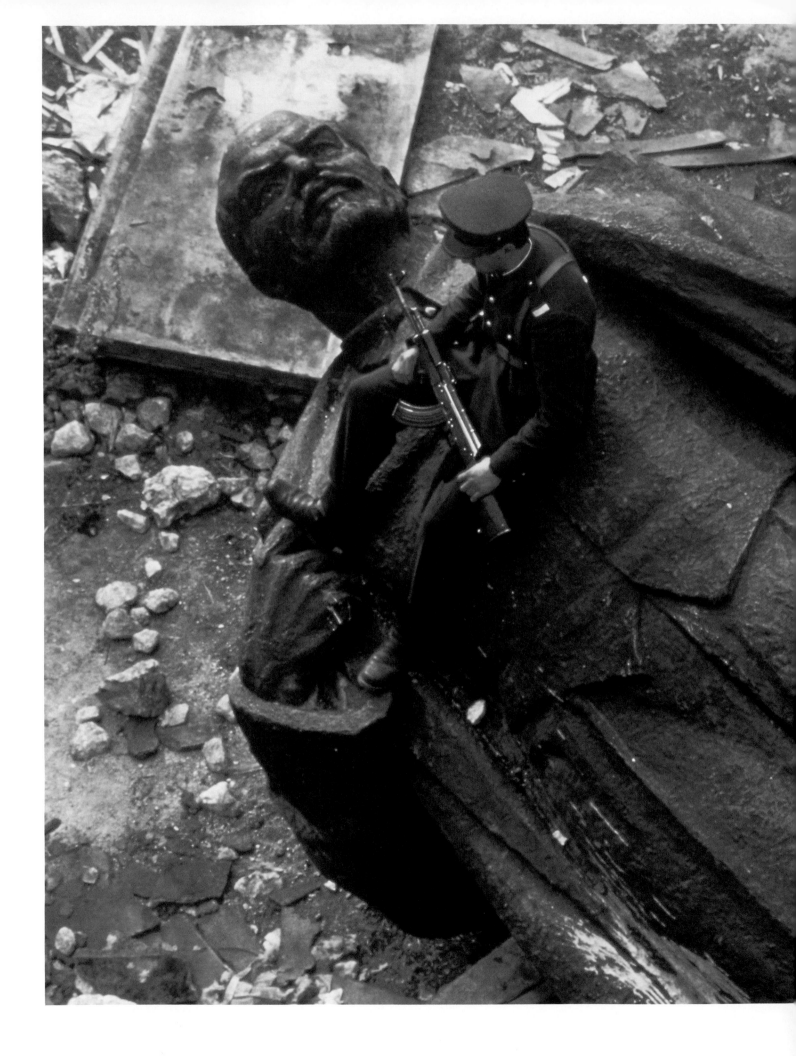

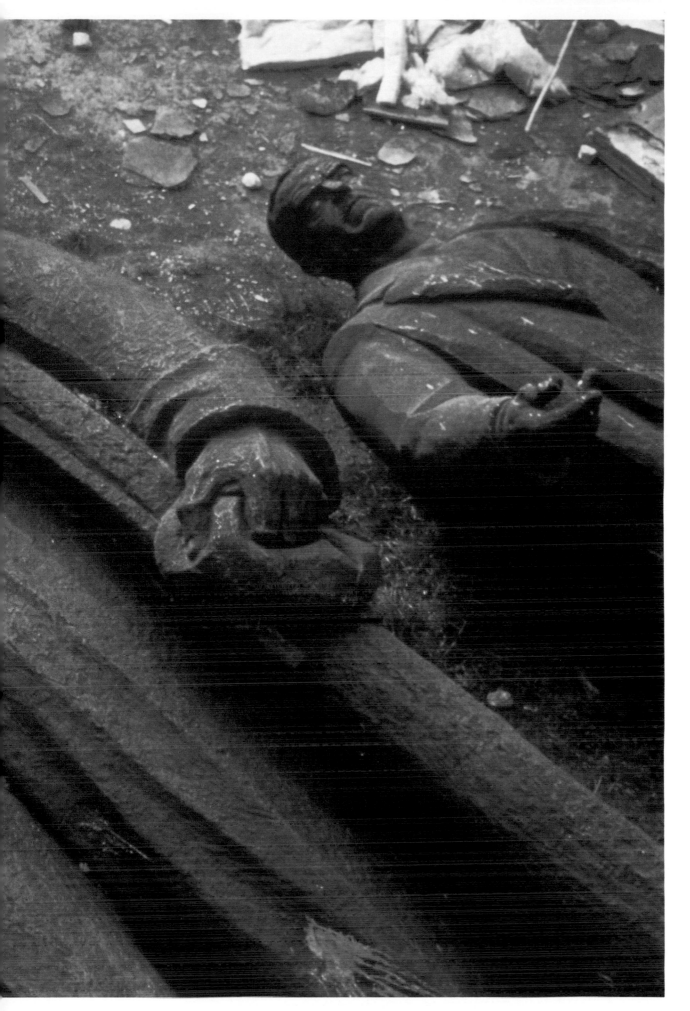

AWARD OF EXCELLENCE
Gad Gross, JB Pictures
A statue of Lenin is taken down in Bucharest, Romania.

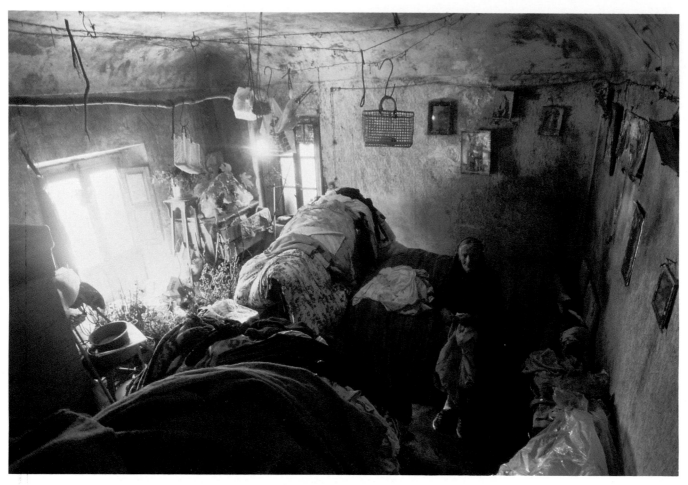

Jerry Valente, A Day in the Life of Italy, Collins Publishing
Maria Carmina Iaconelli, born in 1900, lives alone in the town of San Biagio Saracinisco, Italy.

2ND PLACE

Timothy Barmann, The Providence (R.I.) Journal

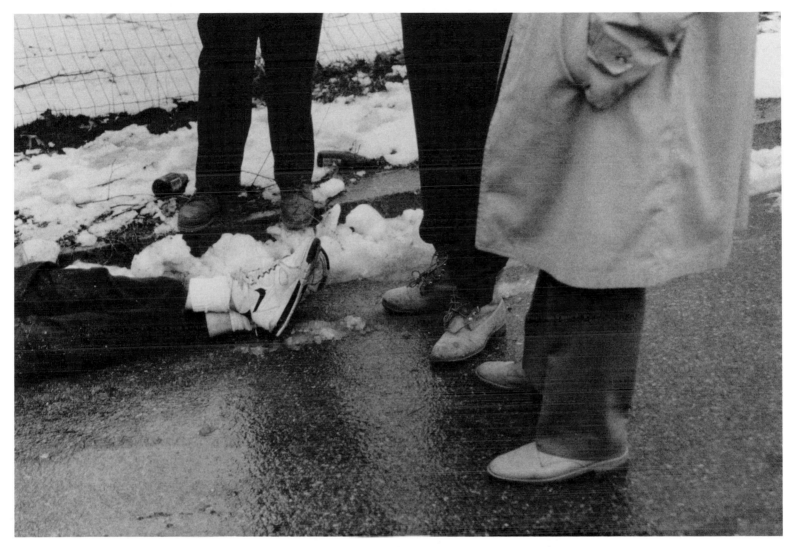

Providence homicide detectives surround the body of Michael LaFlame, 25, the city's first homicide of the year.

FIRST PLACE IN THIS CATEGORY WENT TO PAUL KURODA
OF THE ORANGE COUNTY REGISTER. THIS STORY WAS PART OF HIS
NEWSPAPER PHOTOGRAPHER OF THE YEAR PORTFOLIO AND IS ON PAGES 27-36.

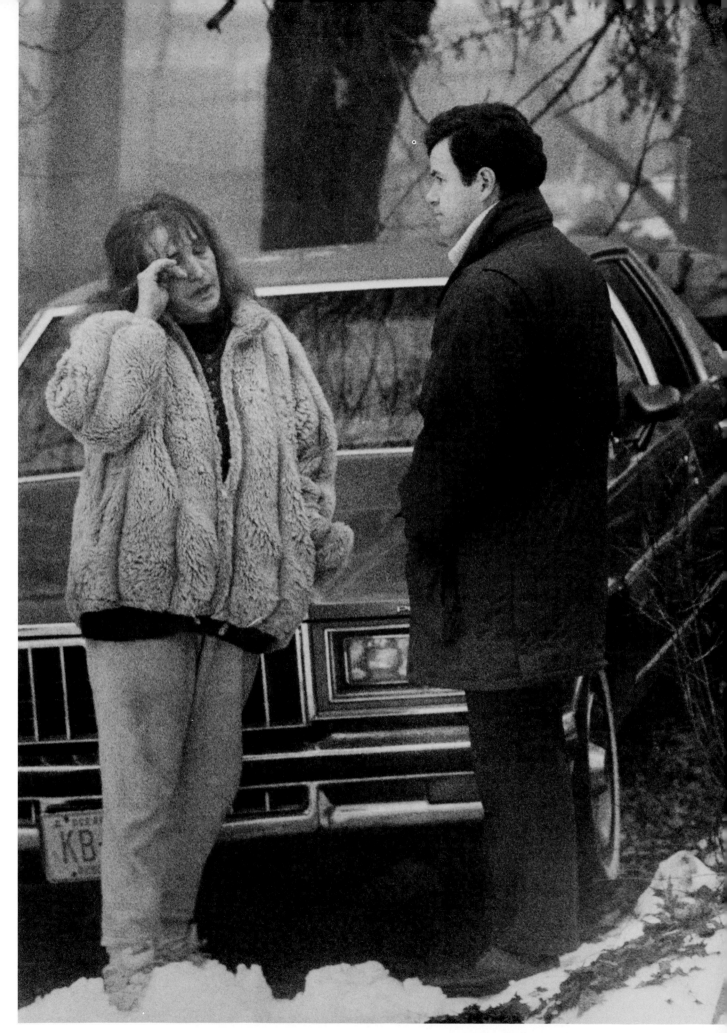

Helga Paige, who called the police about the slaying, talks to Detective Thomas Jacquard.

Timothy Barmann, The Providence (R.I.) Journal

2ND PLACE, NEWSPAPER NEWS PICTURE STORY

Timothy Barmann, The Providence (R.I.) Journal

2ND PLACE, NEWSPAPER NEWS PICTURE STORY

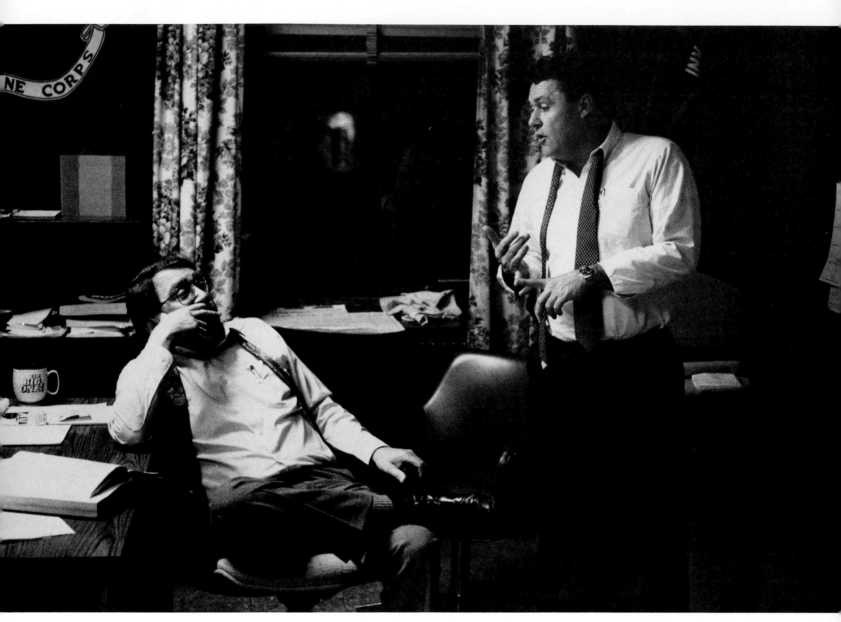

At the police station, Lt. Terrence Crawley (left) and Sgt. Bruckshaw, who are overseeing the case, discuss the investigation.

Timothy Barmann, The Providence (R.I.) Journal

2ND PLACE, NEWSPAPER NEWS PICTURE STORY

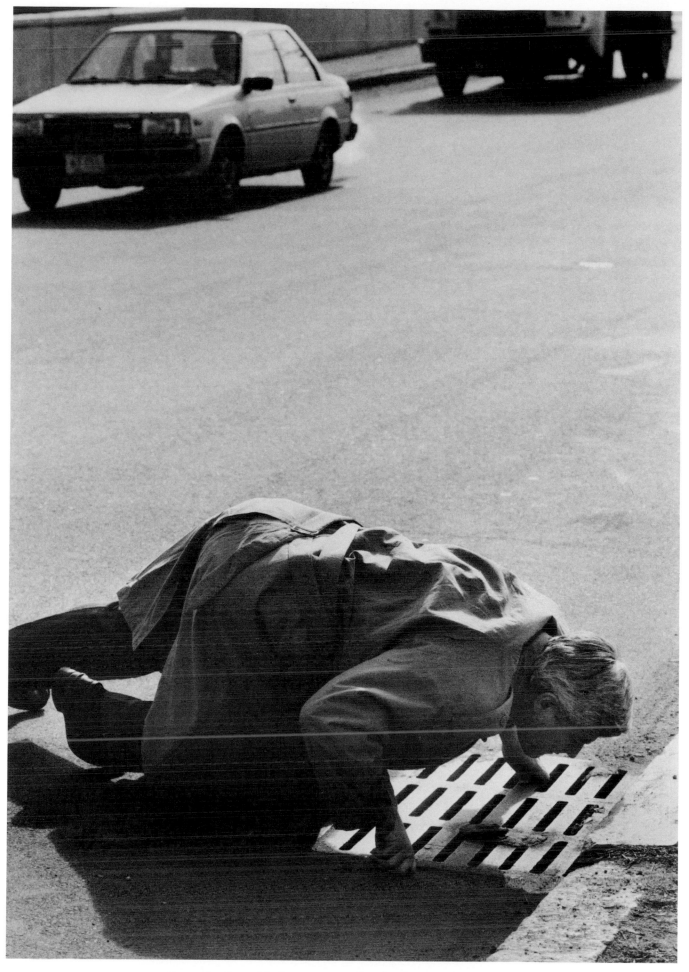

Detective Jerry McQueeney searches for the murder weapon.

Timothy Barmann, The Providence (R.I.) Journal

2ND PLACE, NEWSPAPER NEWS PICTURE STORY

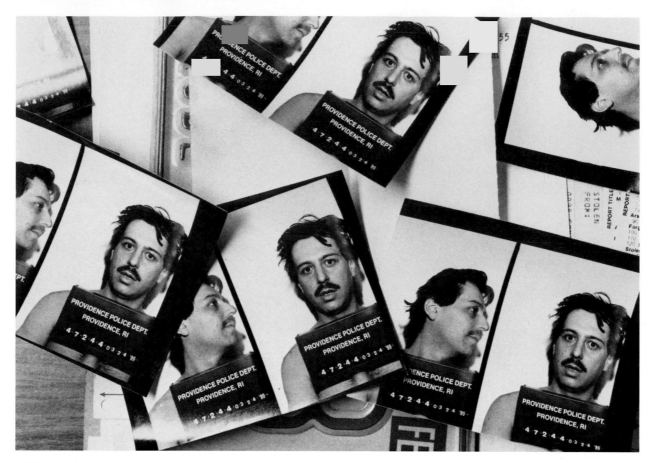

The suspect has a criminal record. His mug shot is printed for distribution. Armed with shotguns (below), McQueeney and other detectives leave the police station to search the suspect's apartment.

Timothy Barmann, The Providence (R.I.) Journal

2ND PLACE, NEWSPAPER NEWS PICTURE STORY

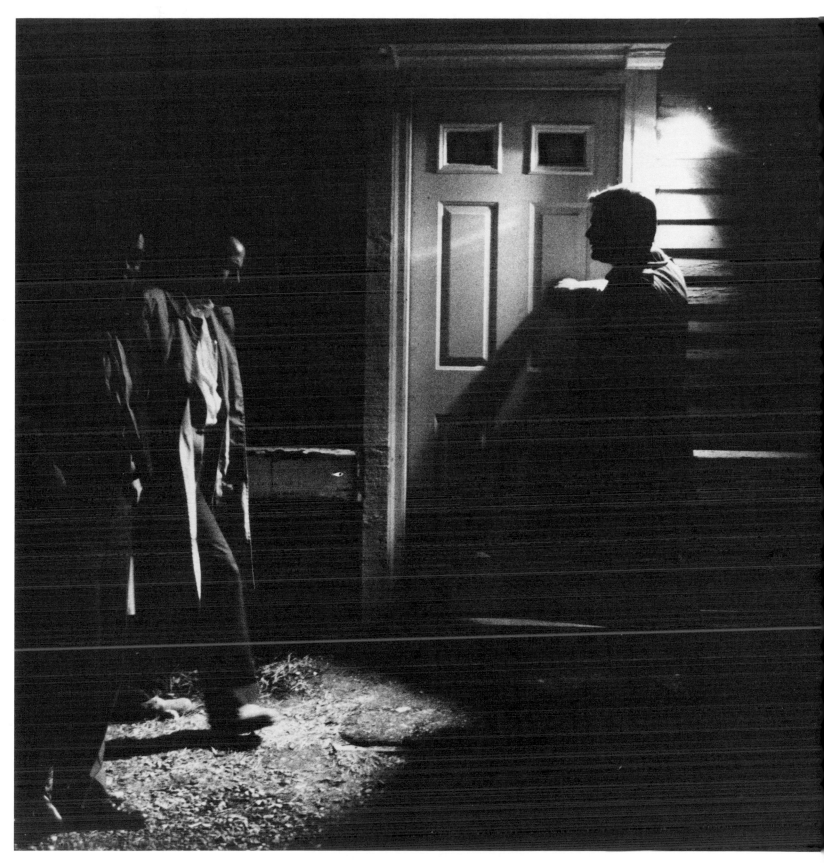

Bearing a search warrant, McQueeney knocks on the suspect's door.

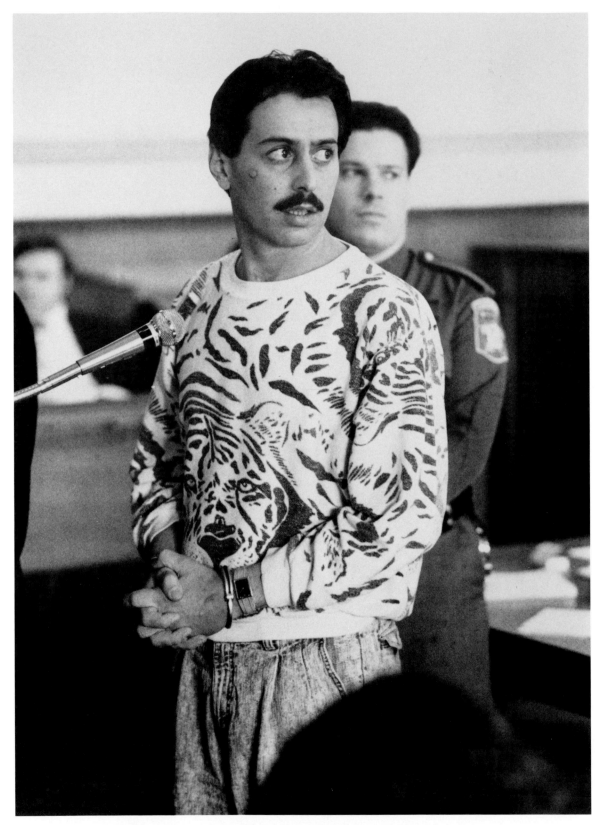

The suspect, James Hopp, is arraigned in court after his arrest.

Timothy Barmann, The Providence (R.I.) Journal

2ND PLACE, NEWSPAPER NEWS PICTURE STORY

3RD PLACE
Marc Halevi, Lawrence (Mass.) Eagle-Tribune

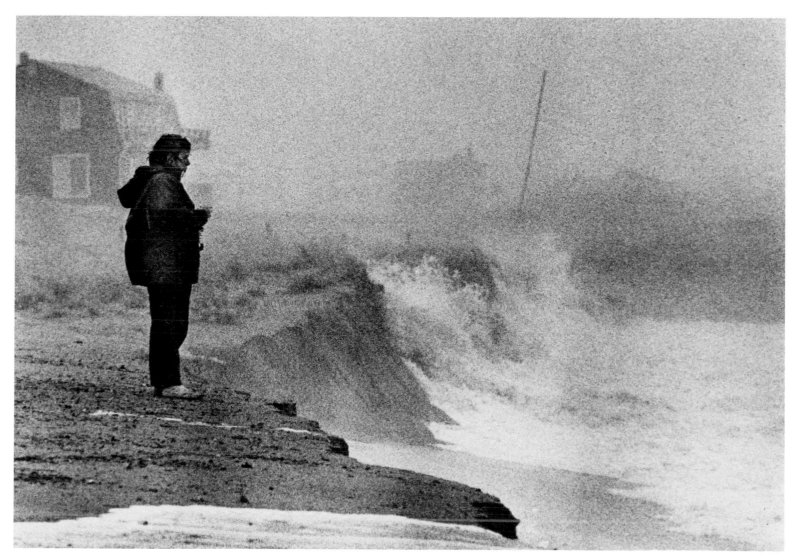

During a storm, Sandra Cook stands near the ocean at Plum Island, Mass., watching the tidal waves.

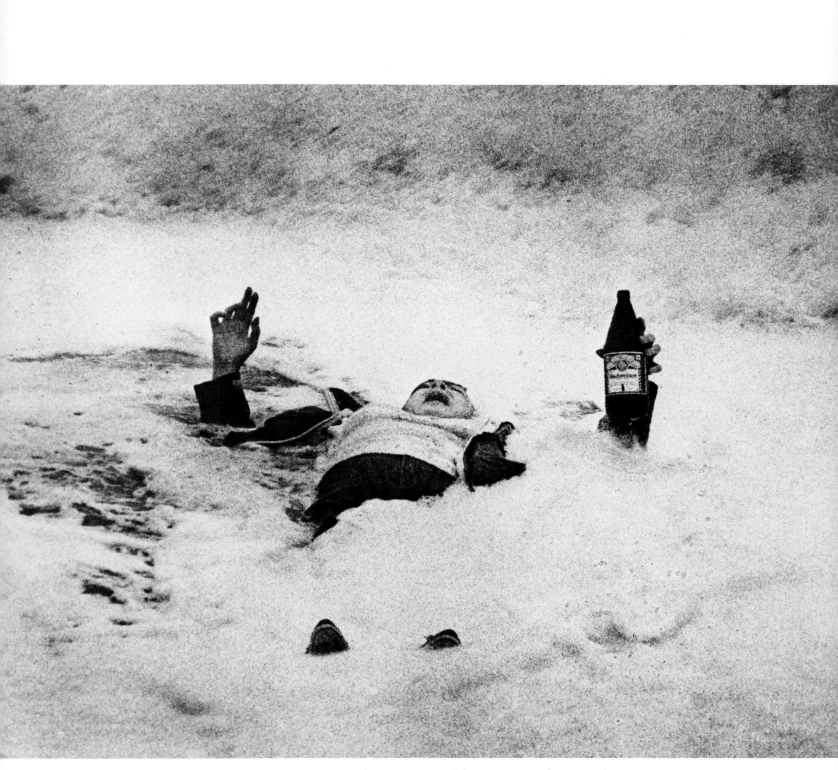

Knocked into the water by a wave, Cook lies momentarily stunned.

Marc Halevi, Lawrence (Mass.) Eagle-Tribune

3RD PLACE, NEWSPAPER NEWS PICTURE STORY

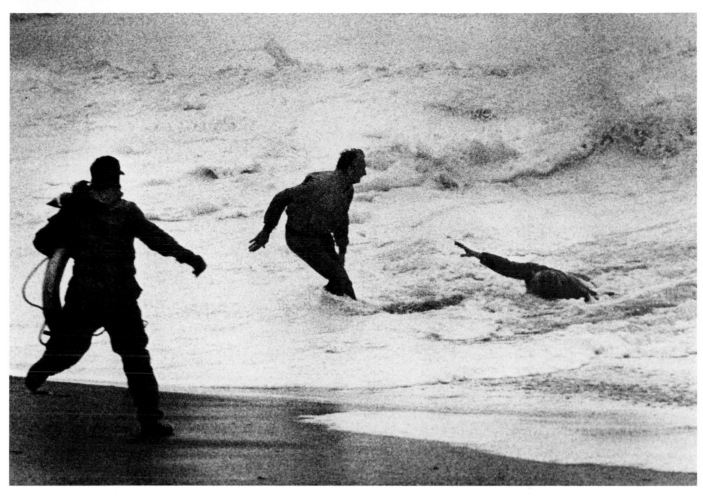

Cook fights for her life against the 10-foot waves as rescuers try to save her. She reaches toward one of the men, but the ocean separates them (below). No one was able to get close to her again.
The photo above also won 2nd Place in the Newspaper Spot News category.

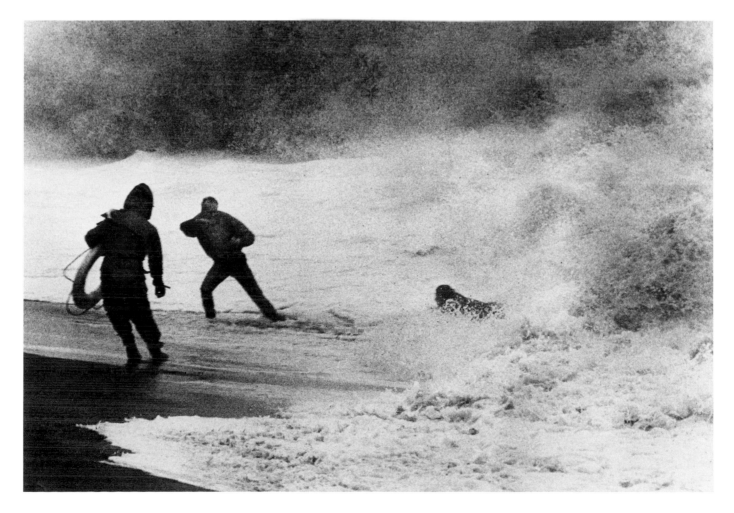

Marc Halevi, Lawrence (Mass.) Eagle-Tribune

3RD PLACE, NEWSPAPER NEWS PICTURE STORY

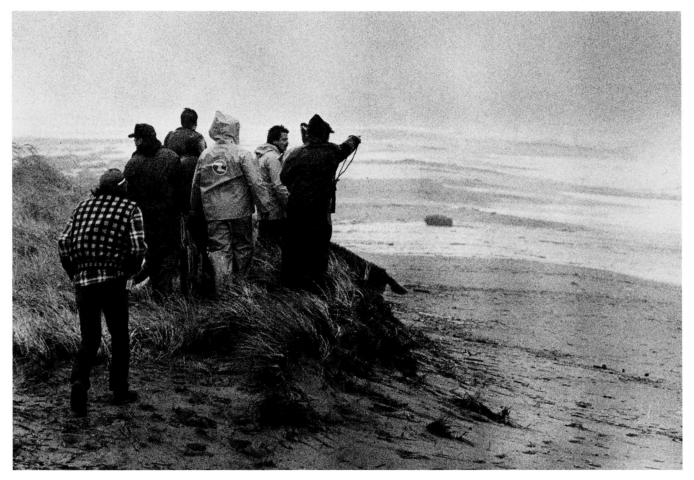

People gather near the spot where Cook went into the sea. Her body washed ashore about five miles away.

Marc Halevi, Lawrence (Mass.) Eagle-Tribune

3RD PLACE, NEWSPAPER NEWS PICTURE STORY

Jane Evelyn Atwood / Contact Press Images

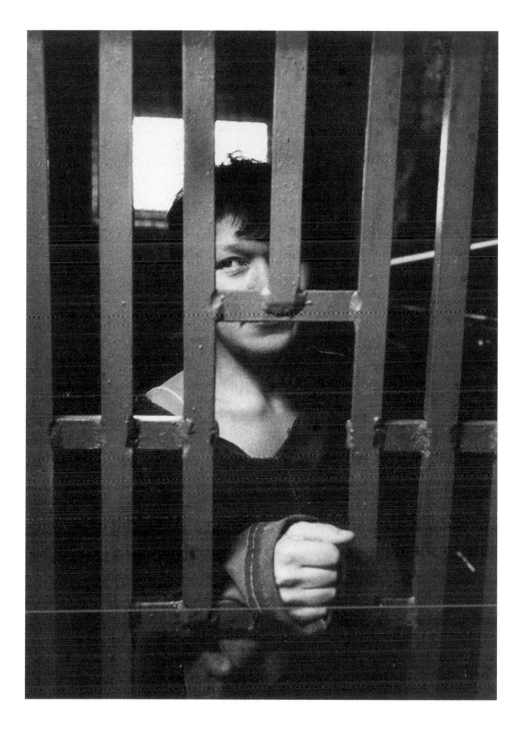

Life in Soviet Prisons

Surrounded by a thick forest of pines, near the Ural Mountains in the Soviet republic of Russia, lies the Perm Penal Colony for Women. No signs give away its purpose. The muddy, potholed driveway and low, red brick buildings look more like a dilapidated farm than a prison.

Free-lance photographer Jane Evelyn Atwood of Paris spent a week visiting the prison. Her photographic series, *U.S.S.R. Women's Prisons,* is the 1990 Canon Photo Essayist winner.

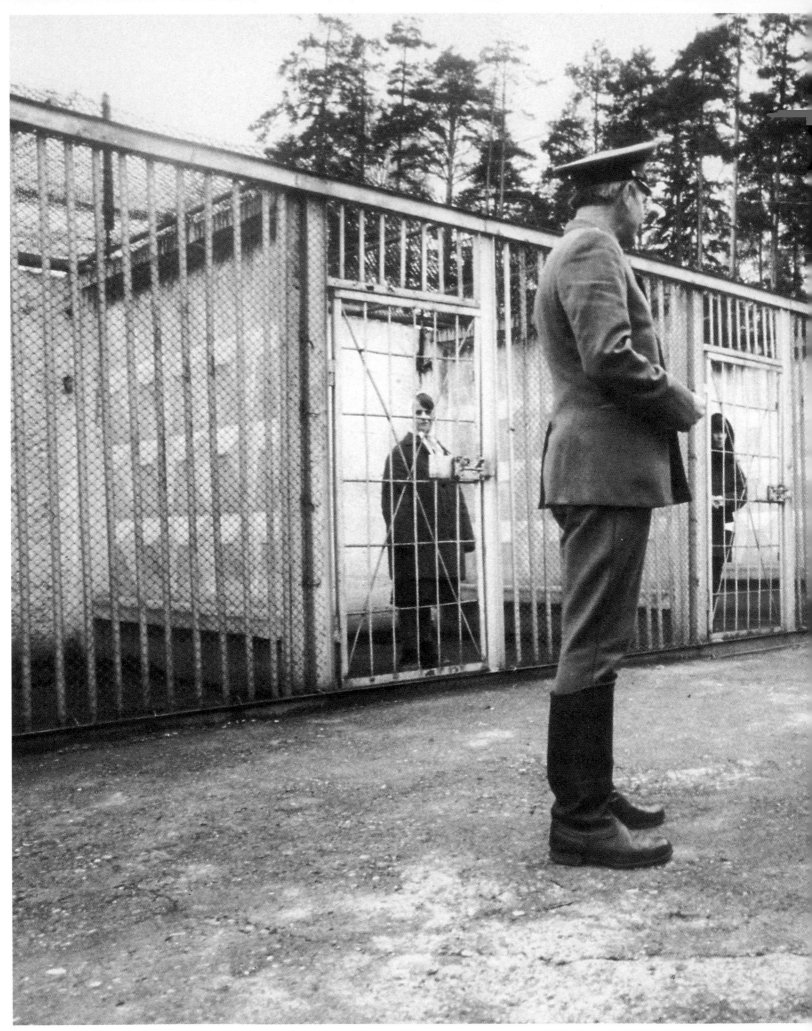

Solitary prisoners are watched during their outdoor exercise time.

Jane Evelyn Atwood

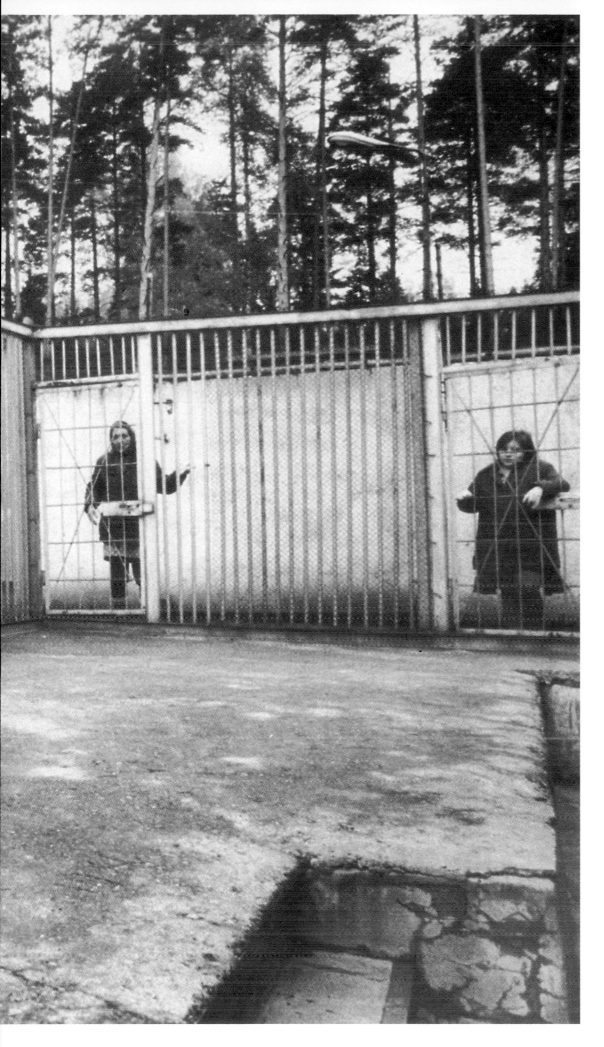

Perm Penal Colony houses from 400 to 1200 women. Although many of the inmates are repeat offenders, few of them are incarcerated for crimes as serious as murder. Most have been sentenced for theft or the crime of being in the wrong town with the wrong papers — a crime Atwood says is slowly being phased out of the books.

The women live in dormitories of 80 to 180 inmates. Toilets are holes in the ground with three sides but no doors.

An extraordinary feature of the prison, Atwood says, is the nursery. Women are allowed to nurse their infants and keep them at the prison until they are 18 months old.

Atwood also visited Ryazan prison, which houses girls ages 14 to 18.

Jane Evelyn Atwood
CANON PHOTO ESSAY

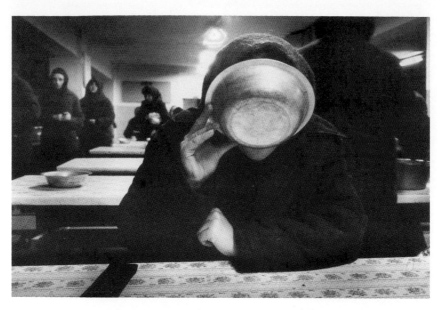

Meals consist of soup and brown bread.

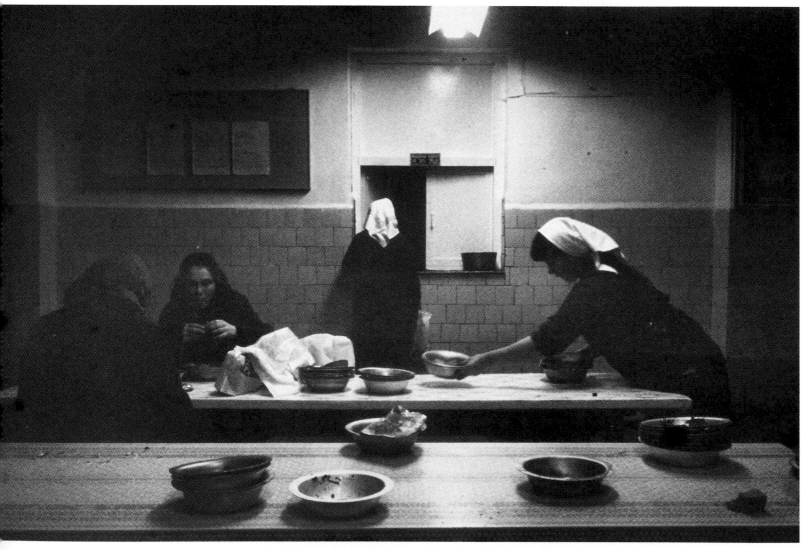

Inmates serve three meals a day in the dining hall.

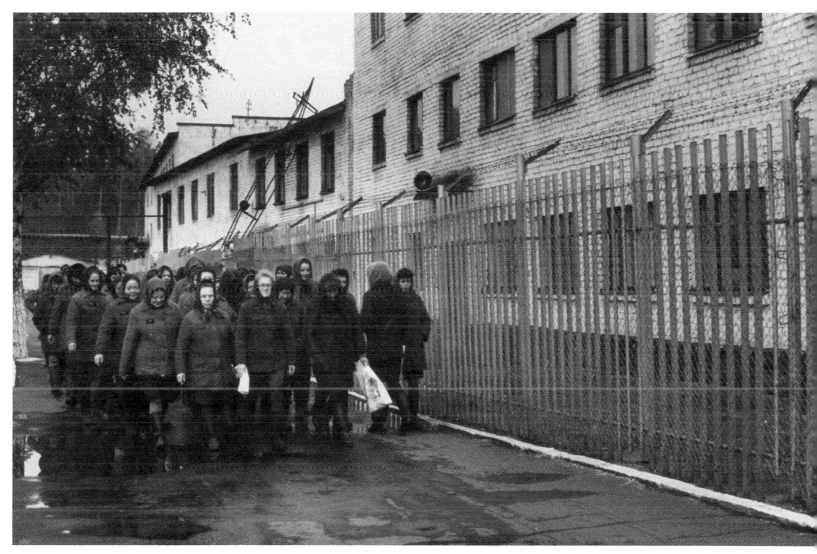

When prisoners go from the dormitory to workplace, they must march in military fashion.

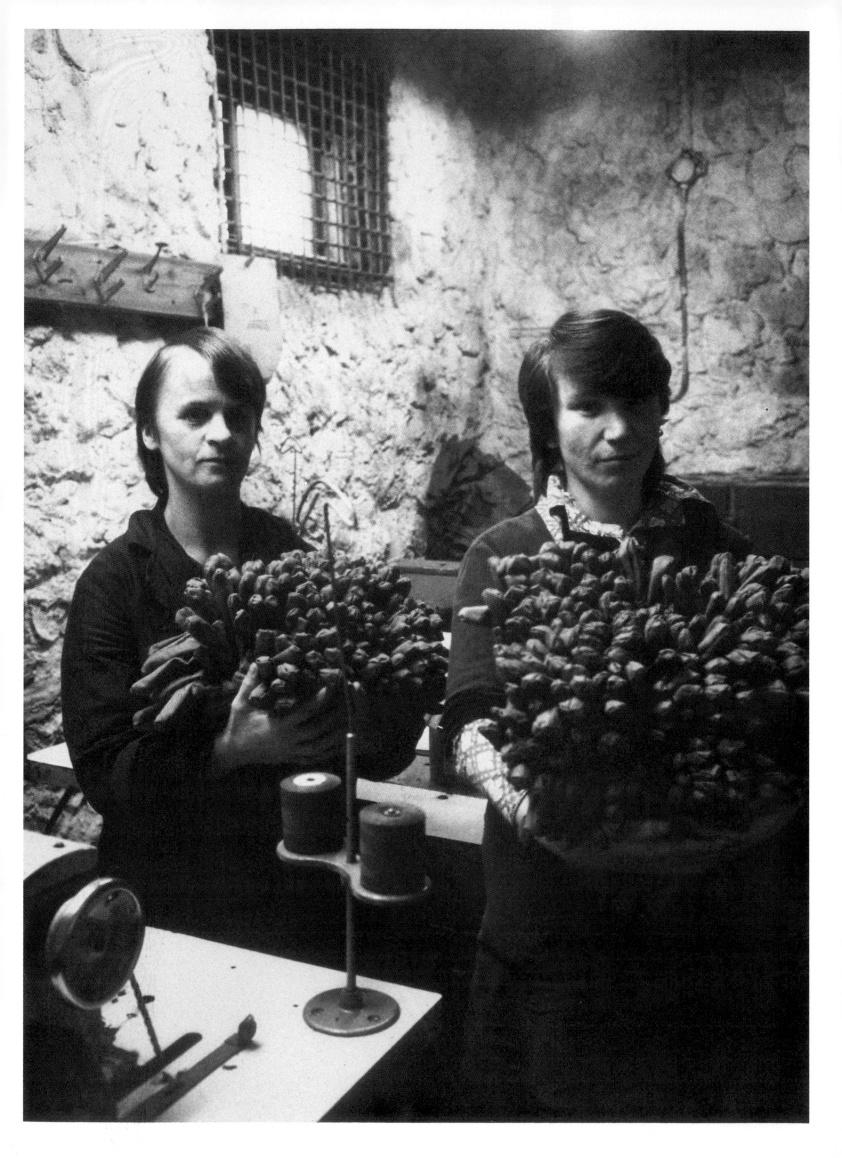

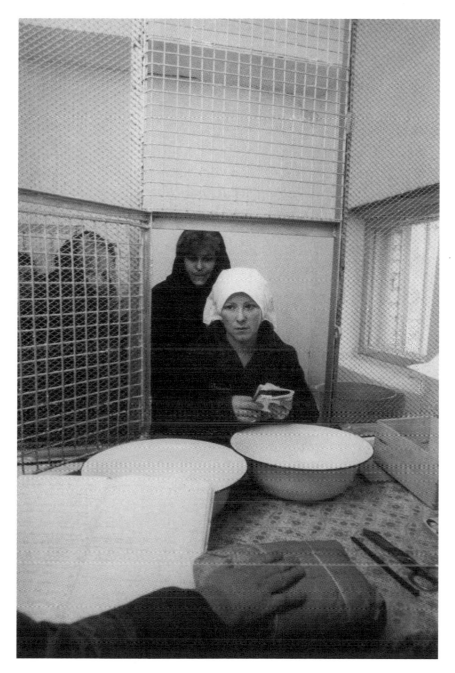

Prisoners may receive two packages a year.

News from the outside.

Previous page:
Prisoners make gloves
for firefighters.

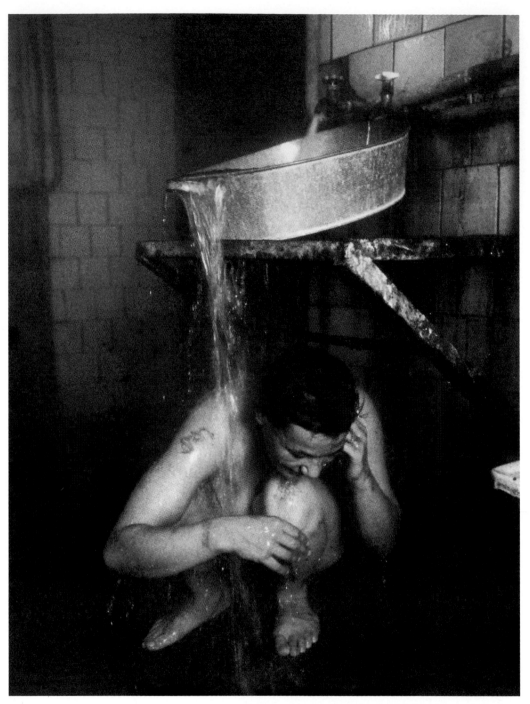

Twice a week, inmates are allowed showers.

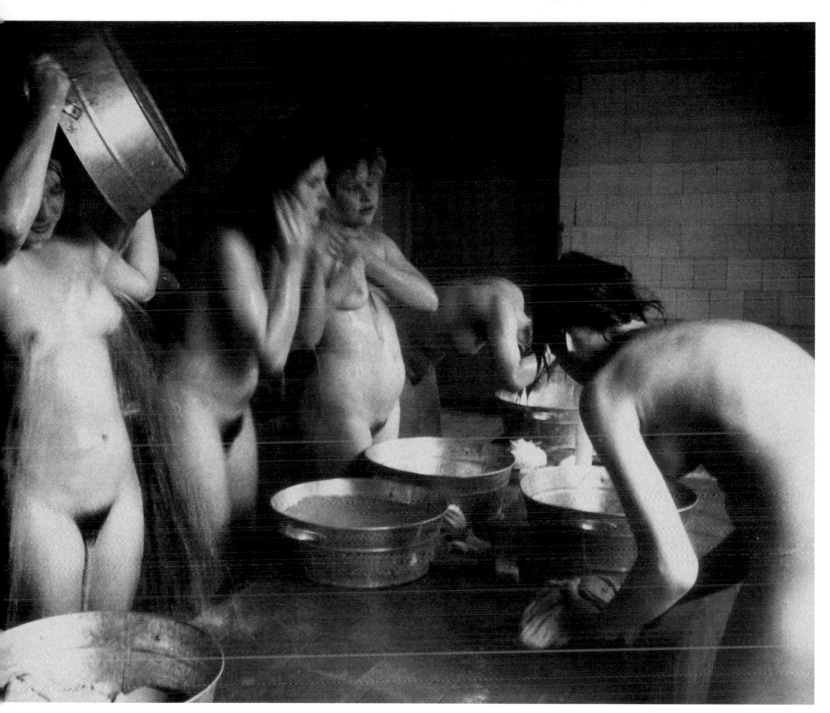

The water is hot and plentiful. Prisoners also wash their clothes while they bathe.

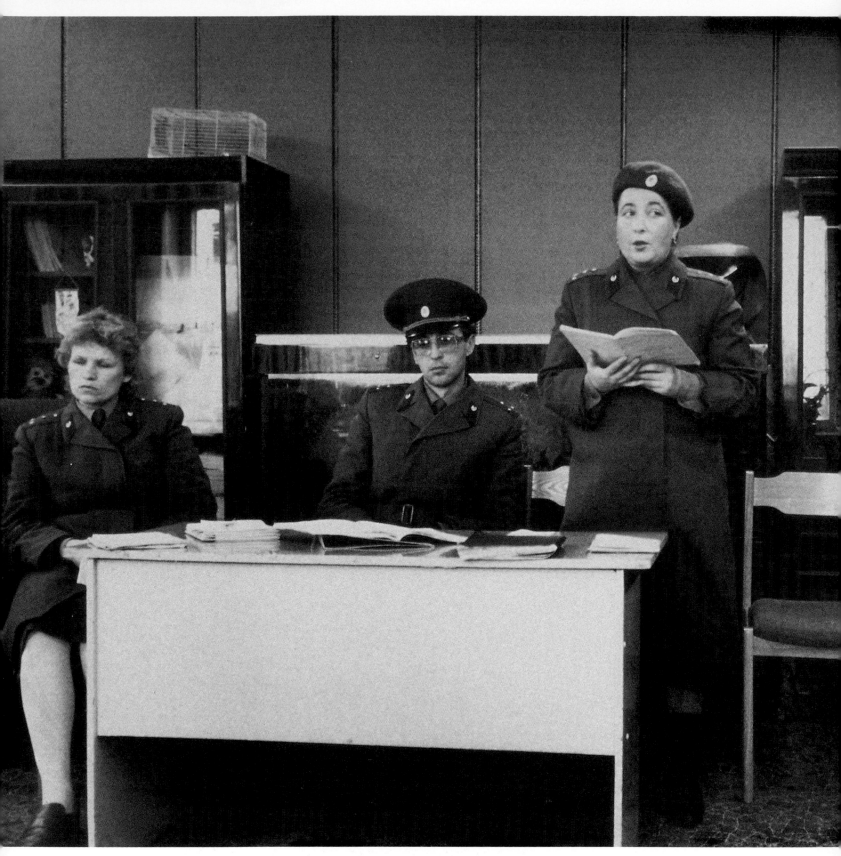

A parole board hearing at Ryazan prison.

Jane Evelyn Atwood
CANON PHOTO ESSAY

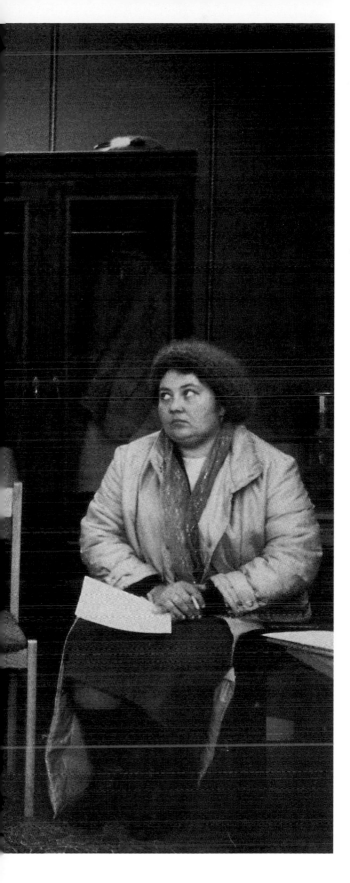

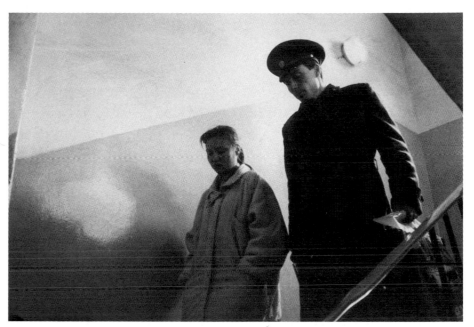

A guard escorts an inmate at Ryazan.

Following pages:
Double bunking
in solitary confinement at Perm.

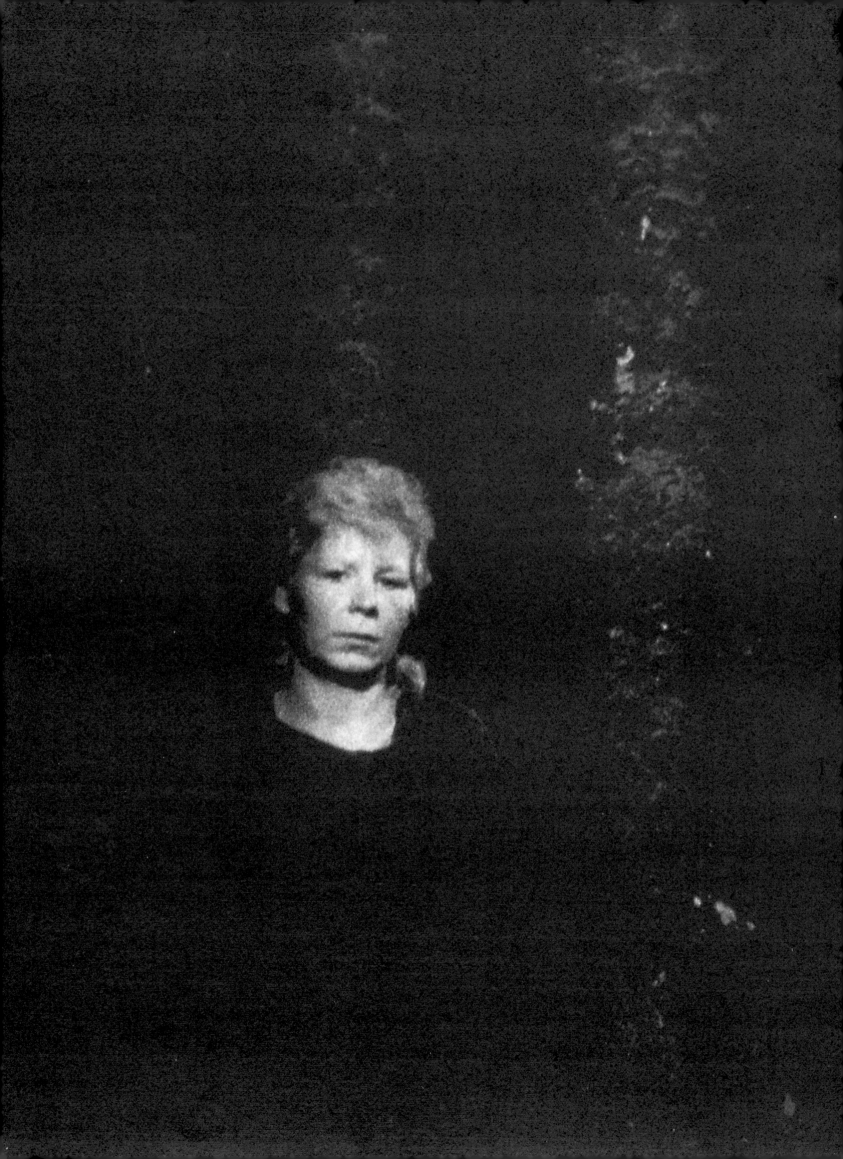

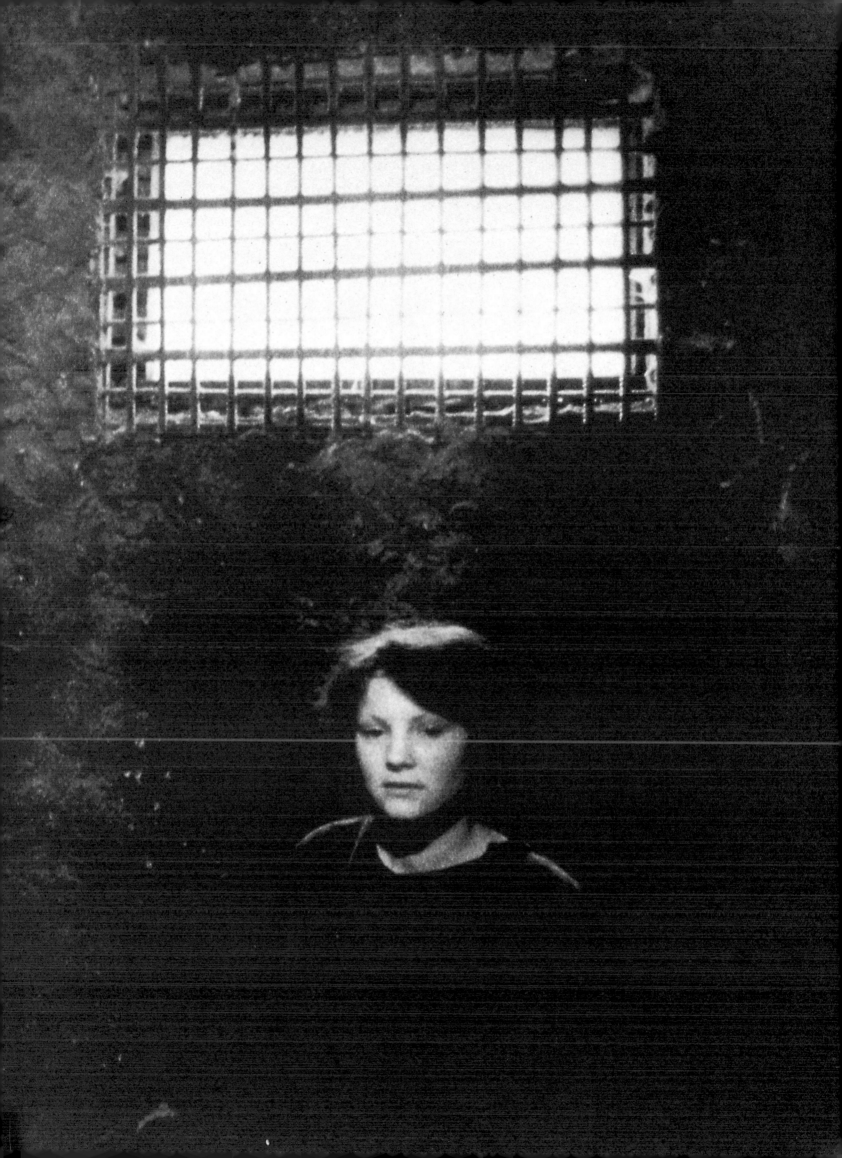

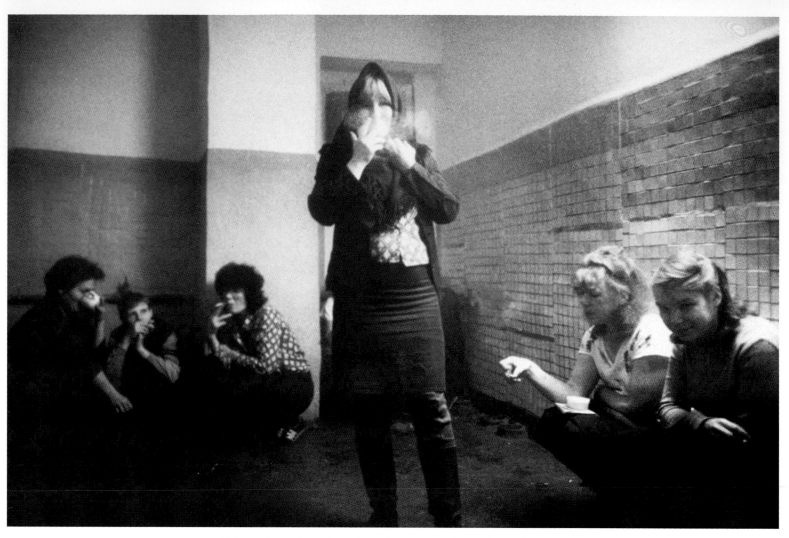

Although smoking is against the rules at Perm, it is tolerated.

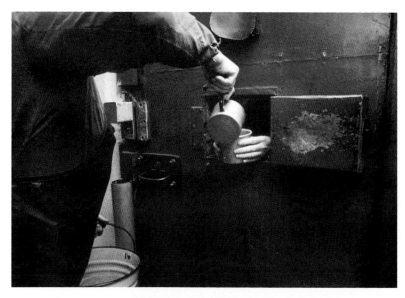

Prisoners in solitary confinement are given hot water
rather than tea to drink.

THE 48TH POY JUDGING

The biggest news from the 48th annual Pictures of the Year Contest is the eruption of photojournalistic production in California on 12 newspapers from San Diego to Sacramento. Golden State photographers and editors took 36 awards (20 percent of all those won by newspapers) including first and second place in the Newspaper Photographer of the Year category and the Angus McDougall Overall Excellence in Editing Award, given for the first time this year.

The Sacramento Bee claimed a total of 10 prizes, more than any other paper in the competition except *The Pittsburgh Press* (which took 11), including the Angus McDougall Editing Award, Newspaper Photo Editor of the Year (Rick Shaw), Newspaper Editing Team of the Year and second place Newspaper Photographer of the Year (Genaro Molina).

Close behind was *The Orange County Register* with nine awards including Newspaper Photographer of the Year won by Paul Kuroda. Kuroda also took first place for both News Picture Story (for documenting the hazards faced by immigrants crossing illegally into California) and Feature Picture Story (for a study of Vietnamese gangs), an extraordinary accomplishment. Judges praised him for his commitment to difficult subjects that had great local interest. His fellow *Register* photographer Daniel Anderson swept the Newspaper Fashion category, taking first, second and third places.

Long Beach (Calif.) *Press-Telegram* photographer Peggy Peattie won both first and second places in the One Week's Work category. She has taken more awards in this category than any other photojournalist since its creation five years ago.

All told, California photographers took 10 first place honors. By way of comparison, NPPA region one (five New England states plus four Canadian provinces), region three (seven mid-Atlantic states) and region six (seven Southeastern states) each took three first places; the other seven NPPA regions claimed one first place award each.

Newspapers that received the greatest number of awards:

The Pittsburgh Press — 11
The Sacramento Bee — 10
The Orange County Register — 9
The Hartford Courant — 6
Minneapolis Star Tribune — 6
Chicago Sun Times — 4
Fort Lauderdale News/Sun-Sentinel — 4
The Philadelphia Inquirer — 4
San Jose Mercury News — 4
The Seattle Times — 4
The Spokesman-Review/Spokane Chronicle — 4

Two other NPPA regions had an unusually large number of winning papers and individual newspaper awards. In region three (Delaware, Maryland, New Jersey, Pennsylvania, West Virginia and the District of Columbia), 12 papers took 24 awards. In region six (Alabama, Florida, Georgia, North Carolina, South Carolina, Tennessee and Mississippi), 10 newspapers won 20 awards.

Magnum photojournalist James Nachtwey made history in the magazine division of POY this year by winning the Magazine Photographer of the Year title for an unprecedented fourth time. Nachtwey also took first places in News or Documentary and in Picture Story.

Twelve magazines and nine photo agencies took honors for photography and editing this year. The top magazine winners were:

Time — 14
Fortune — 9
National Geographic — 8
Life — 5
The New York Times Magazine — 5
Sports Illustrated — 5

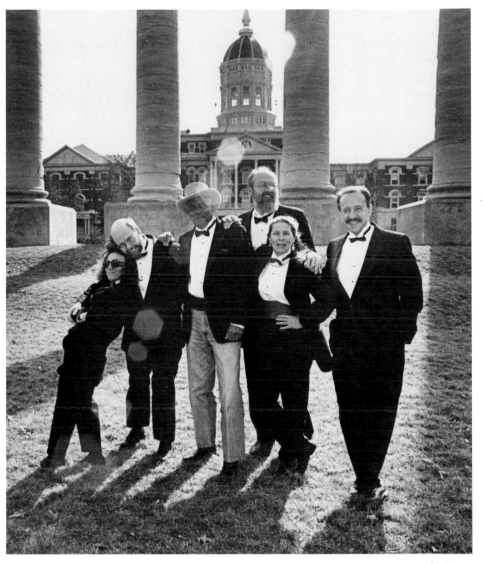

Photo by Sarah Evans
Some of the judges (from left): Michelle McNally, Larry Nighswander, Bernie Boston, Dave LaBelle, Melissa Farlow and Cliff Schiappa.

Agencies credited with the greatest number of awards were:

Black Star — 11 (including Kodak Crystal Eagle winner Donna Ferrato)

Magnum — 9 (including Magazine Photographer of the Year James Nachtwey)

Contact — 8 (including Canon Photo Essayist Jane Evelyn Atwood)

J.B. Pictures — 4

Ever since NPPA and the University of Missouri decided five years ago to strengthen the editing division of POY, a major goal has been to establish a prestigious editing honor comparable to the Newspaper and Magazine Photographer of the Year awards. This year that goal was accomplished through creation of the Angus McDougall Overall Excellence in Editing Award.

The Sacramento Bee won this title because of its consistent demonstration of sound photo-editing principles throughout the several editing categories of POY. In recognition, *The Bee* receives a sterling silver trophy upon which its name is engraved and which it may keep throughout 1991. The overall editing winner of POY 49 will have its name engraved on the trophy and may display it for a year until the next contest, and so on.

The award is named for photographer, editor, author, educator and former POY director Angus McDougall, for his years of inspired leadership to NPPA, the University of Missouri

Continued on next page

STORY BY
BILL KUYKENDALL,
CONTEST DIRECTOR

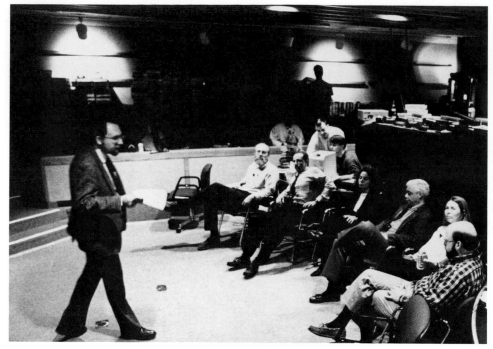

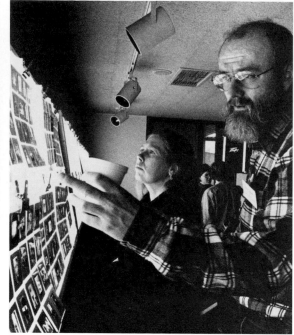

Bill Kuykendall (above) talks to the group of judges.

Photo by Sarah Evans

Photo by Sarah Evans

and the profession of photojournalism.

Participation in POY this year increased over last: Total entrants were up 17 percent, from 1,666 to 1,950. Twenty-two categories became larger, 15 categories shrank and three (Newspaper Portrait/Personality, Magazine Pictorial and the Kodak Crystal Eagle) were essentially unchanged.

The most dramatic increases came in Magazine Sports (up 280 percent) and Magazine Sports Portfolio (16 compared to 8 entries last year). This was due largely to an aggressive push by *Sports Illustrated* photographers, who took five of the nine magazine sports awards that were given.

Magazine photography portfolios increased from 20 to 25, but newspaper photography portfolios decreased from 107 to 84. This is a continuation of a steady five-year decline; 161 portfolios were entered in POY 44. Hopefully, this represents more-realistic editing and a broader understanding on the part of photographers of what winning portfolios require; this seems possible because the number of entrants is about the same today as it was in 1986.

Entries in Newspaper General News rose 26 percent; however, News Picture Story and Feature Picture Story categories dropped 19 and 34 percent respectively. In the editing division, Series or Special Section entries were nearly halved, from 83 to 45. These combined drops suggest that the weak economy which caused travel cutbacks, layoffs and hiring freezes on newspapers throughout the United States during 1990 probably also cut dramatically into the production of photo stories.

Individual and team editing portfolios showed healthy growth, 11 and 27 percent respectively. But total entries in the Best Use of Photos by newspapers were down 20 percent. Newspaper zoned editions dropped from 10 to five entries, possibly reflecting diminished enthusiasm for this specialized news product in many markets around the country.

Thus it seems POY 48 was a good news, bad news year. Significantly more editors and photographers sent in work but they sent less of it. Many individuals were able to assemble portfolios that compared favorably with the best from the past; at the same time, editors sent in fewer strong, consistent newspapers. If this truly reflects publishing practices in 1990, it is unfortunate, for great photos and stories are useless, no matter how many honors they earn, if readers never see them.

Photo by Jerry Willis
Melissa Farlow and Dave LaBelle (top photo) look over finalists' slides in the Newspaper Photographer of the Year category. Michelle McNally (above) considers slide entries.

The Judges

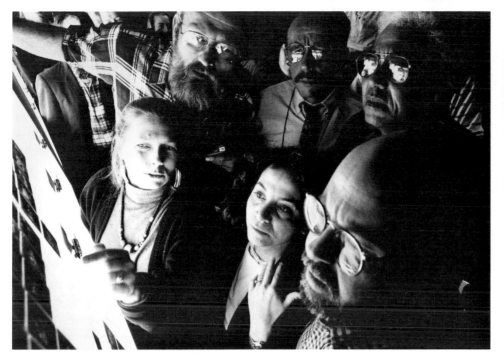

Photo by Sarah Evans

Photo by Jerry Willis

Judge Howard Chapnick (above) offers his opinion. The final round of portfolios (left photo) is considered by several panelists.

Bernie Boston, chief photographer for the Washington Bureau of the Los Angeles Times, began working as a photojournalist in 1963 when he joined the Dayton Daily News in Ohio. He worked at the Washington Star from 1967 until 1981, when he was hired by the Times. He is currently vice president of the White House News Photographers Association (WHNPA).

Howard Chapnick became president of Black Star photography agency in 1964, having started there in 1941 as a messenger boy. Photographer Charles Moore called him "Mr. Photojournalism" for promoting many of the world's finest photojournalists. He was recipient of NPPA's Joseph A. Sprague Memorial Award and the Kenneth P. McLaughlin Memorial Award for his contribution to the field.

Arnold Drapkin joined the staff of Time magazine as a copy boy in 1950. Since then he has served as contributing editor, color director, color editor, and in July 1978 was appointed picture editor. In November 1987, following his retirement, he became consulting picture editor. He also is director of European Programs of the New School/Parsons School of Design. He has received many honors, including the 1983 Joseph A. Sprague Memorial Award.

Melissa Farlow, staff photographer for The Pittsburgh Press, has twice been named the Greater Pittsburgh Photographer of the Year. She worked as a staff photographer for The Courier-Journal and Louisville Times for 10 years following graduation from Indiana University. She also taught photojournalism at the University of Missouri while working on a master's degree in journalism.

Dave LaBelle left The Sacramento Bee in 1986 to join the faculty at Western Kentucky University as a photojournalist-in-residence. He has worked for more than a dozen newspapers in eight states, including The Ventura County (Calif.) Star Free Press, the Muskogee (Okla.) Daily Phoenix and The Anchorage (Alaska) Times. He twice was nominated for the Pulitzer Prize in feature photography. In 1990 he wrote and published The Great Picture Hunt.

Michele McNally has been picture editor of Fortune magazine since 1986. Prior to Fortune, she was picture editor of Time/Life's Magazine Development Group,

editing Picture Week and Quality magazines. She has judged many international picture competitions, and serves on the board of directors and as a faculty member of the Eddie Adams Workshop.

Larry Nighswander is an illustrations editor on the staff of National Geographic magazine. His previous duties there include illustrations editor of the National Geographic Society's World magazine and coordinator of desktop publishing during World & Traveler magazine's conversion to electronic publishing. Prior to joining National Geographic in 1988 he was an assistant managing editor at The Cincinnati Post, picture editor at The Columbus Dispatch, director of photography at the Washington Times and the Cleveland Press.

Kathy Ryan became the deputy photo editor of The New York Times Magazine in January 1985, and has been the photo editor there since October 1987. Prior to that she worked as a photo researcher and editor for Sygma Photo News Agency. She has lectured and judged competitions in both the United States and France.

Gary Settle became photography coach at The Seattle Times in November 1987 after serving as managing editor of graphics there since January 1979. Previously, Settle had been a staff photographer for The New York Times, The Chicago Daily News, The Wilmington (Del.) News Journal, the Topeka Capital-Journal and The Hutchinson (Kan.) News. He was named Newspaper Photographer of the Year in 1968 and 1970.

Cliff Schiappa became a photographer for the Associated Press in May of 1984. Prior to that he worked for three-and-a-half years at The Kansas City (Mo.) Star. In 1979 he graduated from the University of Missouri with a bachelor's degree in journalism.

Rick Smolan created the award-winning Day in the Life series of books in 1981. Previously he was a founding member of Contact Press Images, and worked as a photographer for Time magazine. His work also has appeared in National Geographic, Newsweek, Fortune, The New York Times, The London Sunday Times, Stern, Paris Match and Life. He has won many awards for his work involving computers, photography and publishing, among them the 1986 American Society of Magazine Photographers Award for "Innovation in Photography."

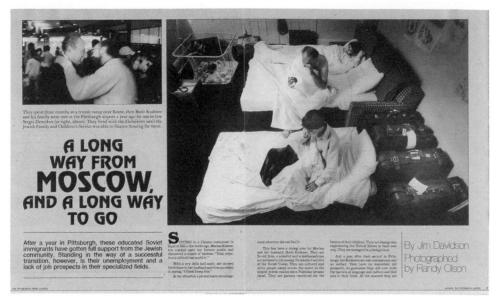

1st Place, Newspaper-produced magazine picture editing

1st Place, Newspaper editing,
series or special section

BEST USE OF PHOTOGRAPHY BY A MAGAZINE
National Geographic, First Place
LIFE, Second Place
The Commission, Third Place
Worldwide Challenge Magazine, Award of Excellence
National Wildlife Magazine, Award of Excellence

BEST USE OF PHOTOGRAPHY BY A NEWSPAPER
25,000 to 150,000
Spokesman-Review & Spokane (Wash.) Chronicle, First
Place
OVER 150,000
The Hartford (Conn.) Courant, First Place
The Seattle Times, Second Place
UNDER 25,000
Biddeford (Maine) Journal Tribune, First Place
ZONED EDITIONS
The Virginian-Pilot/Ledger-Star, First Place

CANON PHOTO ESSAYIST AWARD
Jane Evelyn Atwood, Contact Press Images, *USSR
Women's Prisons*, First Place
James Lukoski, free-lance, *Israeli/Palestinian Conflict*,
Judge's Special Recognition

KODAK CRYSTAL EAGLE AWARD
Donna Ferrato, Black Star, *War on Women*

MAGAZINE EDITING—FEATURE STORY
J. Bruce Baumann, The Pittsburgh Press Magazine,
Welfare Mother, First Place
William Douthitt, National Geographic, *Africa's Great
Rift*, Second Place
Stephanie Gay, Providence (R.I.) Journal, *The Quick and
the Dead*, Third Place
LIFE, *The Testing of Dory Yochum*, Award of Excellence
J. Bruce Baumann, The Pittsburgh Press Magazine, *A
Long Way from Moscow*, Award of Excellence
LIFE, *The Face of God*, Award of Excellence
LIFE, *Shooting Back*, Award of Excellence
LIFE, *Two for the Road*, Award of Excellence
Mark Edelson, Fort Lauderdale News/Sun-Sentinel, *The
Throwaway Kids*, Award of Excellence

MAGAZINE FEATURE PICTURE
Eugene Richards, Magnum, *Mother Crackhead*, First
Place
Anthony Suau, Black Star for TIME, *Off for the Mating*,
Second Place
Anthony Suau, Black Star for TIME, *A Smile and a Song*,
Fourth Place
Anthony Suau, Black Star for TIME, *Distant Dreams*,
Award of Excellence
Richard Kozak, Insight Magazine, *Unknown Sailors*,
Third Place
Jerry Valente, Power to Heal, *Dr. Leila Denmark*, Award
of Excellence
Maria Stenzel, free-lance, *Flower Girl*, Award of Excel-
lence
Bernard Bisson, Sygma, *AIDS Babies*, Award of Excel-
lence
John Chiasson, Gamma Liaison for TIME, *Near Death*,
Award of Excellence
Kenneth Jarecke, Contact Press Images, *Beach Ball Boy*,
Award of Excellence
Cynthia Johnson, TIME, *Chained*, Award of Excellence
R. Ian Lloyd, Fortune Magazine, *Singapore Stewardesses*,
Award of Excellence
Jay B. Mather, The Sacramento Bee, *Observing Yosemite*,
Award of Excellence

MAGAZINE NEWS OR DOCUMENTARY
James Nachtwey, Magnum for The New York Times
Magazine, *The Scream*, First Place
Robb Kendrick, free-lance, *Afflicted with Polio*,
Second Place
David Wells, JB Pictures, *Watching Palestinians*, Third
Place
Mary Ellen Mark, free-lance for Fortune Magazine, *The
Face of Rural Poverty (Earlene Grever)*, Award of
Excellence
Christopher Morris, Black Star for TIME, *Poll Tax
Riots*, Award of Excellence
Galen Rowell, One Earth, *Eco-Tourists*, Award of
Excellence
Jim Richardson, A Day in the Life of Italy, *Lecce Street*,
Award of Excellence
Frank Fournier, Contact Press Images, *Romanian
AIDS Babies*, Award of Excellence
Jodi Cobb, National Geographic, *Innocent Prisoner*,
Award of Excellence
Jerry Valente, A Day in the Life of Italy, *Maria
Carmina*, Award of Excellence
Robert Nickelsberg, TIME, *Protesters*,
Award of Excellence
Bruce Haley, Black Star for US News & World
Report, *Karen Execution*, Award of Excellence
Gad Gross, JB Pictures, *Lenin Statue*,
Award of Excellence
James Nachtwey, Magnum for The New York Times
Magazine, *Their World*, Award of Excellence
James Nachtwey, Magnum for The New York Times
Magazine, *Irrecoverable*, Award of Excellence

MAGAZINE PHOTOGRAPHER OF THE YEAR
James Nachtwey, Magnum, First Place

THE CONTEST WINNERS

READING, WRITING AND REARING A FAMILY

October 21, 1990

1st Place, Newspaper magazine picture editing

CELEBRATING Yosemite

A CENTENNIAL PORTRAIT

1st Place, Newspaper picture editing, team

MAGAZINE PICTORIAL

Jim Gensheimer, San Jose Mercury News, *Pillars and Clouds*, First Place

Jodi Cobb, National Geographic, *Steamy Streets*, Second Place

David Wells, JB Pictures, *Jews at Sunset*, Third Place

Peter J. Menzel, free-lance, *Mount Whitney with Moon*, Award of Excellence

MAGAZINE PICTURE STORY

James Nachtwey, Magnum for The New York Times Magazine, *Institutional Hell for Romania's Abandoned Children*, First Place

Jane Evelyn Atwood, Contact Press Images, *USSR Women's Prisons*, Second Place

Eugene Richards, Magnum, *Children of the Damned*, Third Place

Tomas Muscionico, Contact Press Images, *Copsa Mica: Ceausescu's 'Model' Industrial Town*, Fourth Place

Antonin Kratochvil, The New York Times Magazine, *The Polluted Lands*, Award of Excellence

James Lukoski, free-lance, *Israeli/Palestinian Conflict*, Award of Excellence

Michael Lutzky, JB Pictures, *La Villa*, Award of Excellence

Christopher Morris, Black Star for TIME, *Poll Tax Riots*, Award of Excellence

James Nachtwey, Magnum, *The Condemned Grow Old in Romania's Institutional Hell*, Award of Excellence

Joseph Rodriguez, Black Star, *Romania's Ailing Institutions*, Award of Excellence

Anthony Suau, Black Star for TIME, *Romania: Gentler Moments*, Award of Excellence

Anthony Suau, Black Star for TIME, *Copsa Mica: City in Black*, Award of Excellence

David Binder, free-lance, *The Clean Fix*, Award of Excellence

MAGAZINE PORTRAIT/PERSONALITY

Mary Ellen Mark, free-lance for Fortune Magazine, *The Face of Rural Poverty (Christopher Wayne Grey)*, First Place

Mary Ellen Mark, Fortune Magazine, *The Face of Rural Poverty (Jean and Peggy Rowland)*, Second Place

James Nachtwey, Magnum, *Better Not to See*, Third Place

Mary Ellen Mark, free-lance for Fortune Magazine, *The Face of Rural Poverty (Gigee Sisters)*, Award of Excellence

Mary Ellen Mark, free-lance for Fortune Magazine, *The Face of Rural Poverty (Harvey and Callie Flanery)*, Award of Excellence

James Nachtwey, Magnum, *Age, Suffering, Despair, Madness*, Award of Excellence

Linda Creighton, US News & World Report, *Poverty Lines*, Award of Excellence

Anthony Suau, Black Star for TIME, *Factory Worker*, Award of Excellence

Mary Ellen Mark, free-lance for Fortune Magazine, *The Face of Rural Poverty (Tunica Residents)*, Award of Excellence

Robb Kendrick, free-lance, *Boy in China Hospital*, Award of Excellence

Robb Kendrick, free-lance, *Dr. DeBakey, Pioneer Heart Surgeon*, Award of Excellence

Mary Ellen Mark, free-lance for Fortune Magazine, *The Face of Rural Poverty (John Grey)*, Award of Excellence

Michael Lutzky, free-lance, *Lover and a Fighter*, Award of Excellence

MAGAZINE SCIENCE/NATURAL HISTORY

Igor Kostin, TIME, *Chernobyl Fetus*, First Place

David Doubilet, National Geographic, *Nightmare Flat Tire*, Second Place

Mark Moffett, National Geographic, *Robot Feeds Honeybee*, Third Place

Dilip Mehta, Contact Press Images, *Laying-On Hands*, Award of Excellence

Dilip Mehta, Contact Press Images, *Ayurvedic Treatment*, Award of Excellence

David Doubilet, National Geographic, *Harbor Seal in Kelp*, Award of Excellence

1st Place, Newspaper picture editing, individual

1st Place, Best use of photography by a newspaper under 25,000

THE CONTEST WINNERS

Where early explorers played out their agonies and triumphs, tourists now come to sightsee. Oblivious to his mantle of snow, a passenger nodded off aboard the *World Discoverer* as it plied the Bellingshausen Sea. At Cape Royds on Ross Island a storm rails against Adélie penguins at a point south of 77°, the most southerly penguin rookery known.

1st Place, Best use of photography by a magazine

1st Place, Newspaper editing, feature story

Tom Haley, SIPA for TIME, *Pollution*, Award of Excellence

Michael Quan, free-lance, *Kilauea's Fury*, Award of Excellence

Louis Psihoyos, Matrix for Fortune Magazine, *Computer Customization*, Award of Excellence

J.B. Diederich, Contact Press Images, *Texas Oil Spill*, Award of Excellence

Lynda Richardson, National Wildlife Magazine, *Eels*, Award of Excellence

MAGAZINE SPORTS PICTURE

Jonathan Weston, Sports Illustrated, *Mike Eskimo*, First Place

Budd Symes, free-lance, *Meracquas Synchro Swim*, Second Place

Bill Frakes, Sports Illustrated, *Championship Touch*, Third Place

Bill Frakes, Sports Illustrated, *Shadow Dance*, Award of Excellence

Damian Strohmeyer, free-lance, *Conga Line*, Award of Excellence

Heinz Kluetmeier, Sports Illustrated, *Jeff Rouse*, Award of Excellence

Walter Iooss Jr., Sports Illustrated, *Dominique Wilkins*, Award of Excellence

Tim DeFrisco, Allsport USA, *Backstretch*, Award of Excellence

Joseph Arcure, free-lance, *Sea of Helmets*, Award of Excellence

NEWSPAPER EDITING—FEATURE STORY

Rick Shaw, The Sacramento Bee, *Water: Quest and Conflict*, First Place

John Rumbach, The Jasper (Ind.) Herald, *Great Expectations*, Second Place

Mike Davis, The Albuquerque Tribune, *Surf the Rails*, Third Place

Scott R. Sines, The Spokesman-Review & Spokane (Wash.) Chronicle, *The Old School*, Award of Excellence

Karen Kelso, The Orange County Register, *Anxious for a Fair Chance*, Award of Excellence

Bill Kelley III, The Columbia (S.C.) State, *When Children Have Children*, Award of Excellence

NEWSPAPER EDITING—SERIES OR SPECIAL SECTION

Mike Davis, The Albuquerque Tribune, *Changing Voices*, First Place

M. Cole Porter, The Seattle Times, *Our Troubled Earth*, Second Place

Scott R. Sines, The Spokesman-Review & Spokane (Wash.) Chronicle, *Desperate Days at the Merlin*, Third Place

Barry Locher, The Springfield (Ill.) State Journal-Register, *Poltava*, Award of Excellence

NEWSPAPER EDITING—SPORTS STORY

Sandra Eisert, San Jose Mercury News, *Field of Dreamers*, First Place

J. Bruce Baumann, The Pittsburgh Press Magazine, *Slap Shot Revisited*, Second Place

NEWSPAPER FASHION ILLUSTRATION

Daniel Anderson, The Orange County Register, *Dune Magic*, First Place

Daniel Anderson, The Orange County Register, *Socks Appeal*, Second Place

Daniel Anderson, The Orange County Register, *Sundress Sweet*, Third Place

Leilani Hu, The Sacramento Bee, *Shades of Summer*, Award of Excellence

Michael McMullan, The Memphis Commercial Appeal, *Waterfall Swimsuit*, Award of Excellence

Guy Reynolds, Baton Rouge (La.) State-Times/Morning Advocate, *From Sofas to Sundresses*, Award of Excellence

Cloe Poisson, The Hartford (Conn.) Courant, *Figure-Flattering Swimwear*, Award of Excellence

Mary M. Kelley, Colorado Springs (Colo.) Gazette Telegraph, *40's Style Suits*, Award of Excellence

Ted Jackson, The New Orleans Times-Picayune, *The Tracy Look*, Award of Excellence

NEWSPAPER FEATURE PICTURE

Fritz Hoffmann, The Knoxville (Tenn.) News-Sentinel, *Blessing of the Hounds*, First Place

Paul Hanna, Reuters News Pictures, *Bullish*, Second Place

Pat Davison, The Pittsburgh Press, *Do You Wanna Dance?*, Third Place

Shaun Zimmerman, Jefferson City (mo.) News and Tribune, *Hot Pursuit*, Award of Excellence

Earl Richardson, Topeka (Kan.) Capital-Journal, *Roadside Urinalysis*, Award of Excellence

Richard D. Green, Salinas Californian, *It Wasn't My Fault*, Award of Excellence

David Schreiber, Torrance (Calif.) Daily Breeze, *Family Feud*, Award of Excellence

Tom Reese, The Seattle Times, *Felling a Giant*, Award of Excellence

Gerald McCrea, The Newark (N.J.) Star-Ledger, *Rare Rescue*, Award of Excellence

Al Podgorski, Chicago Sun-Times, *Yoga Power*, Award of Excellence

THE CONTEST WINNERS

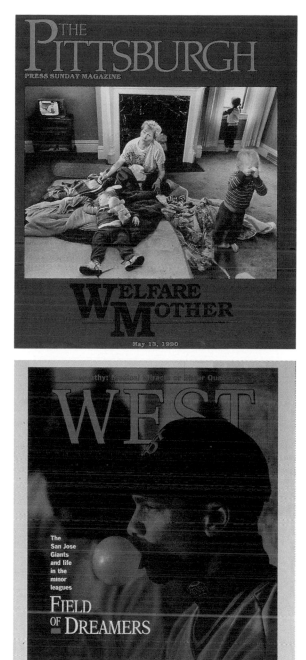

1st Place, Magazine editing, feature story (top).
1st Place, Newspaper editing, sports story (bottom).

Rady Sighiti, Reuters News Pictures, *Family Funeral*, Award of Excellence
James Skovmand, The San Diego Union-Tribune, *Looking for Hope*, Award of Excellence
Julie Rogers, Contra Costa Times (Santa Cruz, Calif.), *Korean Curiosity*, Award of Excellence
Kent Meireis, The Denver Post, *Home Delivery*, Award of Excellence

NEWSPAPER FEATURE PICTURE STORY
Paul Kuroda, The Orange County Register, *Vietnamese Gangs*, First Place
Ronald Cortes, The Philadelphia Inquirer, *The Senior Senior of Olney High*, Second Place

Richard Messina, The Hartford (Conn.) Courant, *Timmy's Dead End Street*, Third Place
Tim Rasmussen, free-lance for The Hartford (Conn.) Courant, *Facing AIDS*, Award of Excellence
Genaro Molina, The Sacramento Bee, *For Love of Lula*, Award of Excellence
Andrew Itkoff, Fort Lauderdale News/Sun-Sentinel, *Street Kids*, Award of Excellence
Al Podgorski, Chicago Sun-Times, *Mother York's Life Sentence*, Award of Excellence
Pat Davison, The Pittsburgh Press, *Changing Voices*, Award of Excellence

NEWSPAPER FOOD ILLUSTRATION
Bob Fila, Chicago Tribune, *Edible Flowers*, First Place
Robert Cohen, The Memphis (Tenn.) Commercial Appeal, *Foods for the Fourth*, Second Place

NEWSPAPER GENERAL NEWS
Jeff Tuttle, The Wichita (Kan.) Eagle, *Last Hug*, First Place
William Snyder, The Dallas Morning News, *Romania's First Election*, Second Place
John H. White, Chicago Sun-Times, *Mandela, First Appearance*, Third Place
Jeff Greene, The Palm Beach Post, *Sylvester Busted*, Award of Excellence
Gary Cameron, Reuters News Pictures, *Oh, No! Not the Budget!*, Award of Excellence
David Schreiber, Torrance (Calif.) Daily Breeze, *A Reckoning*, Award of Excellence
Peter Haley, The Tacoma (Wash.) Morning News Tribune, *Soldier is Bored*, Award of Excellence
Chas Metivier, The Orange County Register, *Transients Tussle*, Award of Excellence
Robert Cohen, The Memphis (Tenn.) Commercial Appeal, *Wrapped up in Grief*, Award of Excellence
Christine Keith, The Arizona Republic, *Citizen's Academy*, Award of Excellence
Geoffrey Kerrigan, The Cross River (N.Y.) Ledger, *When the Bough Breaks...*, Award of Excellence
Bryan Berteaux, The New Orleans Times-Picayune, *Dead Patient*, Award of Excellence
Sean Dougherty, Fort Lauderdale News/Sun-Sentinel, *Face of Concern*, Award of Excellence
Kenneth George, European Stars & Stripes, *Bush Tosses a Souvenir*, Award of Excellence
William Snyder, The Dallas Morning News, *Pollution Shrouds Copsa Mica*, Award of Excellence
E. A. Kennedy III, The Palm Beach Post, *Last Hurrah*, Award of Excellence
Bill Tiernan, The Norfolk Virginian-Pilot/Ledger-Star, *Seeking Shelter*, Award of Excellence

NEWSPAPER NEWS PICTURE STORY
Paul Kuroda, The Orange County Register, *Of Lines and Shadows*, First Place
Timothy Barmann, The Providence (R.I.) Journal, *Anatomy of a Murder*, Second Place
Marc Halevi, Lawrence (Mass.) Eagle-Tribune, *A Woman's Final Moments*, Third Place
E. A. Kennedy III, The Palm Beach Post, *Nicaragua Elections*, Award of Excellence
Carol Guzy, The Washington Post, *Haiti Elections*, Award of Excellence

1st Place, Newspaper editing, series or special section

1st Place, Newspaper picture editing, news story

THE CONTEST WINNERS

1st Place, Best use of photography by a newspaper 25,000 to 150,000

1st Place, Best use of photography by a newspaper over 150,000

Bill Neibergall, The Des Moines Register, *White Knuckle Ride*, Award of Excellence

David Turnley, Detroit Free Press, *Desert Shield Tank Crew*, Award of Excellence

NEWSPAPER PHOTOGRAPHER OF THE YEAR

Paul Kuroda, The Orange County Register, First Place

Genaro Molina, The Sacramento Bee, Second Place

Al Podgorski, Chicago Sun-Times, Third Place

Vince Musi, The Pittsburgh Press, Award of Excellence

NEWSPAPER PICTORIAL

Rob Clark Jr., free-lance for The Cincinnati Post, *Racer Repairs*, First Place

Guy Reynolds, Baton Rouge (La.) State-Times/Morning Advocate, *Moving Wall on the Move*, Second Place

Jeff Horner, Walla Walla (Wash.) Union-Bulletin, *A Solitary Sunset*, Third Place

Jim Wilson, The New York Times, *Faces, Faces*, Award of Excellence

Bill Uhrich, Reading (Pa.) Eagle/Times, *Swans III*, Award of Excellence

Thomas Kelsey, Los Angeles Times, *Morning Mist*, Award of Excellence

Chris Ochsner, Topeka (Kan.) Capital-Journal, *At Heaven's Gate*, Award of Excellence

Larry Mayer, The Billings (Mont.) Gazette, *Lumber Mill Pond*, Award of Excellence

NEWSPAPER PICTURE EDITING/INDIVIDUAL

Rick Shaw, The Sacramento Bee, First Place

Mike Healy, Minneapolis Star Tribune, Second Place

Geri Migielicz, San Jose Mercury News, Third Place

Scott R. Sines, The Spokesman-Review & Spokane (Wash.) Chronicle, Award of Excellence

Bill Kelley III, The Columbia (S.C.) State, Award of Excellence

J. Bruce Baumann, The Pittsburgh Press Magazine, Award of Excellence

Thomas McGuire, The Hartford (Conn.) Courant, Award of Excellence

NEWSPAPER PICTURE EDITING/TEAM

The Sacramento Bee, First Place

The Seattle Times, Second Place

Anchorage Daily News, Third Place

The Columbia (S.C.) State, Award of Excellence

The Orange County Register, Award of Excellence

NEWSPAPER PICTURE EDITING–NEWS STORY

Fredrika Sherwood, Minneapolis Star Tribune, *Children of Crack*, First Place

Guy Cooper, Newsweek, *Romania: Last Days of a Dictator*, Second Place

Bill Ostendorf, The Providence (R.I.) Journal, *Russia*, Third Place

Joe Abell, San Antonio Express-News, *Shipping Out*, Award of Excellence

The Wichita (Kan.) Eagle, *The Road Back*, Award of Excellence

Rick Shaw, The Sacramento Bee, *Our Troops in the Gulf*, Award of Excellence

Overall excellence in newspaper editing

NEWSPAPER PORTRAIT/PERSONALITY

John Mottern, free-lance, *The Boy Warrior*, First Place

Brian Masck, The Muskegon (Mich.) Chronicle, *Tactile Vision*, Second Place

Kathi Lipcius, free-lance, *Children of the Damned*, Third Place

Sean Dougherty, Fort Lauderdale News/Sun-Sentinel, *Broken Doll*, Award of Excellence

Mark Sluder, The Charlotte (N.C.) Observer, *Gay Bashing*, Award of Excellence

John Trotter, The Sacramento Bee, *Jim Criss, Projectionist*, Award of Excellence

Joey Ivansco, The Atlanta Journal-Constitution, *Home in Projects*, Award of Excellence

John Moore, The Albuquerque Tribune, *Life Member*, Award of Excellence

Joe Patronite, Dallas Times Herald, *Young Soviet*, Award of Excellence

Tom Burton, The Orlando (Fla.) Sentinel, *Toasted*, Award of Excellence

Randy Olson, The Pittsburgh Press, *John Can't Sleep*, Award of Excellence

Albert Dickson, The Hartford (Conn.) Courant, *Coal Miner*, Award of Excellence

NEWSPAPER SPORTS ACTION

Mark Welsh, Arlington Heights (Ill.) Daily Herald, *Tippy-Toe Catch #2*, First Place

Donna Bagby, Dallas Times Herald, *Shoelace Tackle*, Second Place

THE CONTEST WINNERS

Eric Hegedus, Vestal (N.Y.) Press & Sun-Bulletin, *Dynamic Duo*, Third Place

Todd Anderson, Jackson Hole (Wyo.) Guide, *Defense*, Award of Excellence

Ron Garrison, Lexington (Ky.) Herald-Leader, *Unseated*, Award of Excellence

Kevin Geil, Fort Worth Star-Telegram, *Bull by the Tail*, Award of Excellence

Michael Ging, The Arizona Republic, *Water Show*, Award of Excellence

Matthew J. Lee, The Oakland Tribune, *Eye Opener*, Award of Excellence

Phil Masturzo, The Prince George's Journal (Lanham, Md.), *Surprised*, Award of Excellence

Frank Niemeir, Atlanta Journal-Constitution, *Can't Catch This*, Award of Excellence

Scott Sommerdorf, San Francisco Chronicle, *Blindsided!*, Award of Excellence

Sharon J. Wohlmuth, The Philadelphia Inquirer, *Over the Edge*, Award of Excellence

NEWSPAPER SPORTS FEATURE,

Kurt Wilson, The Missoulian (Mont.), *A Close Shave*, First Place

Chris Seward, The Raleigh (N.C.) News & Observer, *You Gotta be a Baseball Hero*, Second Place

George Wilhelm, Los Angeles Times, *Little Mermaid*, Third Place

Helena I. Sheldon, The Pottstown (Pa.) Mercury, *Sync or Swim*, Award of Excellence

Jim Evans, Jackson Hole (Wyo.) Guide, *Rush Hour Traffic*, Award of Excellence

Jason Grow, San Jose Mercury News, *Field Inspection*, Award of Excellence

Lacy Atkins, Los Angeles Times, *Morning Kiss*, Award of Excellence

Brian Peterson, Minneapolis Star Tribune, *Looking for the Green*, Award of Excellence

Carl D. Walsh, Biddeford (Maine) Journal Tribune, *Bus Lock Out*, Award of Excellence

Paul Howell, Houston Chronicle, *Tennis Doubles*, Award of Excellence

NEWSPAPER SPORTS PORTFOLIO

Gerard Lodriguss, The Philadelphia Inquirer, First Place

Louis DeLuca, Dallas Times Herald, Second Place

Kurt Wilson, The Missoulian (Mont.), Third Place

Vince Musi, The Pittsburgh Press, Award of Excellence

Brian Peterson, Minneapolis Star Tribune, Award of Excellence

NEWSPAPER SPOT NEWS

Osman Karakas, New York Post, *Don't Let Him Die!*, First Place

Marc Halevi, Lawrence (Mass.) Eagle-Tribune, *Reach for Rescue*, Second Place

David E. Dale, The Sharon (Pa.) Herald, *The Chase*, Third Place

Bill Lyons, New Castle (Pa.) News, *Raging Blaze*, Award of Excellence

Chris Taylor, Bristol (Va.) Herald Courier, *Truck Rescue*, Award of Excellence

Brian Masck, Muskegon (Mich.) Chronicle, *Moment of Despair*, Award of Excellence

Bruce Moyer, Naples (Fla.) Daily News, *Busted by...*, Award of Excellence

Bernardo Alps, The Santa Monica (Calif.) Outlook, *Demonstrator Clubbed*, Award of Excellence

David Handschuh, New York Daily News, *On the Edge*, Award of Excellence

David Handschuh, New York Daily News, *Grand Central Jumper*, Award of Excellence

Thomas Ondrey, The Pittsburgh Press, *Sniper's Suicide*, Award of Excellence

Richard Sennott, Minneapolis Star Tribune, *Under Cover*, Award of Excellence

Richard Sennott, Minneapolis Star Tribune, *Drug Bust*, Award of Excellence

Jeff A. Taylor, The Lewiston (Idaho) Morning Tribune, *I'll Jump!*, Award of Excellence

Michele McDonald, The Boston Globe, *Street Struggle*, Award of Excellence

NEWSPAPER-PRODUCED MAGAZINE PICTURE EDITING AWARD

J. Bruce Baumann, The Pittsburgh Press Sunday Magazine, First Place

The Philadelphia Inquirer Magazine, Second Place

Lucy Bartholomay, The Boston Globe Magazine, Third Place

NEWSPAPER-ONE WEEK'S WORK

Peggy Peattie, Long Beach (Calif.) Press-Telegram, First Place

Peggy Peattie, Long Beach (Calif.) Press-Telegram, Second Place

Jack Gruber, The Flint (Mich.) Journal, Third Place

OVERALL EXCELLENCE IN EDITING AWARD FOR NEWSPAPERS

The Sacramento Bee

The Index

The Index

How & What

Photojournalism #16 was created using Macintosh computers. We used the following software:
• **PageMaker** 4.01 by Aldus was used for design. Work was done with images scanned "for position only."
• Special typography was created with Aldus **Free-hand** 3.0.
• Typefaces used were Galliard and Stone, both by Adobe.

After design work was completed, images were replaced with stripping "windows" and the pages were output as film.

The editors wish to thank Apple Computer (Phoenix) and Bob Gentile for lending equipment to this project and Aldus Corporation and Larry Baca for technical support.